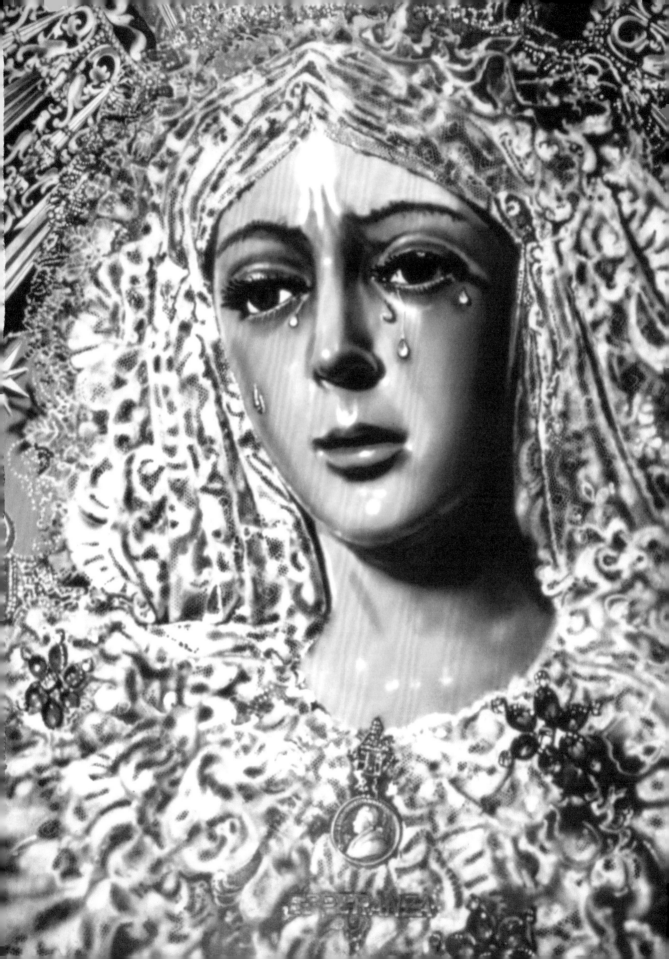

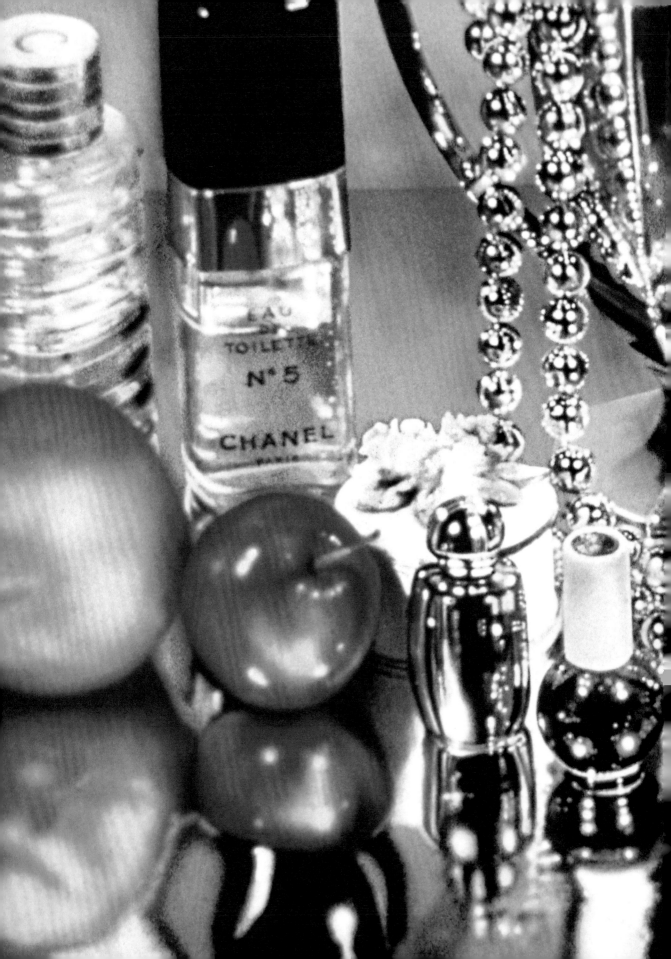

The Pennsylvania
State University Press
University Park,
Pennsylvania

AUDREY FLACK

With Darkness Came Stars

Library of Congress Cataloging-in-Publication Data

Names: Flack, Audrey, author.
Title: With darkness came stars : a memoir / Audrey Flack.
Description: University Park, Pennsylvania : The Pennsylvania State University Press, [2024] | Includes bibliographical references and index.
Summary: "An autobiography of artist Audrey Flack, from her early days as a young woman artist in the midst of the male-dominated Abstract Expressionist movement to the peak of her career as a pioneer of Photorealism"— Provided by publisher.
Identifiers: LCCN 2023024962 | ISBN 9780271096742 (hardback)
Subjects: LCSH: Flack, Audrey. | Artists—United States—Biography. | Women artists—United States—Biography. | Art, American—New York (State)—New York—20th century. | Photo-realism—United States. | LCGFT: Autobiographies.
Classification: LCC N6537.F53 A2 2024 | DDC 709.2 [B]—dc23/eng/20230602
LC record available at https://lccn.loc.gov /2023024962

Printed in China
Published by
The Pennsylvania State University Press, University Park, PA 16802-1003
10 9 8 7 6 5 4 3 2 1

The Pennsylvania State University Press is a member of the Association of University Presses.

It is the policy of The Pennsylvania State University Press to use acid-free paper. Publications on uncoated stock satisfy the minimum requirements of American National Standard for Information Sciences—Permanence of Paper for Printed Library Material, ANSI z39.48–1992.

Cover illustration: Audrey Flack, *Self-Portrait*, 1974, detail. Private collection, Switzerland. Endsheets: (*front*) Audrey Flack painting at Yale University, detail; (*back*) Audrey Flack, *Self-Portrait with Flaming Heart*, 2022, detail. Photos courtesy of Audrey Flack. Additional images, all artworks by Audrey Flack: page i, *Macarena Esperanza*, 1971; page ii, *Chanel*, 1974; page viii, *Diamonds and Sky*, 1951; page x, *Bad Girl*, 2017; pages xiv–xv, 100, *Banana Split Sundae*, 1974; page xvi, Audrey Flack, ca. 1950; page 14, The Cedar Bar, 1950s; page 80, *Lady with a Pink*, 1952; page 172, *Angel with Heart Shield*, 1981; page 244, *Self-Portrait with Flaming Heart*, 2022; page 248, Audrey and daughters Missy and Hannah.

To my wonderful daughters

CONTENTS

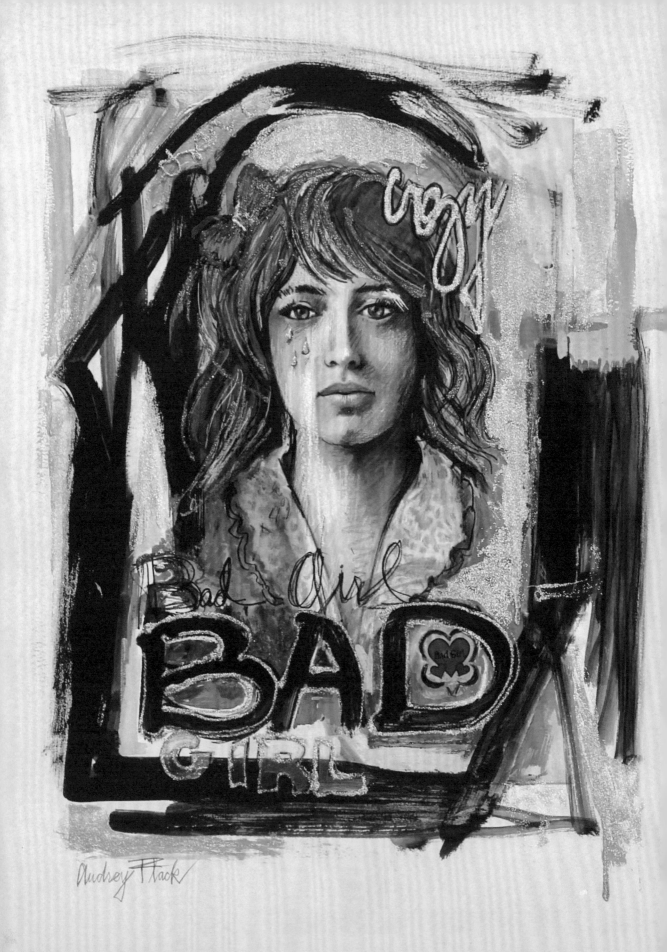

ILLUSTRATIONS

Unless otherwise noted, all artworks are by Audrey Flack.

ACKNOWLEDGMENTS

I want to thank my amazing, beautiful, radiant daughter Hannah, and my daughter Melissa, one of the stars that twinkle in the sky. I have been nourished by my husband Bob's children—Mitch and Leslie, and the late, sweet Aileen—who have been a loving family constellation for me. Bob, the steady sun and moon throughout my life and for the entire family, inspires me to reach for the sky. Thanks to Audrey Adams, my constant friend, advice-giver extraordinaire, and luminous asteroid. I am eternally grateful to Severin Delfs, my studio manager, advisor, and dear friend. I couldn't have completed this book without you. With deepest appreciation, I acknowledge Samantha Baskind, a brilliant art historian and writer who has been my steadfast supporter and unsurpassed interpreter of my work for over two decades, and most of all a loving friend. Last but surely not least, I recognize Patrick Alexander, whose editorial expertise was indispensable.

Chapter 1

The Buddhas of Eighty-Third Street

It was the last days of September 1983, and a chill was in the air. I jumped out of bed, pulled on my sweatshirt and jeans, and headed for the studio. *Skull and Roses*, my latest painting, was waiting half-finished on the easel. I mixed a color. It was cadmium red blended with burnt orange. I loaded my brush with the thick, creamy pigment, but I couldn't apply it to the canvas. I simply couldn't paint. I tried again and again until my arm tensed and ached from sheer frustration, and then my fingers began to cramp. The episode was so upsetting that I left the studio and headed for Broadway, where I sat on a bench and wasted away the hours, thinking about this bombshcll of a painting block that had hit me. I listened to the rumbling motors and honking horns of Upper West Side delivery trucks and buses, silently watching the neighborhood residents shopping, pushing baby carriages, and going about their business.

Sprawled on nearby benches were mentally ill patients from the Eighty-Fifth Street shelter, addicts slumped over in stupors of drugged dreams, and neighborhood alcoholics who swigged from bottles wrapped in brown paper bags as if the bag would conceal its contents.

At first, I thought it was just a phase, a temporary block. I'd had them before when I was younger; they usually lasted a couple of days

and rapidly dissipated. I could easily get back to work, and sometimes I even felt refreshed. But now I was fifty-two and this one was different. It was as if a sheet of steel had dropped between the canvas and me, like Richard Serra's sculpture *Tilted Arc*, solid and impenetrable.

I went to bed that first night, safe in my husband's arms, and woke up when the sun came shining through my bedroom window. I wasn't sure that I had ever fallen asleep. I slipped on my jeans, sneakers, and a sweatshirt, ready to confront the canvas again, hoping things had changed. But the block appeared before me with increased intensity. I froze in front of the easel, my body stiffened, my hands trembled, and I had to get out. I bolted from the studio and headed for Broadway. It was a brisk morning, and the few remaining leaves blew about me as I made my way up Eighty-Third Street.

Someone had already occupied my bench. He was a nervous wreck who stared at me suspiciously. He hadn't bathed or shaved in weeks, but I could read beneath the stubble and grime that he was young—sadly, only in his twenties. His leg vibrated up and down like a seismic tremor, shaking his loose pants, red shirt, and rumpled plaid jacket. I nodded to him as I sat down, but he shot me a wild-eyed, terror-filled look. I understood. He didn't frighten me; he was most likely schizophrenic. He fired a quick glance at my paint-splattered jeans and decided I belonged. We sat there silently, staring at nothing, the Buddhas of Eighty-Third Street.

Being a New Yorker and sketching in parks, restaurants, and back alleys, I had observed over the years that people with schizophrenia like to dress in vivid colors. They put together crazy outfits: print scarves, hats, beads, pins, anything with a lot of energy to keep up with the high-voltage electricity in their brains. They reminded me of my mother. She was not schizophrenic, just a larger-than-life gambling addict who liked to wear beaded sweaters with rhinestone brooches. She sewed lace collars onto print blouses and adorned herself with pearl necklaces. She either tucked her hair into a sequined jet-black snood or wore fanciful hats draped with a netted veil and embellished with peacock feathers or clusters of artificial flowers. Her hats were worn tilted to one side, and in spite of her extravagant taste for ornamentation, she exuded an air of elegance.

Another week passed, and still, I couldn't paint. The block had clamped its venomous incisors into my neck and paralyzed me. To make matters worse, I was under pressure. Time was running out. I had a

show scheduled to open in November at the Louis K. Meisel Gallery in SoHo. The gallery had already placed the ads, collectors and museums had been notified, and articles were being written. Along with Chuck Close, Richard Estes, and Robert Bechtle, I was a Photorealist at the peak of my career, and I was the only woman in this groundbreaking group of artists who were to have a profound effect on art history. My work was in collections of major museums throughout the United States and Europe, and colleges and universities were inviting me to lecture—but since the painting block hit, I wanted no part of it. I refused all invitations, withdrew from friends, stayed away from art openings. All I could do was sit on the bench, immobilized in a state of depression verging on despair.

Art was my vehicle, yet in spite of the years of study and hard work, my world had collapsed. I was reduced to a semi-hypnotic state, with my mind wandering back and forth in time. It was five o'clock and the sun was setting when I felt something irritating my throat. I cleared it a few times, but it got worse; I began to cough, splutter, and then choke. The exhaust pipe of a stalled bus was belching out black, toxic fumes, its foul smoke enveloping the whole center island. I doubled over, my throat constricted, and tears flooded from my eyes. Backed-up cars honked their horns and my lungs hurt. I couldn't breathe. There was a scramble and everyone on the benches scattered in all directions looking for fresh air. I staggered out of the fog and coughed my way home.

The Portfolio

Days later, back on the bench, I closed my eyes to the bright sun. My thoughts zigzagged back to the time I was thirteen, when I unequivocally concluded that life was not worth living without art. Yet here I was, forty years later, stranded on the Broadway bench without the very thing that held me together. I felt depressed, disillusioned, disconnected, dazed, and derelict, all Ds . . . just like my report card grades.

I woke up the next morning not wanting to return to the Broadway island of smoke, isolation, and exile. But the idea of facing my unfinished canvas was even more upsetting. So I bypassed the studio and headed for Broadway, where my usual spot was waiting. The bus and its offending fumes were long gone, the air was clean, and it was a pleasant day. I made myself comfortable and settled in for the long haul.

What had brought me to this point of desolation? How did it all begin? Even as a young girl in primary school, I had wanted to become an artist—to learn art's rules, study its techniques—but I had no idea how to do it or where to go. Fortunately, one day in early 1945 I bumped into Flora, a girl who lived in my building. Flora received private lessons after school and kept apart from neighborhood children, but, just this once, Flora stopped and offhandedly mentioned that she was taking the test for a high school that specialized in art. Overcome with excitement, I bombarded her with questions. She was reluctant to offer details but eventually revealed the name . . . it was the High School of Music & Art on 135th Street in Harlem, and you needed to take an entrance exam and bring a portfolio.

From that moment on, I became obsessed and thought of nothing but getting into this school where I could learn the craft of art. I was also worried and perplexed, because I didn't know what a portfolio was. I asked my mother; she knew nothing and wasn't particularly interested in finding out. However, mom was more than willing to let me pursue my ideas so she could carry on with her gambling addiction.

Ironically, my mother had strong artistic abilities, yet failed to value them in herself or in me. She embroidered tablecloths, crocheted blankets, designed her own needlepoint pillows, and set up carefully arranged flowers. She cut reproductions of Old Master paintings from magazines and placed them all over the apartment. A Rembrandt self-portrait hung over the green velour sofa in the living room. He wore an oversized beret and pleated smock. That's when I realized that artists worked in specific outfits. Rembrandt hung next to a fifteenth-century Italian artist named Ghirlandaio, who painted a beautiful young boy looking up at an old man whose nose was grotesque, bulbous, swollen, and infested with hideous warts. It hurt just to look at him. I knew the boy loved the old man in spite of his deformity because of the beautiful expression on his face, and I also knew the painting was great in spite of its subject matter. But I couldn't understand why my mother liked it. She gravitated toward the strange and unbalanced and sought out disturbing images. Her tastes ranged from kitsch to the most profound expression of high art.

Right next to the Ghirlandaio was Jan van Eyck's 1434 *Arnolfini Portrait*. The people in these paintings became my friends. They inhabited

the house and kept me company when I was home alone. They looked after me as they glanced down from the living room wall.

Rembrandt was the grandfather I never had, Mary Cassatt my good aunt, Paul Cézanne my steadfast uncle, Amedeo Modigliani my wayward brother. Art itself took on the role of substitute mother and family. Not only did it invigorate me but it also protected me from the confusion of the outside world. The concept of art took over my life. The history of art became my history; the making of art, my truth; and the essence of art, my religion.

Centered over the piano was a romantic print of a violinist flinging his instrument in the air in order to kiss his beautiful young accompanist. In the bathroom, a sexy Alberto Vargas pin-up girl with bulging double-D breasts, nipples popping out of her tight white blouse, hung over the towel rack. Vargas was an illustrator for *Esquire* and *Playboy* magazines and one of the first artists to use the airbrush. The airbrush was considered a mechanical device used only by lowly retouchers and illustrators for their slick commercial work. In spite of Vargas's subject matter, his technique intrigued me and filtered into my decision to go against art-world doctrine and experiment with the airbrush years later. Chuck Close and I were to legitimize the use of the airbrush in fine-art painting.

I found myself attracted to images of passion, sorrow, love, anguish, joy, and inner truth. Artists concretize these emotions and freeze them on the canvas. It is one of the miraculous offerings of art.

Besides the drawing test to be given at the school, I had two weeks to create ten works for my portfolio. I pulled out a few sheets of erasable bond typewriter paper and two yellow Mongol pencils from the family desk in the foyer. In those days, pencil sharpeners had to be screwed to the desk and rotated by hand. Only schools or offices had them, so I used my father's single-edged razor blade to sharpen my stubby pencil tips.

I searched the apartment for subject matter and found a bottle of Old Grand-Dad whiskey stashed under the kitchen sink. Old Grand-Dad's craggy face, with his round, wire-rimmed glasses and deeply etched age lines, reminded me of the old men I hung out with in the park. I liked old men. From as early as five or six, I sat on their laps and watched them play chess and checkers. I was alone most of the time because of my mother's gambling addiction. These men were like parents to me. Besides, unlike the cliquey girls, they accepted me and tolerated my mood swings. Looking back on it now, I was lucky none of them were perverts.

Old Grand-Dad would be my very first drawing. I set to work on our white enamel kitchen table and proceeded to render every hair on Old Grand-Dad's head. Then I spit on my fingers and smeared the graphite to achieve dramatic chiaroscuro effects. I thought it was terrific; I didn't know any better.

Using a picture in the *Daily News* advertising *Mrs. Miniver*, a movie about World War II, I drew a portrait of the British actress Greer Garson. The reproduction was so blurry I had to refocus her face in my drawing. That presaged what was to come years later in my Photorealist painting of Marilyn Monroe. My next drawing was a cartoon of two girls walking, taken from an illustration inside a Kotex box. The last few sketches were of the old men playing chess, the horse chestnut trees I loved so much, and the pigeons pecking away on the cobblestones.

That was it; my ten drawings were done. It was time to get a portfolio to put them in. I asked my father where I could find one, but he had never been to an art supply store and wasn't even sure what a portfolio looked like. My brother Milton might have known, but he was away at college, about to be shipped off to war.

My mother said, "Ask at the local five-and-ten-cent store. Woolworth's has everything."

Getting to Woolworth's on 181st Street was a long and potentially dangerous walk because I had to cross Broadway and enter Amsterdam territory, where the Irish Dukes beat up the Jewish kids. We were secular Jews who only observed major Jewish holidays like Yom Kippur and Passover, but it didn't matter if you were religious or not—you were likely to be verbally abused or physically attacked. But I needed that portfolio. I half-ran, half-walked, never looking back until I found Woolworth's, all lit up with its red-and-gold sign above the entrance.

I pushed open the swinging doors and asked the first salesgirl I saw, "Where can I find a portfolio?"

"A what?"

"A portfolio, you know, to put things in."

The girl chewed her gum and shook her head.

"Never heard of it."

I moved to the next aisle, and asked again.

"Do you know where I can find a portfolio?"

Nobody knew what I was talking about, so I decided to fiddle with a basket of lipsticks at the cosmetic counter. I pulled the off the caps and

tested the colors on the heel of my thumb. The cosmetic salesgirl stood
there chewing her gum, oblivious.

"Do you know where I can find a portfolio?"

She looked up. "Yeah, take a look at the stationery counter, over
there."

I made my way to the next aisle, where stacks of loose-leaf binders,
steno pads, paper clips, erasers, rubber bands, and other assorted par-
aphernalia were bunched together in little cubicles. And there it was! A
small, brown leatherette folder with the word PORTFOLIO embossed diag-
onally across the front in shiny gold script.

"Wow, am I lucky!" I thought.

The only thing that puzzled me was the writing paper and envelopes
inside. I paid the salesgirl with my allowance money and headed home.
Once inside, I pulled out the paper and envelopes and slid my drawings
into the slots, amazed at how perfectly they fit.

It was hard getting to sleep that night. I tossed and turned and woke
up the next morning nervous and wired. I asked Flora if she would go
with me, but her parents were already escorting her and didn't offer to
take me along. I was trying to figure out what trains to take when my
father offered to drive me. It was a kind and unexpected act that I am
ever grateful for. I sat beside him, clutching my portfolio, as his old Buick
Riviera chugged up the steep hill at 135th Street to Convent Avenue.

"That must be the school!" I said excitedly when I saw the stately
old Gothic building.

My father pulled over to the curb to let me out. I swung open the
heavy door, put one foot on the sidewalk, looked up, and gasped in horror.

Right across the street were several dozen students walking deter-
minedly toward the front door, all carrying huge black cases, which I
instantly knew must be portfolios, *real portfolios*, not like my inexcus-
able five-and-ten-cent-store letter-writing tablet.

My God, there was Flora walking between her parents with the big-
gest one of all. She never let on, never told me what a portfolio was or
how prepared she was. I was later to find that inside of Flora's huge black
case was a series of watercolors, pastels, and oil paintings. She had been
attending classes at the Art Students League all year in preparation for
this day. To her credit, even though she hid her training, Flora did tell
me about the test for Music & Art. She was my first experience with the
fiercely competitive art world.

I yanked myself back into the car and slammed the door shut. I slouched down and sat there feeling stupefied and stupid—betrayed by Flora and crushed by the thought of my impending doom. Ashamed and embarrassed, and not wanting to leave the safety of the car, I asked my father to take me home or at least drop me off at the bus stop. With a stern look, he leaned over and pushed me out.

"You're a Flack, and Flacks don't give up. Take the test!"

I watched the old Buick disappear down the hill and stood at the curb, shaken. I must have stayed in that spot for quite a few minutes, because when I looked up, no one was around. I was alone on the street; all the students had already entered the building. *What have I got to lose?* I took a deep breath, walked through the front door and found my way to the test area, where I saw the formidable mountain of black portfolios piled high in front of the room. I edged my way to the front, slinking along the side wall and hoping no one would notice me or my ridiculous writing tablet. I slid it in between two giant portfolios, turned around, spotted an empty place, and took my seat.

Within a minute the instructor appeared and distributed several sheets of eighteen-by-twenty-four-inch newsprint paper and a stick of black charcoal. I had never seen or used either of those items before. We were told to arrange our chairs in a circle, leaving enough room in the center for a model to pose. A senior student dressed in black leotards took her place on the model stand. The instructor held up a stopwatch and explained the rules.

"I will be timing you. Start drawing only when I give the signal. You cannot make another line after I say 'Stop.' There will be four five-minute poses and two twenty-minute poses. Are you ready? Everybody start."

Down went her hand as she pressed the button on her stopwatch. The only sound heard was the scratching of charcoal sticks as they moved back and forth over the rough newsprint paper. I felt a burst of adrenaline shoot through my body as I began to sketch. It was the first time I had ever drawn from a model. I felt exhilarated; everything around me faded away. I was alone with the model, the charcoal, and the newsprint—all firsts.

I felt a sense of my own power and command. I could translate that figure onto paper. I sat up even straighter and looked around to get a glimpse of my competitors' work. From what I could see, my drawings were good. I knew they were good. Three weeks later, I received the letter.

Dear Audrey Flack:
We are pleased to inform you that you have been accepted for entry
to the High School of Music & Art.

It was a miracle.

Another chance meeting occurred the year I graduated from Music
& Art, when I bumped into a schoolmate, Margie Ponce. Margie would
eventually become Margie Israel, wife to Marvin Israel, the renowned
artist, photographer, art director, and lover of Diane Arbus. In 1945,
Margie declared that she was going to take the test for Cooper Union,
an art school that was tuition-free. "It doesn't offer a college degree,
just a three-year graduate certificate," said Margie. But I jumped at the
chance and immediately investigated how to proceed.

My immigrant parents were unable to help financially. No woman
in my family had ever gone to college. *Too much education spoils a girl's
chance of getting married* was my mother's warning, and she repeated
it endlessly like a mantra. I decided then and there to go it on my own.

It was a bright summer's day when I took the A train from 175th
Street to the Eighth Street station in Greenwich Village to compete in
the grueling test for Cooper Union. I put on my Saint-Gaudens necklace
for good luck. It was a small bronze medal that I hung on a simple chain.
Saint-Gaudens was the fine art award presented to the most outstand-
ing artist at Music & Art, and I loved the sense of validation it gave me.
I was surprised that the medal showed a woman wearing a long skirt,
drawing from a plaster cast, instead of a male artist. I wondered if boys
also got the medal of this woman.

I rubbed the medal as I walked to Cooper Union from Sixth Avenue
over to Astor Place via Eighth Street. Eighth Street was a wide cross-
town shopping area buzzing with cars, buses, pedestrians, and stores
the likes of which I had never seen: specialty shops with exotic win-
dow displays, and jewelry stores that designed custom wedding rings,
not at all like the boring standardized jewelry the Washington Heights
matriarchs wore. One small shop made hand-crafted leather sandals,
each one uniquely designed by the owner, a young bearded hippie who
left his workbench and took an imprint of your foot by tracing each toe
on a piece of cardboard. By my senior year, I had saved enough money
to order a pair of custom-made Roman gladiator sandals with lace-up
ankle straps.

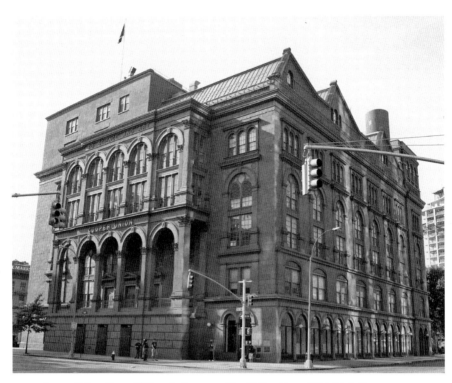

Fig. 1 Cooper Union. Photo: Wikimedia Commons / David Shankbone (CCA-SA 3.0).

My eyes glanced at a sex shop with life-sized mannequins wearing nothing but feather boas and lace panties with slits where they shouldn't be. Oversized dildos with the cocks pointed upward rested against their bare ankles. This was a world far removed from the family-owned Jewish bakeries, grocery shops, and kosher butchers of Washington Heights.

As much as I wanted to take in the thrill of Eighth Street, I had to get to the test on time, so I fast-walked across Mercer Street and Fifth Avenue until I arrived at the spacious triangle of Astor Place. A crowd of students had already gathered outside Peter Cooper's visionary building. Built out of huge blocks of brownish-purple stone, it looked like a mysterious temple crowned with a row of gigantic pointed skylights. For me, Cooper Union seemed to dominate the entire Lower East Side of Manhattan like a giant monolith.

At the stroke of nine, the oversized metal doors swung open and hundreds of anxious students rushed in to secure seats. I spotted Margie and waved, but we got separated. The tests were designed to determine intellectual and artistic abilities and took two days to administer. Every twenty minutes a new booklet was handed out. We had to complete as many pages as possible before the next one was distributed. Cooper

Union would select ninety students out of three thousand candidates. Only forty-five of us would graduate. The thrill of being one of the graduates is difficult to explain.

I was seventeen years old and a student in one of the greatest art schools in the country.

Avant-garde artists taught there and worked in surrounding studios. They were serious professionals like Peter Busa, Steve Wheeler, and Will Barnet, who formed the Indian Space painting movement; Charles Gwathmey, a star of the Social Realist group; and Nick Marsicano and John Ferren, who were part of the hot new Abstract Expressionist movement. These artists were producing some of the most radical and shocking art forms of the century.

Abstract Expressionism was electrifying the city, revolutionizing the art world, and riveting the public. It would be historically and socially epic. Jackson Pollock, Willem de Kooning, and Franz Kline were to become legends. And here I was, a young, aspiring artist, miraculously scooped up by this whirling tornado and deposited in the center of one of the most exciting periods in all of art history.

Because Cooper Union was free, it didn't have dormitories, cafeterias, bookstores, or lounges. Students lived at home with their parents and commuted back and forth on buses and trains every day. A few slept in a rented loft in the neighborhood. After my first semester, with money from odd jobs and an occasional sale of a drawing or watercolor, I was able to rent a cheap loft in a condemned building on Eighth Street right alongside the Third Avenue elevated subway. It was illegal and considered too dangerous to inhabit, but I knew I could get around the tilted staircases, broken banisters, and wet rot that weakened the floors. I was thrilled to have a studio of my own! John Grillo, a handsome, talented Ab Ex painter, rented the top floor. Bob Lander, a comic-book illustrator who inked Spiderman, rented the first floor, and my studio was in the middle. I could watch Lander work from the sinkhole in the center of my loft, and when he needed some extra help to meet deadlines, I helped ink Spiderman for him.

My studio was directly across the street from Cooper Union, its second-floor windows on the same level as the elevated train tracks. The tracks were supported by powerful steel T-beams that had become so encrusted with rust over the years that chunks of orange-colored crumbling metal chipped off and stained your fingers and jeans if you accidentally brushed against them. The overhead railroad ties cast slatted

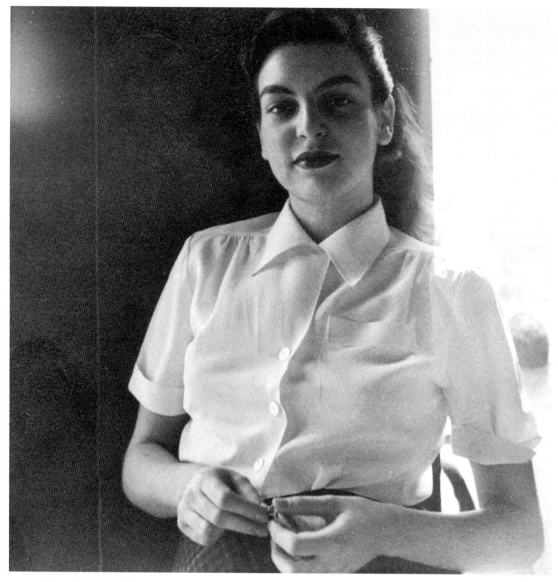

Fig. 2 Audrey Flack, ca. 1950. Photo courtesy of Audrey Flack.

shadows on the streets below and spread a dull pall over the neighbor-hood. Everything was sooty black and gray, except for the door to my condemned building, which the previous tenant had painted bright cad-mium red. It was the only upbeat color in that godforsaken Bowery. Like a Jasper Johns target painting, it sucked in color and breathed out energy. I was living in the center of the action, looking out of the eye of the bull.

The local trains rattled into the Astor Place station every five minutes, blowing a storm of cigarette butts, crumpled newspapers, paper cups,

and threadbare rags. The winos who took shelter under the tracks slept in makeshift tents, oblivious to the earsplitting, high-pitched shrieks of the metal wheels as the local trains screeched into the station. Most of the time I worked with cotton stuffed in my ears. The screech was muted when the express train whizzed past, but the reverberations from its accelerated speed shook the building, rattled my windows, and buzzed my feet as if they were plugged into an electrical socket. The art world was open to me—but so were the pitfalls of Abstract Expressionist life. It was exhilarating, but also rough and fast.

The New York
Art Scene
(1949–1959)

Chapter 2

The Bowery and the Cedar Bar

A restlessness often swept across me on the bench on Broadway. What would break this spell of immobility? I escaped to the past, which was not always comforting or reassuring, but it did remind me that I once had been an artist. In these flashbacks, I often found myself at the Cedar Bar or in the Bowery. Its sounds, smells, and memories never left me.

Life was exhilarating, unpredictable, and volatile from the moment I woke up in my chilly studio until the wee hours of the morning, when I said goodbye to the few stragglers who remained at the Cedar Bar until closing time. It was romantic, it was glamorous, and I was young and eager to be part of the scene, creating art that pushed the limits to the breaking point.

The Bowery gained fame for being a gathering place for hundreds of homeless derelicts and alcoholics who wanted nothing more than to find their next bottle of rotgut. There was little to no help or hope for them, except for a nearby Salvation Army station. These men hitched rides on boxcars or walked hundreds of miles from all over the country

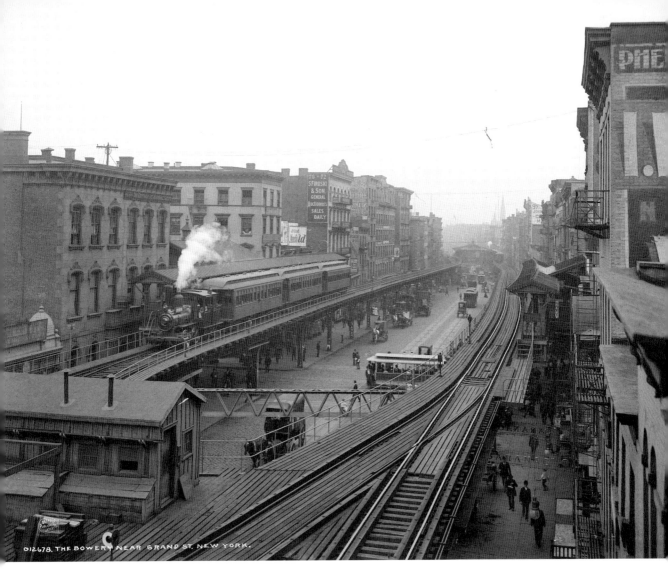

Fig. 3 Bowery hotel with elevated train, ca. 1900. The Bowery near Grand Street in New York City. Photo: Granger Historical Picture Archive.

because the word was out that they could live on the streets and the police wouldn't bother them. One or two flophouses offered these poor men a bed to rent for a few pennies, but the majority of them slept, pissed, and shat in the streets. Some decrepit bodies were nearly always passed out in my doorway. I had to push them aside just to get through the front door and then quickly shove them back out before they fell into my hallway.

Ironically, it was the staggering alcoholics who lent a steady stability to the area, because they could always be found in their favorite spots setting up their makeshift beds and sipping their putrid concoctions. More disruptive were the Abstract Expressionists flocking there in droves, invigorating the area with excitement and energy. This new

American movement was gathering force with such speed that artists from all over the country and as far away as Europe felt its magnetic pull. Artists packed up their canvases, left their homes, and resettled in studios on the Lower East Side of Manhattan. Paris was over. New York City was rapidly becoming the international hub of art activity.

Max Ernst and Marcel Duchamp flew in from France, and Piet Mondrian from Holland; Willem de Kooning, also from Holland, stowed away on a ship; Jackson Pollock rode a bus from the prairies of the Midwest; Franz Kline took a train from the coal mines and steel mills of Pennsylvania. They brought a storm of activity and eye-opening ideas to our small area on the Lower East Side.

Artists rented raw, rough, barnlike studios with few amenities on Eighth, Ninth, and Tenth Streets. There was no heat. Toilets were in the outside hallway and shared by several tenants. Life felt open, dangerous, and free—completely American, not like the elegantly carpeted, luxurious ateliers of nineteenth-century European artists. Younger artists sensing the energy arrived, rented studios, and gathered around older mentors, generating concentric rings of artistic energy.

Artists were everywhere. Just walking along the street you could hear them discussing their latest work. We all knew one another, and even if we didn't know someone's name, the familiar face was acknowledged and accepted just from being around. Everyone needed to talk. Ideas were spilling onto the canvas so fast that artists began to congregate: exchanging information about galleries and dealers at the Cedar Bar, drinking coffee and sharing ideas at the Waldorf Cafeteria on Eighth Street, buying art supplies at Lou Rosenthal's basement store around the corner. Lou knew all the artists and cared about them. If there was a specific color I wanted, he would slip it to me if I didn't have enough money.

Landès Lewitin's career never took off, but he was a valued member of the community. He could be found most afternoons sitting in the Waldorf Cafeteria, bent over a cup of coffee with his sketchbook open beside him, engaged in heated discussions about art with Aristodimos Kaldis, a tall, imposing Greek who was never seen without his red scarf tossed over one shoulder. I would peer through the plate-glass windows, hoping to spot those two philosophers so I could listen to them pontificate.

The Waldorf was a stripped-down, shabby cafeteria, with lighting so grim the people inside looked embalmed, but it was a good place to get out of the cold, and we could sit there for hours over a Parker House roll

and a hot cup of coffee. When we were short on money, we made meals out of hot water and ketchup. Jack Kerouac and some of the other Beat poets hung out there, and Franz Kline and Bill de Kooning would saunter in and join us after they finished painting. They were the respected masters, the heroes, and I was the young woman artist. Somehow I had managed to position myself as part of the new Ab Ex movement and not just another young woman to fuck. These men accepted me and I was thrilled to be in their presence, listen in, and take part in their conversation.

The Waldorf was depressingly lit, and the Cedar Bar was too noisy for any serious discussion, so a group of artists got together and formed a social club. We simply referred to it as the Artists Club, and it was exclusively for hardcore Abstract Expressionists. Poets, writers, and musicians were also invited. It was not open to the public; only members or invited guests were allowed in. The Club met on Wednesday, Friday, and Sunday nights and was run by the sculptor Philip Pavia, who collected the dues and offered free syrupy black coffee he brewed in a huge aluminum urn. At first the club moved to wherever Pavia could rent a cheap loft, but in 1948 he found a permanent meeting place at 39 East Eighth Street.

Nick Marsicano, my teacher at Cooper, was one of the ten charter members. He brought me as his guest, but it was more like a date. I felt special. That's how I first met Bill, Franz, and Jackson. I remember watching them toss down tumblers of scotch chased by swigs of beer. I was an awestruck, thrilled eighteen-year-old, and they were my heroes—as much as Rembrandt, Tintoretto, and Picasso were.

Friday nights were special because of panel discussions where critics and artists were invited to present their ideas. Fevered debates broke out, and it was not unusual for disagreements to turn into shouting matches. One evening, a woman on the panel surprised the audience by wearing a white Kabuki mask and not saying a word throughout the presentation. Urged to take it off, she removed it, only to reveal another one underneath. When she finally exposed her naked face, it was the strikingly beautiful Marisol.

She had turned the evening into a performance piece. I wondered why Marisol was on the panel in the first place; she rarely spoke, with her barely audible, high-pitched voice. I soon learned that despite being the same age as I, she was already having an affair with de Kooning, who was in his late fifties.

Marsicano resembled Michelangelo's marble statue of Lorenzo de Medici. His handsome oval face and discourses on art were mesmerizing, and every girl in class had a crush on him. For a brief period, I shared his rickety studio at 12 Little West Twelfth Street, in the heart of the meatpacking district. It was a dangerous and desolate area in those days. Derelicts lay around in cardboard boxes, urinated in the street, and set gasoline drums on fire to warm their chilled bodies. Marsicano's wooden studio building was a tinderbox that could have easily gone up in flames, but the rent was cheap and the space ample. We worked in separate rooms, but I could see that Marsicano was breaking away from Abstract Expressionism and experimenting with figuration.

"Pose for me," he said, and I did.

The studio was deadly quiet; the streets were empty. (The bleak meatpacking district came alive in the wee hours of the morning.) The only thing moving, besides a stray cat, was Nick's arm, swishing his sable brush in a jar of liquefied black pigment thinned to the consistency of light sweet cream. We were engulfed in an eerie, magical quietude. Nick painted me with rapid, spontaneous brushstrokes, executed in the style of a Zen calligrapher. He worked with passion and intensity. Moving in to take a closer look, he whispered, "I love the pout of your lower lip."

He ran his fingers over my profile and kissed me, a sweet, gentle, tender kiss, and then returned to work.

One after another he ripped sketches off the page, completing ten or more before taking a break.

Nick was also breaking away from his wife. People called her a witch. Merle Marsicano was an intimidating figure, in the style of Lee Krasner. Merle was a modern dancer known for her firm, taut body and severe, angular dance style. Her face was pockmarked, her mouth a turned-down slit, her eyes mean.

Merle was a featured artist in several John Cage concerts that were held in shabby, dimly lit rooms. We took it all very seriously as we silently filed in. We sat on wooden folding chairs and waited until a plunk, thud, or mysterious rattling sound emerged from a "prepared piano." Sometimes a silent interval would last for fifteen minutes; we obediently waited for the next sound to emerge from God knows where and sound like God knows what. It seemed to me that those isolated sounds were the equivalent of solitary marks on the canvas. On special occasions, Merle appeared on stage and performed stiff, jerky, avant-garde dance movements to accompany the spasmodic music. Dressed in layers

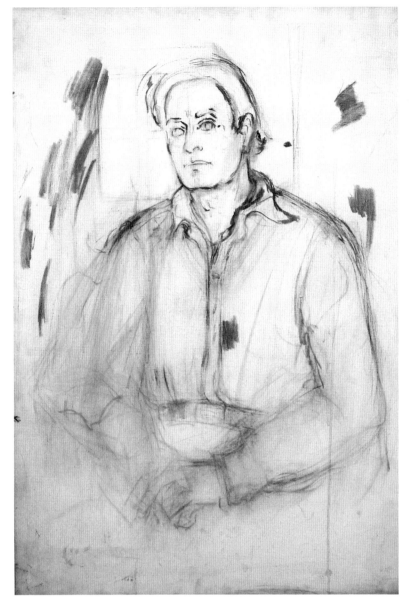

Fig. 4 Nick Marsicano, 1951–52. Oil on canvas, 40 × 27½ in. Photo courtesy of Audrey Flack.

of transparent veils, she moved barefoot and grim-faced across a barren stage illuminated by a wash of blue light.

Nick began to call me at home, sometimes four or five times in a row.

"Marry me." Nick proposed the day after graduation.

I was shocked. He never hinted at the seriousness of his feelings or discussed his marriage. He was gentleman enough to wait until I graduated, but I was nowhere near ready for marriage. Besides, being two generations older, he was part of a social world that scared the hell out of me. I distanced myself, Nick never left Merle, and we remained friends.

It was the first time I had caught a glimpse of how vulnerable these god-like men were.

In those days we respected our teachers, our masters. Years later Grace Hartigan complained to me, "Audrey, we used to wonder about what we could do for our teachers. Now our students want to know what we can do for them."

The time at the Club was alive with heated intellectual debates, liquor, black coffee, flirting, and sex. Avant-garde music, poetry, and dance were an important part of the scene. I mingled and interacted with John Cage, Merce Cunningham, John Ashbery, Kenneth Koch, Frank O'Hara, and Morton Feldman, an ultramodern composer gaining notoriety. Mort understood the scene and commented, "What really matters is to have someone like Frank O'Hara standing behind you. Without that, your life is not worth a damn."

I was intrigued by his music and thought process until he once made a move on me. Mort wrapped his enormous arms around me and began to plant kisses on my lips, cheeks, and neck. I tried to push him away, but he was beefy, overweight, and he overpowered me. So I jammed my elbow into his belly and shoved. He stumbled backward and fell, injuring his elbow.

Mort righted himself and left in a fury. The following week Mort appeared at the Club with his arm in a sling. I felt bad and apologized, but we never spoke again.

The entire area felt like a Wild West boomtown, with people stumbling out of saloons wandering aimlessly along the streets amid macho workmen wearing gunslinger-style tool belts. All this was interspersed with artists leaving their studios in their working outfits. You could see Bill de Kooning walking along wearing his white house-painter overalls and matching cap, or Jackson Pollock in his paint-stained denim jeans, black T-shirt, and workman's boots. The streets were 95 percent male, with very few women populating them. I was wary about going out at night.

Jackson Pollock

Memories of the evenings I spent talking art and flirting at the Cedar Bar brought a smile to my otherwise morose face as I sat on the bench. The young man nearby noticed my bemused look and smiled back. His was miniscule, just a small upward curl at each corner of his mouth.

Still, I was happy to see his spirits lifted. I tucked my red T-shirt into my jeans and stretched out my legs. I could wear that bright color now, but I never wore color when I painted. It interfered. I wore denim jeans, a black sweatshirt, no lipstick, no makeup. My hair had to be pinned back, and even my underwear couldn't have any color. No ego, nothing to get in the way of clear vision. As I sat on the hard wooden slats, I saw myself back in my barren loft from so many years ago, getting ready for the night that was to change my life.

As the light grew dim, I cleaned my brushes, used the turpentine-soaked rag to scrub the paint off my hands, and walked over to the Cedar Bar on Eighth Street and University Place. But before I left, I spread creamy geranium red lipstick over my lips, smacked them together, and tinted my cheeks with rouge. I unpinned my hair and let it fall to my shoulders, leaving a few loose strands dangling seductively over one eye, Veronica Lake–style. I fastened the clasp of my turquoise and silver necklace and headed for the thrill and action of the bar.

Being pretty mattered. Comments about women's looks were brazen and disparaging. Poor Lee Krasner was considered ugly, and even though she had a great body, her face was the butt of nasty jokes. Bill de Kooning said that if she were to sit on his lap he would spread his legs and let her fall on her ass. Everyone laughed.

After being alone all day, you felt a need to socialize, flirt, rub up against another body, and talk about art. Conversations vacillated between the Old Masters and Modernism, between the Mondrian show at the Sidney Janis Gallery or de Kooning at Egan. Artists formed small groups and gossiped about dealers and galleries: which ones were drunks, which ones didn't pay their artists, which ones were approachable, and which co-op galleries were offering exhibition opportunities.

Openings were held on Tuesday evenings, and the word spread about which galleries were serving drinks and hors d'oeuvres. Co-ops had little food to offer, but the Madison Avenue venues came alive with bands of artists stopping traffic as they zigzagged from gallery to gallery, filling their stomachs with assorted cheeses, crackers, cashew nuts, and white wine.

At the Cedar Bar, passions ran so high about the aesthetics of art that arguments broke out. Was Greek art superior to Roman art, was

Cézanne better than Delacroix, was Courbet better than Corot? Shoving, pushing, and even occasional fistfights erupted. Reckless sex, heavy drinking, and drugs were part of the scene. Artists considered it essential for the vitality their work. Grace Hartigan told me she couldn't paint without the Sturm und Drang of lovers and whiskey.

I was always on guard at the Cedar Bar. A sense of danger hung in the air, particularly for a woman alone. Young artists, excitement seekers, and groupies would sip beer and scan the room, hoping to get a look at the big honchos. Seeing Jackson Pollock, Bill de Kooning, and Franz Kline leaning over the bar at the same time was like hitting the jackpot on a slot machine: three wild cards lined up in a row, each of them tossing down shots of scotch with beer chasers.

Saturday nights were standing room only. Artists in denim shirts and paint-stained jeans were jammed together, drinking beer and talking art. Cigarette smoke hung heavy in the air and cast a yellow haze over

Fig. 5 The Cedar Bar, 1950s. Photo: Getty Images (Fred W. McDarrah).

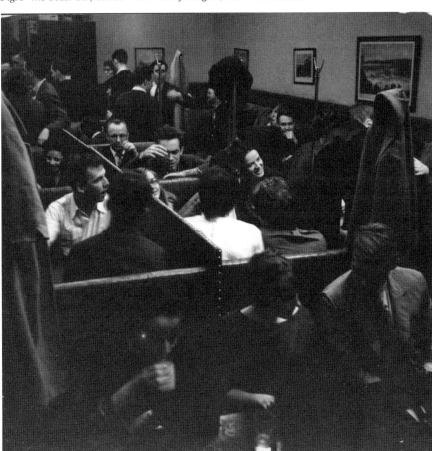

the bar. All the tables and booths were filled with art-world denizens on dates or conducting gallery business. The noise of bar talk and laughter was punctuated by the clinks of beer bottles and shot glasses. Occasionally, arguments broke out. A hush took over as heads turned toward the source, anticipating a fistfight.

Most of the artists drank heavily, and some dabbled in drugs; you never knew what they might do. I remember spotting Mike Goldberg and Larry Rivers sitting in a front booth with two women squeezed next to them, puffing on Camel cigarettes, laughing, and making a lot of noise. Empty beer bottles, shot glasses, and cigarette butts littered the table. I didn't know at the time that Larry was also shooting heroin, nor did I know what a strange and violent man Mike was.

Mike beckoned me over. He shoved one woman aside and patted the seat next to him. "Sit down," he said, with a coy smile. Mike was extremely handsome and the look he gave me was sexy and alluring. I was attracted to him and felt a stir in my loins, but the beer bottles and raucous behavior made me wary. I stopped and chatted for a moment but decided not to accept his offer, even though this was a sought-after group. Being a part of it would have given me entry into the "in" world, but I smiled and said, "No thanks, Mike," and headed toward the back where it was quieter. My instincts were right; Mike was having an affair with Joan Mitchell. He smacked her around, beat her up, and later broke someone's kneecaps. He was jailed and spent time in a mental institution where Joan was raped by an attendant while visiting him. That sort of extremism was frightening and out of my realm of experience.

I ordered a glass of wine and sat down at a small round table opposite the far end of the bar. I had taken a few sips when Jackson Pollock strode in. I could tell he was there because a hush took over the place. You could hear the whispers, see the glances and the fingers pointing. Everyone knew we were in the presence of someone great. Pollock was the most important artist in town, and to be near him, to overhear his conversation, or to talk with him directly was like being in the presence of a god.

Acting the macho, drunken artist was fashionable, and Pollock played the part perfectly, insulting rich collectors and offending art-world potentates. At one of Peggy Guggenheim's parties, he unzipped his fly and pissed in her fireplace in front of the influential crowd. To defy wealth and power made him an art-world hero, and I believed every bit of the myth attached to him.

But it was also frightening to be around Pollock. He had an impulse disorder. One moment he could be talking normally, and the very next second, he'd flip over a table or throw a cup of coffee in your face. People knew it. They felt the fear, but few talked openly about it, except for Jimmy Ernst (son of Max Ernst) years later, when I visited him in East Hampton.

Jimmy wanted to sell his old Victorian East Hampton home and move around the corner. It was 1971. I had recently remarried and was selling my work, and my husband Bob was doing well, so we could afford a house. (Besides, East Hampton prices were not what they are today.) Jimmy cordially showed us the various rooms but left the studio for last. I loved the golden-section proportions of the house, but the minute I set foot into his amazing studio, I knew I could work there. Jimmy knew I would use his studio well and wanted me to have it. We bought the house that weekend. Jimmy was creating black paintings and needed the dark, but I needed light. I enlarged the studio, installed skylights,

Fig. 6 Audrey Flack's East Hampton studio. Photo courtesy of Audrey Flack.

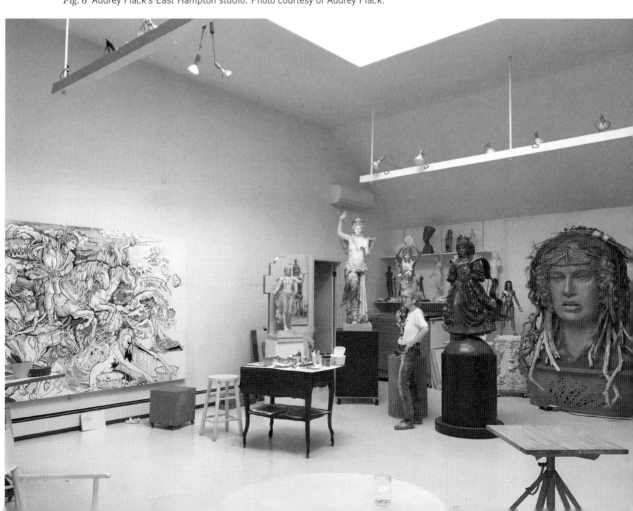

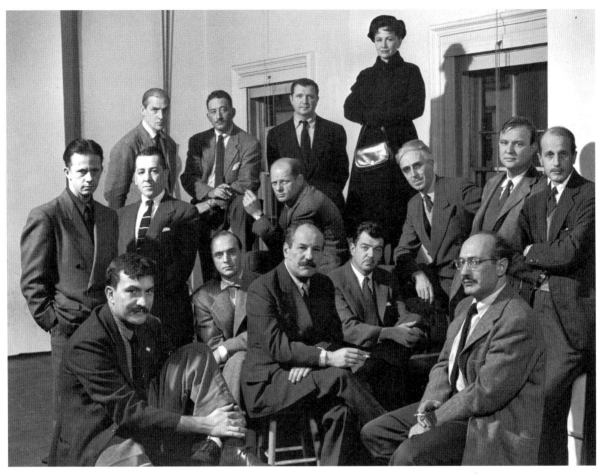

Fig. 7 A group of American abstract artists (including Jimmy Ernst, with bow tie), collectively known as "The Irascibles," New York, November 24, 1950. Photo: Nina Leen / The LIFE Pictures Collection / Shutterstock.com.

lowered the windows—which reminded me of those in my father's factory—and allowed the light to flood in.

Even though Jimmy was part of the Abstract Expressionist group, prominently sitting amid them in the famous *Life* magazine "Irascibles" group portrait, he was a family man: married to one woman, Dallas, and the father of two children, Eric and Amy. This sort of stability was unusual among the Ab Ex painters. Jimmy ushered us into the living room. Seated in white wicker chairs, we sipped hot coffee and reminisced about the Cedar Bar. Jimmy admitted that he had been afraid of Jackson, and I quickly said I felt the same way, that I always thought it was because I was a woman, but here was a man who felt it too. I noticed Jimmy's hands shaking each time he took a sip of coffee. He

couldn't be nervous, not around me. Only after we left did I realize that the soft-spoken, gentlemanly Jimmy Ernst, like so many, had the DTs.

Jackson and I occasionally met and talked at the Artist Club. I kept my distance because of the danger signals his very presence emitted. But I loved his work, and here I was sitting alone at a table with the great Jackson Pollock only six feet away. He sat on a barstool with his elbow bent against the bar; his hand cupped his forehead, holding up his large and heavy head. The heel of his shoe dug into the foot rail as he tossed down one tumbler of scotch after another. I genuinely wanted to talk to him, to ask questions about his techniques, his philosophy, his life, about what Old Masters he liked and what he thought of Bill de Kooning and Franz Kline. When he finally looked up, he stared like an animal. His scorching eyes forced me to look away; he was too overwhelming. I felt high with fear and anticipation. I was young and not yet toughened by life. We had come across each other before, but this was different: something intense was happening, something personal.

Jackson's art influenced me, just as it did others, but I never wanted to imitate him. His sense of freedom and his break with the traditional systems intrigued me. He refused to be tied down; he cut the cord and moved headlong into uncharted territory. You didn't just look at his paintings. You walked into them. You left the ground and entered a new universe.

Jackson set his empty tumbler on the bar and headed toward me, zig-zagging, staggering. A five-day stubble covered his cheeks. He reminded me of a porcupine shooting out prickly quills to protect itself. He was only forty-three years old, but he looked puffy and waterlogged. His shiny nose bristled with tiny broken red capillaries. He hung over me, unsteady and wavering. He pressed his face close to mine and then pulled back, moving back and forth like a zooming camera lens trying to come into focus. Finally, he fell sideways into the seat next to me.

We talked about the latest show at the Janis Gallery and pondered whether to order a hamburger or a ham sandwich from the limited menu. During periods of silence, we just looked, scanned, and searched each other's faces. Jackson's eyes seemed to burn in their sockets. They could set you on fire and hold you in place. We were artists—the visual was more important than the verbal. I was aware of nothing else as Pollock let his guard down. He was taking a chance, casting aside the bravado of his public persona. Maybe he saw something young, not yet spoiled or sordid, in me. Maybe he thought I could help him. He'd had enough

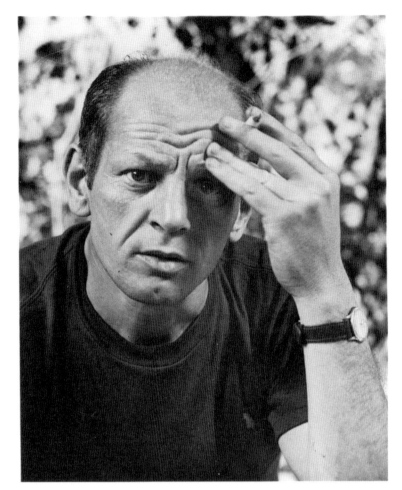

Fig. 8 Hans Namuth, photograph of Jackson Pollock in the studio, 1950. Photo © Hans Namuth Ltd. Courtesy Pollock-Krasner House and Study Center, East Hampton, New York.

of art talk, galleries, collectors, and critics. His soul needed mending. I imagined that his hopes were awakened, thinking he may have found a person to share the desperate state of his being.

I asked him about his work. I wanted to talk art, but Jackson was anxious; he needed a fix. He needed instant contact, so he leaned over and tried to kiss me. I quickly turned away and felt his stubbly beard scratch my cheek. I knew he was married. I wondered where Lee was and what the hell he was doing. He put his lips close to my ear and whispered, "How about a fuck. Let's fuck."

He was out of control and belched. That embarrassed him, so he grabbed my thigh and tried to pinch my buttocks. Was he was using machismo to cover up his pain and fear? He was in bad shape. I felt a profound connection with him; he was a great artist, someone I revered.

I wanted so much to help him but the thought of kissing him revolted me. I couldn't do it. I put my hand on his arm and rested it there.

We continued sitting together, sometimes talking, sometimes just being quiet. I took another look at Jackson's ravaged face and knew I no longer wanted to be a part of the scene. So much for the myth. I felt his pain. I still do. He tried again.

"Let's go to your place and fuck."

I shook my head no.

"Then come home with me."

"No thanks, Jackson. It's time for me to go."

How could I have known that this hero I worshiped was having a nervous breakdown? I wanted to believe the myth of power, strength, and masculine authority.

How could I have known, as a young girl sitting at the table with him, that he was completely incapable of making love? Anyone that drunk, whose hands, feet, and face were swollen and alcohol-logged, would be incapable of any sexual act. And he must have known it too, but the image had to be preserved. Everyone believed it and it tore him apart.

I didn't want my hero toppled from his pedestal, but sitting in front of me was a broken man, a man who covered his insecurities behind a drunken, brawling, belligerent persona that appeared to be defiantly strong.

Jackson Pollock was suicidal and disturbed long before he became an artist. What Jackson really needed was to be taken care of, soothed, cradled, and mothered. Instead, he was marketed and promoted as the big bad boy genius of twentieth-century art. He was no longer a person but a commodity, a legend. The glamorous myth of the suffering male genius has to be demystified.

As a child, Jackson couldn't complete with his alpha-male brothers. They dated, had girlfriends, and eventually married, while Jackson found a rather odd pianist whom he courted for one year and only kissed once. He eventually proposed a marriage that never took place.

Jackson wasn't much interested in art, but he looked up to and relied upon his brother Charles, a serious artist who eventually introduced Jackson to Thomas Hart Benton. Jackson became Benton's assistant and only then got involved with art. Jackson didn't think like a painter

or move paint around like painters do. He didn't enjoy the touch of the brush against the canvas or the thought process that comes with applying paint like de Kooning did. But Jackson did something else, something extraordinary. He put the canvas on the floor and merged his tortured soul with pigment and created a brand-new visual language. He fused his pain and agony, encapsulating it into ribbons, streaks, drips, and arabesque ropes of beautiful patterns and colors that made the pain more palatable.

Matthias Grünewald paints the ultimate agony in his Isenheim Altarpiece, but his passion, skill, and artistic genius transcend the pain and create beauty in the process. Jackson's work does the same thing by creating swirling vortexes of raw, unfiltered emotions. Jackson said that artists who paint in circles are madmen, like Van Gogh, but Van Gogh heaped up swirls of thick paint to create the moon and starbursts in *The Starry Night*, whereas Pollock's works are a merger of his intestines, heart, and internal organs projected onto the canvas with poured and squirted pigment. He wanted blood, too, and once stepped into broken bits of glass, cut his feet on his painting so his blood could mingle with the pigment. He was a painting shaman, driving himself into altered states, carried away by his own healing process.

In 1949 *Life* magazine sent a reporter to cover the exploding movement. Jackson was posed in front of one of his drip paintings with a lit cigarette dangling from his lips, looking sexy and powerful but also troubled. It reminded me of the Hollywood advertisements for James Dean movies just before the young actor died in a car wreck. Jackson stared directly at the camera, imitating Dean's tragic look. The caption read, "Jackson Pollock: Is he the greatest living painter in the United States?"

Suddenly everyone knew the name Pollock, and the Abstract Expressionists became famous overnight. Our enclave on Tenth Street was invaded; the nature of the group began to change. The "insiders" were now exposed to the outside. Prices remained modest until museums got involved and set themselves up as arbiters of taste. They decided who was worthy and became a link between the collectors and the galleries. Younger artists were pushed aside and a caste system was set up. Placement in art society interjected itself, with strata and entry levels. A few years later the scene fell apart, fractured by the onslaught of fame. It was as if a missile had landed in our midst and shattered the group.

Despite the glamorous appearance of camaraderie, the Abstract Expressionists worked in isolation. They are linked together in art history

texts, but it is important to realize that they worked in totally different ways. Bill de Kooning and Jackson Pollock couldn't be further apart in technique and style.

These artists wandered into unexplored territory alone in their studios. Only religious artists of the past had been permitted such aspirations. Byzantine, Gothic, and Renaissance artists devoted their lives to exploring the kingdom of God, but no matter how far they ventured into the heavens, they remained grounded on earth. They belonged to guilds and religious orders. The Abstract Expressionists, however, were isolated individuals who painted themselves into a corner, unable to return to a stabilized life.

Jackson was shoved, promoted, and pushed to produce; he hated it. De Kooning suffered a similar fate. At the end of his life, sick and suffering from advanced Alzheimer's, he should have been able to watch the sun set over his beloved Louse Point bay, listen to the flapping of the seagulls' wings, and paint when he wanted. Instead, paintbrushes were shoved into his fingers to produce more art. Making marks on a canvas may have given his addled brain a bit of pleasure, but the underlying motives of his "friends" were elsewhere.

When I resisted being pulled into Pollock's spiraling downward vortex and determined to leave the glamorous mythology of Abstract Expressionism, I paid a heavy price by absenting myself. I hated to leave Jackson alone at the Cedar Bar, but it was two in the morning, and the streets were nearly deserted. I briskly walked to Twenty-First Street scared and alone and headed for my newly rented fifth-floor walkup in Chelsea. This was not the life for me. That night I vowed never to return to the Cedar Bar. It was also the last time I saw Jackson Pollock alive.

Pollock's paintings are visions of the universe. He was an astronaut wandering through galaxies, severed from worldly connection. I loved Pollock's work, but I didn't want to wind up a depressed and broken woman. Nor did I need the emotional chaos the Abstract Expressionists found necessary to create art; I had experienced enough emotional chaos within my own family. I wanted stability. Art was the most important thing in my life, but I wasn't going to let it kill me. These artists produced some of the greatest works of the twentieth century, yet they were self-destructive and were overcome by lethal addictions. I could never be mistress, wife, babysitter, promoter, or cook for any of them.

I wanted to find another kind of man, a decent man who could be a good father. Already I knew that one day I wanted to have a child, a

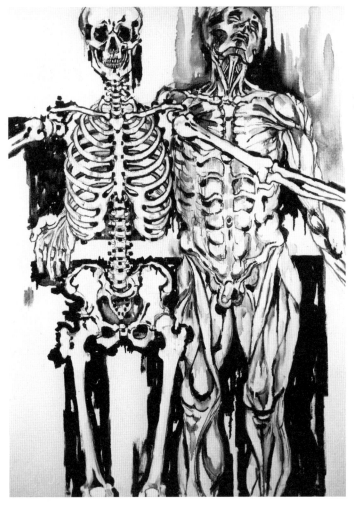

Fig. 9 Vesalius Study, 1958.
Oil on canvas, 50 × 36 in.
Photo courtesy of Audrey Flack.

child I could love with all my heart, a child who would return my love. I was an artist—nothing would stop that—but I also wanted a stable, safe environment for my future family. And I believed I could do it all.

As a result of leaving the Cedar Bar and Abstract Expressionism behind, my work went through a series of changes that led me in a new and more structured direction. Abstract Expressionism was my mother, but you have to leave your mother in order to grow. My work did not come from a reckless place or a broken spirit; what I wanted was order and structure. When I left Jackson at the Cedar Bar, I essentially left Abstract Expressionism.

The Old Masters intrigued me. I began to copy them and strived to achieve their incredible technique, narrative, and iconography. Forever amazed at their magnificent talents, I wondered if any contemporary artist could come near their greatness. I studied an ever-expanding collection

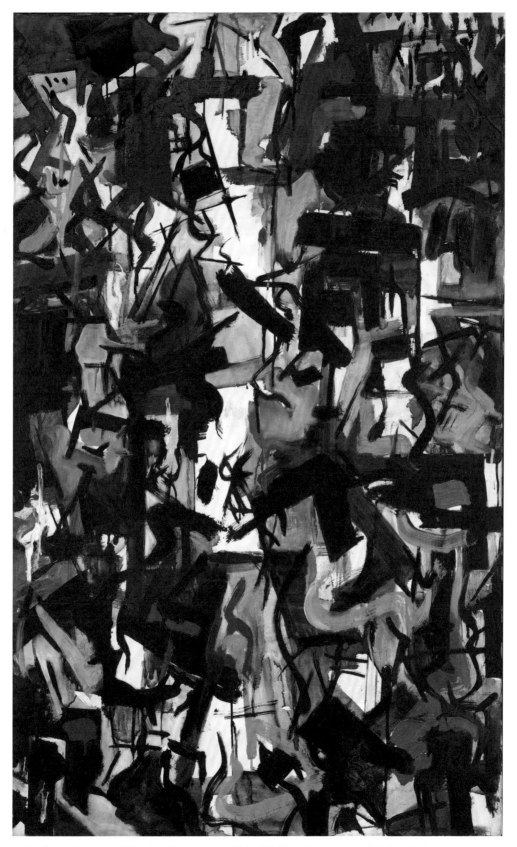

Color Plate 1 Flashback, 1949–50. Oil on canvas, 44½ × 27¾ in. Photo courtesy of Audrey Flack.

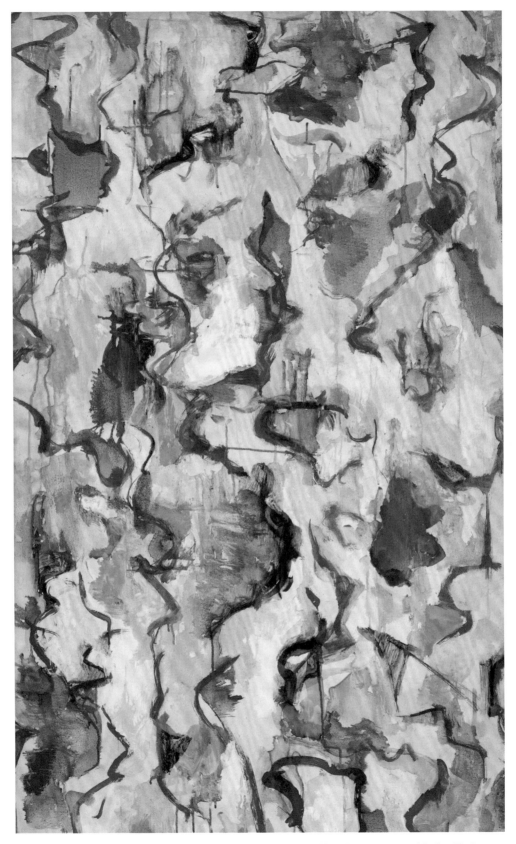

Color Plate 2 Figures and Trees for Bill, 1949–50. Oil on canvas, 48 × 28 in. Photo courtesy of Audrey Flack.

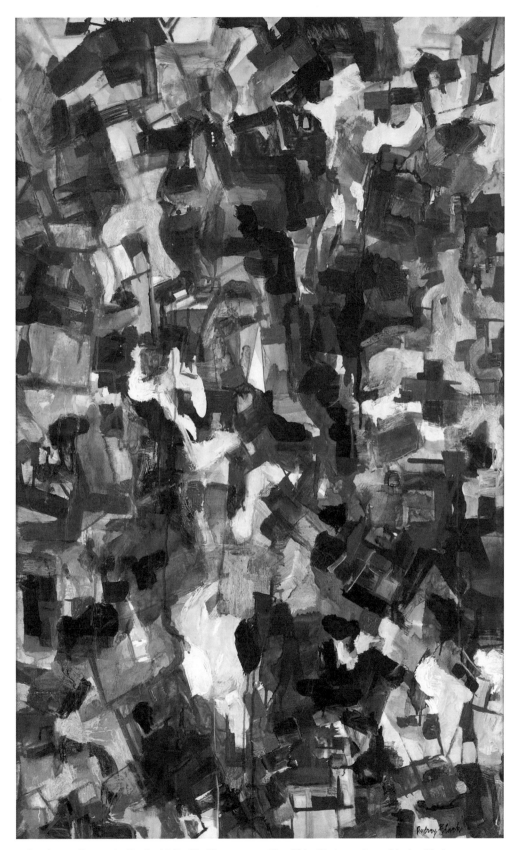

Color Plate 3 Abstract for Tomlin, 1949–50. Oil on canvas, 45 × 28 in. Photo courtesy of Audrey Flack.

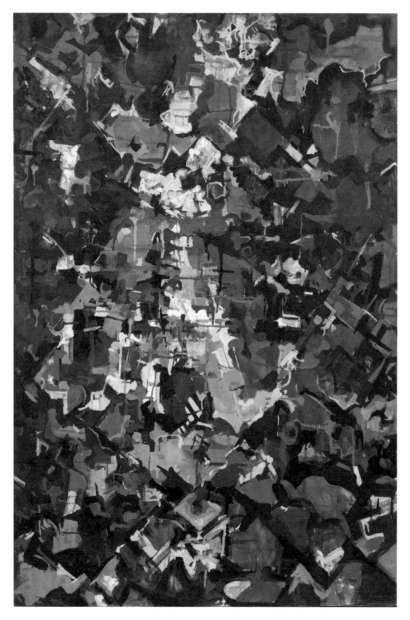

Color Plate 4 Diamonds and Sky, 1951. Oil on canvas, 49½ × 33½ in. Photo courtesy of Audrey Flack.

Color Plate 5 (opposite) Abstract Expressionist Landscape (with Sky), 1951. Oil on canvas, 42 × 33 in. Photo courtesy of Audrey Flack.

Color Plate 6 *Abstract Force: Homage to Franz Kline*, 1951–52. Oil on canvas, 50 × 72 in. Photo courtesy of Audrey Flack.

Color Plate 7 *Still Life with Apples and Teapot*, 1955. Oil on canvas, 28 × 36 in. Photo courtesy of Audrey Flack.

Color Plate 8 The Three Graces, 1962. Oil on canvas, 67 × 40 in. Photo courtesy of Audrey Flack.

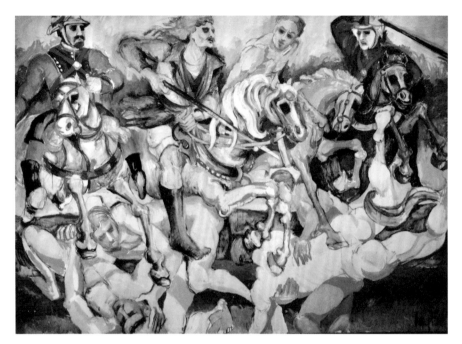

Color Plate 9 Four Horsemen of the Apocalypse, 1962. Oil on canvas, 76 × 107 in. Photo courtesy of Audrey Flack.

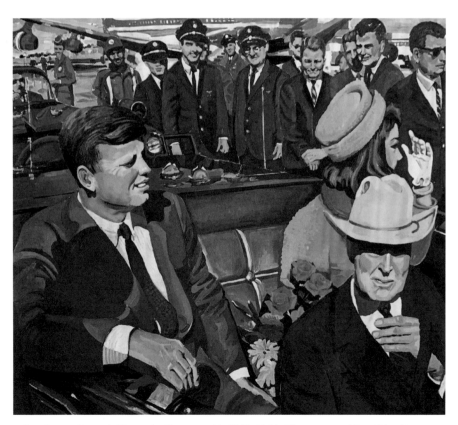

Color Plate 10 Kennedy Motorcade, November 22, 1963, 1964. Oil on canvas, 38 × 42 in. Photo courtesy of Audrey Flack.

of anatomy and drawing books from Vesalius to Robert Beverly Hale. The path I took eventually led to the invention of Photorealism—but I never completely abandoned Abstract Expressionism. My Photorealist paintings have a tilted picture plane and allover patterns that extend to the edges of the canvas. They are directly informed by Ab Ex spatial concepts.

The Women of Abstract Expressionism

As I grew into young womanhood, the pressure to choose between my panties or my art increased exponentially. It reached a peak during my days at Cooper Union, when my teachers, all men, thought nothing of squeezing my buttocks or rubbing their hands against my thigh during a crit. I never took it seriously; that's the way life was. It occurred with even greater frequency at the Cedar Bar, where drinking and interchangeable sex partners were expected, normal behavior.

Reuben Nakian was an Abstract Expressionist sculptor whose work I greatly admired. I saw a small terracotta figure he did at the Gruenbaum Gallery and wanted to buy it, but I didn't have the money. When I finally met Nakian, he was with a group of heavy-hitting male artists. I was surprised to find that he was a small man, just about my height. Pleased to meet him, I extended my hand, which he ignored, and without a moment's hesitation, he clamped his two thick, muscular hands on my breasts like suction cups. Of course, I was offended and looked down in disbelief, but the ridiculousness and petty absurdity of his act almost made me laugh.

Aside from incidents like that, it was also a time of great purity and idealism. There weren't very many of us, we all knew each other, and everyone strived for greatness. I felt high with the sheer thrill of being an artist and the ecstasy of challenging the gods alone in my studio. When my painting went well, I felt as if I had entered another universe, exploring outer space with my brushes in hand.

I loved the incessant art talk, but I didn't like that it was dominated by male artists whose primary drive was to promote and propagate their own art. I could see that Elaine de Kooning, Lee Krasner, and Grace Hartigan's paintings were considered second tier in spite of the strength of their work. Most of the wives and girlfriends were treated like servants or secretaries. Each sent out mailings, stretched canvases, posed, cooked, and promoted her man's work. The women on the periphery who hung around the Cedar Bar were thrilled with the scene and would

do anything to snag an important artist. As a result, they were passed around among the honcho hierarchy and they didn't seem to mind at all. Years later, when I was reminiscing with Dorothy Pearlstein (Philip Pearlstein's wife and an artist in her own right), she commented sarcastically, "Those sleep-around groupies thought the guy's sperm would rub off and elevate them."

Still, I tried to be part of the scene, to act sophisticated and sexy. But I was a young woman alone; I did not yet know the degree of danger that existed. Sylvia Stone and Joan Mitchell were being physically abused—Joan by Mike Goldberg and later by the painter Jean-Paul Riopelle, and Sylvia by the painter Al Held. Even the beautiful, wealthy Helen Frankenthaler was smacked around by her lover, the influential critic Clement Greenberg, who visited his favorite artists' studios and made comments about their work. If they followed his advice, it guaranteed entry into collections and publications. Helen eventually left Greenberg and married Robert Motherwell, a wealthy and important member of the Abstract Expressionist community. These women knew they had to be involved with the top men in their field to be seen as relevant.

Everyone seemed to be sleeping with one another. Women artists slept with critics, curators, and dealers to promote their husbands' work as well as their own. And male artists serviced female gallery owners to ensure their position. Max Ernst was briefly married to Peggy Guggenheim (it is said she had over a thousand lovers). I wanted a more stable life and I wanted a family. These men offered fame and stardom but not stability. I reprimanded myself for being too middle-class. By Washington Heights standards, I was a wild, bohemian rebel, but among the Abstract Expressionists I felt bourgeois.

My work was based on thought and structure, not only on impulses and freefall. My paintings had an underlying pattern, a grid, blocks of color, and form. I wasn't going to fall off a ladder splattering a can of paint all over the canvas or find myself passed out on the studio floor of some artist I hardly knew.

I had my share of boyfriends, but none in the art world. I have asked myself why I didn't sleep with Jackson Pollock, Bill de Kooning, Franz Kline, Mike Goldberg, Mort Feldman, or Clement Greenberg. Power, fame, entrée into intellectual circles, exhibitions, and reviews all came with these men, yet I couldn't do it. I wasn't attracted to testosterone-fueled aggression and out-of-control drinking. So I stayed on the outside of the inside, looking, listening, observing, learning. Alone, apprehensive,

but never showing it, I couldn't shake the terrible feeling that if *this* was the art world, I didn't fit in.

Being around accomplished, strong, women like Lee, Grace, Joan, and Elaine felt good. I hoped that one of them could become a friend or mentor. (Even the word "mentor" has MEN in it.) They were older and more experienced, but as I drew closer, I realized that I couldn't live their lifestyle. I couldn't ingest as much alcohol as they did. My body simply couldn't handle it, so hanging out with them at a bar became more of a chore than a pleasure, and I couldn't sleep with the type of men they chose even though they were powerful and exciting. For me, they were old and dangerous, hardly men I could settle down and raise a family with. I felt inferior because these women were taking chances that I couldn't bring myself to do. I thought it was because I was younger. I was more than twenty years younger than Lee, nine years younger than Grace, and twelve years younger than Elaine. But there was only a two-year difference between Helen and me, and I was only a year younger than Marisol and Ruth Kligman. So age could not have been the reason. Artistically I belonged, but socially I felt apart.

Grace, Elaine, and Joan were a vital part of the scene and moved in influential circles. Their ability to chain-smoke and drink as fast and as much as any man put them in the center of all the action. Their intellect and critical insights were sought after, yet no matter how significant their art was, they never got the adulation or respect the men did. The greatest compliment a woman artist could receive was the one Hans Hofmann gave to Lee Krasner: "Your work is so good, you would never know it was done by a woman."

At one point, Grace and I decided to change our signatures to conceal the fact that we were women. I signed my paintings *A. Flack* and Grace signed hers *George Hartigan*. But it had little effect on sales or prices. The Ab Ex women worked on large-scale canvases with the same bravado and energy as their male counterparts. They painted aggressively with wide brushstrokes, making quick and intense gestural markings. Their paintings had to be big and tough to be noticed, but even creating big and tough paintings wasn't enough.

Many of my female counterparts suffered. Even hurt or sick, they never let on, not to each other and maybe not even to themselves. As artists, they achieved an important place in art history, but they paid a high price to get there. A mythology of glamour surrounds their lifestyle and accomplishments, but I witnessed a reality far from glamorous.

I loved Joan Mitchell's paintings. Scattered among her brushstrokes were lyrical, delicate gestural markings of violets, lavenders, and gold, filled with beauty and light. I always wanted to tell her so and had the opportunity when she approached me one night at the Artists Club. It was the night Marisol had participated in a panel discussion. Joan seemed unsteady on her feet. Her reputation for cursing, for rough sex, and for having a difficult personality was well known among the artists, but I thought that if I could get through to her, we might become friends. I extended my hand. She took it and shoved me against the wall, rammed her face into mine, her lips one inch away, too close, much too close.

After a minute of stunned silence, she pulled back and let out a barrage of foulmouthed curses.

"You fucking cunt, motherfucking bitch."

She was a mistress of obscenities. I managed to mumble something like "Calm down, Joan, back off." But she continued to rattle off a slew of profanities that projected forth like vomit from an exorcism. Suddenly she stiffened, turned around, and staggered out the door. Marisol, observing the fracas, came over and asked, in her squeaky voice, "What is wrong?" I just shrugged.

What had provoked Joan's rage? Maybe it was because I was young, and her beauty was fading with age and a dissipated lifestyle. Joan felt that older women were no longer considered sex objects. She expressed those feelings during an interview with Cindy Nemser, saying, "They still have sexual desires and want to fuck, just like the men, but nobody wants to fuck with them." I was just an easy target for Joan's inner torment. Unfortunately, I didn't get the woman friend I was hoping for.

Joan had affairs with Mike Goldberg and Barney Rosset, and she lived passionately, miserably, and violently in Paris with Jean-Paul Riopelle. Joan moved to Vétheuil, a town outside Paris, where she drank and painted until she died of throat cancer forty years later. She was a major figure in the Abstract Expressionist movement, yet her career took second place to those of Jackson, Bill, and Franz. Only now are her paintings achieving the status and prices they deserve.

Mitchell and Frankenthaler were wealthy women. Joan could afford spacious lofts, and Helen bought a townhouse on the Upper East Side. I didn't get to know Helen, but we did share an assistant as well as a doctor. After several months of working for Helen, my assistant, a compliant and most helpful young woman, called and said she couldn't take

it anymore. Helen had demanded such exactitude and obedience that she was beginning to suffer from nervous exhaustion. The final blow came when Helen was planning a dinner party with her dealer, André Emmerich, analyzing which art-world potentates and collectors would sit next to each other. My assistant was sent out to buy specialty items, including a specific brand of small gherkin pickles. She was instructed to measure each one with a ruler to be sure they were exactly the same size. She quit!

This kind of obsessive behavior may have caused the severe migraines Helen suffered throughout her life. We used the same doctor, an internist who, after he retired, told me she appeared in his spacious Park Avenue office one afternoon and demanded that he attend primarily to her, that she wanted him on call every day. In return, she would give him her artwork. He declined the offer. She badgered him until he referred to Helen and her husband, Robert Motherwell, as "Frankenstein and Motherfucker."

In this complex arena, there were other reasons for the Abstract Expressionist women's demeaning position, and oddly enough, it surfaces in Joan Mitchell's reflections about herself: "I think women are inclined more than men to be self-destructive, and I really think I had the masochistic medal there for a while." Both men and women can be self-destructive, but women just do it in a different way—like having a heart attack. Men experience sudden, clutching pain, whereas women's symptoms are more subtle, last longer, and are harder to detect.

When I write about the drinking, sex, and self-destructive behavior of the Ab Ex women, it is not to pass judgment. On the contrary, I feel a deep well of sadness and compassion for their suffering. I knew them; I saw it. My hope is to demystify the false glamour that is still being cast on their lives and to bring to light the centuries of collective oppression imposed on women, specifically on women artists.

I find it hard not to mention a few dramatic examples of sadomasochistic behavior in the lives of several other women artists. Hannah Wilke was an early feminist artist who gained fame in the mid to late 1960s and 1970s. She worked in unconventional materials like latex, gum, and kneaded erasers to denote women's historical lack of access to art supplies and education. She cited the reason for her chewing gum presentation: "It's the perfect metaphor for the American woman—chew her up, get what you want out of her, throw her out and pop in a new piece."

I got to know Hannah when she was spending time in East Hampton suffering from lymphoma. Hannah was extraordinarily beautiful and retained her beauty even when she was undergoing treatment. Her face and neck were distorted and swollen, yet in spite of the pain and chemotherapy she was going through, the only thing she wanted to talk about was how Claes Oldenburg had mistreated her. After living with him for many years, she came home one day to find herself locked out of their apartment.

"He locked me out!" she repeated endlessly.

"Hannah, stop! You're obsessed. You're making yourself sick. You need to heal, get your mind on more pleasant things." But nothing could stop Hannah from reliving the story of her abuse. She died in 1993 at the age of fifty-two.

And then there was Camille Claudel. She was born in 1864 and died in 1943. I first saw her work at the Rodin Museum in Paris in the mid-1970s. I knew of Camille Pissarro and thought Camille Claudel was a man as well. My husband Bob and I were on vacation, and I was reluctant to go to the Rodin Museum because of my distaste for Rodin. But I decided I was unfairly prejudiced, and we gave it a chance. The minute I saw Claudel's work I loved it; the beauty and form, the sense of scale, proportions, and emotional content, all reminded me of my own sculpture. I felt that in many ways Claudel's work surpassed Rodin's heavy-handed modeling. When it was time to leave, I bought the catalog and was shocked and delighted to find that Camille Claudel was a woman!

The beautiful and talented Claudel entered Rodin's workshop and quickly became his primary assistant and lover. Their affair was intense and passionate and lasted ten years, during which time Claudel carved his marbles, modeled his clay, and collaborated with him on *The Gates of Hell* and *The Kiss*. She even sculpted the hands and feet of *The Burghers of Calais*, the most expressive elements of that dynamic sculpture. Over and over again, Rodin promised to marry her, but in the end refused.

Claudel tried to break off the unfair and exploitive relationship several times, but Rodin wrote desperate, pleading letters declaring that he could not live without her, that she must have pity on him because she was his muse and inspiration. Eventually, she gave in, because she was in love with the "great bombastic genius" that all of France admired. Later, Claudel became enraged when Rodin refused to acknowledge or support one of her public art projects. She ended their relationship, left his atelier, and moved into a small apartment where she attempted to

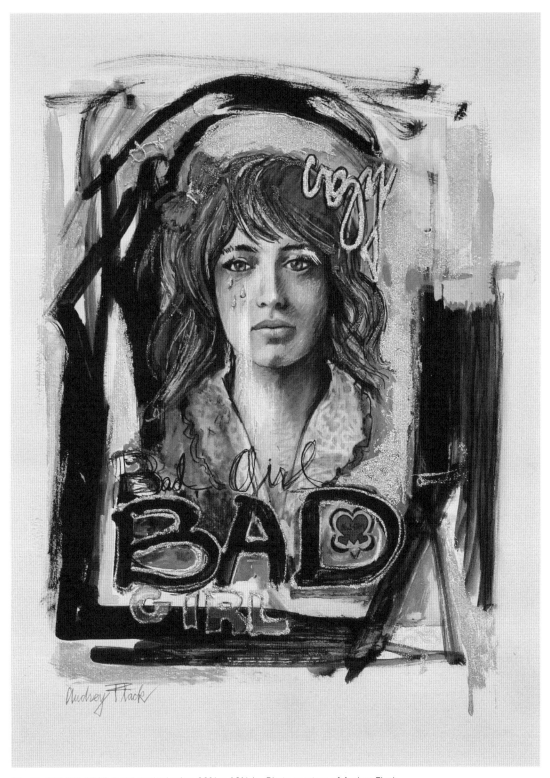

Fig. 10 *Bad Girl*, 2017. Hand-worked print, 23¾ × 18½ in. Photo courtesy of Audrey Flack.

establish her independence as a sculptor. Separated from her friends at the atelier, however, she was isolated and broke. Rodin paid her rent for a while, but it was hardly enough compensation for the years of devotion and work. Alone and poor, she became despondent, and at one point, in a fit of rage, she smashed all of her work. Crazy, they said; she was institutionalized.

Through my research, I uncovered writings by close friends that intimated Camille Claudel had had an abortion and perhaps even a child with Rodin. The abortion was the underlying reason her devotedly religious brother Paul Claudel institutionalized her. It was not uncommon to institutionalize "bad girls" at the time, and the practice continued well into the 1950s. Paul Claudel would never let her be released, even when she was repeatedly pronounced sane by the director of the institution. She was buried in a pauper's grave that has since been demolished.

I discovered another wonderful woman artist while reading a book about Pierre-Paul Prud'hon, one of my favorite draftsmen. Constance Mayer studied with Jean-Baptiste Greuze and worked with Jacques-Louis David. Like Camille Claudel, she was also an artist's beautiful assistant. While Prud'hon was painting the portrait of Empress Josephine, his wife went insane and was held in an asylum. Prud'hon took custody of their five children. Napoleon gave him an apartment in the Sorbonne. At about the same time, Napoléon purchased two of Mayer's paintings and provided an apartment for her, too. There she served as Prud'hon's assistant, raised his five children, and was known as his "favorite pupil," even though she was an artist in her own right. Prud'hon and Mayer collaborated on many works. He sketched the design; she made the paintings. Many were exhibited under her name, but when they became part of public collections, they were attributed to Prud'hon.

After Prud'hon's wife died, Mayer expected that he would marry her. But he refused, disregarding the many years she had served as his professional assistant, housekeeper, and mother to his children. Prud'hon preferred drawing to painting, and some of his canvases were painted by Mayer. Even so, he refused. Forty-seven years old, humiliated, and despondent, she entered his studio, seized Prud'hon's razor, sliced her throat, and bled to death in front of him. The sadistic treatment of Claudel and Mayer was assumed to be normal behavior by society. Because of their despairing response, they were considered crazy.

The Abstract Expressionist women were also involved in destructive relationships, just not as overtly dramatic. These women fought back

as well as they could under the circumstances. In many ways they were heroic—certainly in the persistence of their art. Yet they remained under the spell of the "male genius." They were strong, admirable women, and I loved them. But their lives have been romanticized. The experiences of multiple abortions, physical, verbal, and psychological abuse, heavy drinking, and abandoning children are not admirable or feminist, and they resulted in long-term illness and suffering. Abstract Expressionist women were caught in a transitional time period. The role they played in transforming the plight of woman artists is significant and remains to be reevaluated, not mythologized.

Lee Krasner

I longed to go back to the days when painting was a spontaneous, glorious act, yet here I was, sitting on the Broadway bench in a suspended, paralytic state. Thankfully my mind was active, even overactive: it was wandering from decade to decade, year to year, trying to figure out why I could no longer paint.

The pressure to finish the paintings increased. It was now October, and the show would be opening in one month. I woke up early that morning, more determined than ever. I took a cold shower, rubbed my body down with a rough towel, ran up Riverside Drive, and came home to stand in front of *Skull and Roses*, prepared to fight the demon. Every muscle, every cell in my body was on full alert. *At least let me finish this one!*

By now the bench had become my second home. Sitting out on the street with no attachments and no grounding allowed my mind to go anywhere in time and slide from place to place. During my musings, a uniformed city worker came by, set down a box of tools, and got to work. I watched him for the next two hours as he attached a rectangular wooden plaque to the iron railing that surrounded the narrow center island. On it, in big black letters, were the words THE BROADWAY MALL.

My sanctuary was now officially named. What a joke! Some bedraggled, oxygen-starved bushes, two worn-out benches, and a wire-mesh garbage can filled with half-eaten pizza crusts, chewed-up chicken bones, and crushed beer cans was now a mall. I stretched out my legs, watched a few people walk by, and let my thoughts wander back to when it all started, long before Photorealism, before galleries, before I even knew the art world existed. Back to first grade, when I was a hyperactive child

who experienced a condition unknown at the time but now called ADHD, attention-deficit/hyperactivity disorder. As I look back from a safe distance, I can see that I was having some sort of breakdown, break out, or breakthrough on the bench. I wasn't running around screaming, shouting, or sobbing; I just "was." I had entered a drifting time warp.

It was Sunday morning, and there was a stillness in the air. Bob was lying next to me sleeping soundly, exhausted from a busy work week. I slipped on my jeans and walked barefoot into the studio. The painting was still on the easel but the damned block enveloped me like a black fog. With a slightly trembling hand, I picked up a brush and began to paint. The block cleared for two weeks, long enough for me to complete the painting. My exhibition *Light and Energy* opened at the Louis K. Meisel Gallery in March 1983, and every painting sold, even *Skull and Roses*. Salvador Dalí showed up with a leopard on a chain and created a stir of excitement, particularly for my mother, who followed him around and barely noticed my work. I was happy with the response, but mostly I was relieved that the pressure was off and I could decompress, take time off. But the brain doesn't work that way. When there is a problem and unresolved emotion, the matter lingers in the corners of your mind and body until it is dealt with, no matter how long it takes. As a result, three weeks later when I stretched a fresh canvas and stared at its blankness, all I saw was the monster block staring back at me. I had to get out. Broadway was quiet, no delivery trucks, few people. I stretched out on my bench and thought about Lee Krasner.

I admired her, looked up to her. She was the grande dame, the oldest and most experienced among my acquaintances. I first knew of her only as Jackson Pollock's wife, but Lee was an established artist long before she met Jackson. In 1940 she designed murals, along with Ilya Bolotowsky and Byron Browne, for the WPA (Works Project Administration), a federal organization that provided employment for artists during the Depression. Lee and Jackson met in late 1941, when they were both abstract artists exhibiting together.

In 1945, the year World War II ended, they married, drove to East Hampton, and bought a small fisherman's cottage on a spacious grassy field at the edge of Accabonac Harbor in Springs. There was a separate

barn on the property that Jackson took for his studio, while Lee painted in a small upstairs bedroom.

I rented a shack near them on Neck Path. I remember the first time I saw Lee's tiny studio. I stood there in disbelief, trying to figure out why this powerful, independent woman would paint in a small bedroom when there were other options available. Only years later would I find out about the verbal and emotional abuse that came with the marriage. I excused it because she was in love with Jackson and enthralled by his work. I wanted to believe in her strength. Now, however, I realize that a deeper and more sinister exchange was taking place. Theirs was a codependent relationship, driven on her part by a belief in male genius, though I suspect there was also a hint of underlying opportunism.

While Jackson desperately needed Lee, he was continually degrading and insulting her, whether alone or at dinner parties in front of friends and important collectors. She accepted the abuse and helped him even more, and everyone saw it. Lee continued to mother and tend to his drunken body, fixing eggnog concoctions after a deadly binge, bandaging his feet after he cut them, all the while forcefully promoting his career.

But the personal cost to her was fierce. Lee was stricken with severe arthritis and ulcerative colitis, and she was deprived sexually. And yet she lived for her man and was caught up in the whirlwind of male domination. Lee had to be incredibly strong to sustain the abuse handed out on a daily basis. I still admired her.

Lee woke up one morning to find Jackson sleeping with Ruth Kligman in her own house while she was there. (Regrettably, I had introduced Ruth to Jackson. She was ferociously ambitious and was willing to risk everything for the fame and fortune she could get through an affair with him.) Only then did Lee become enraged. She demanded that Ruth get out. She also demanded a divorce and threatened to leave, but Jackson, who was smitten with Ruth, said "... ok, GO!" Lee was dumbstruck. She begged, pleaded; she wanted him back. On the advice of friends, Lee postponed the idea of divorce. She told Jackson she needed time to think things over and took off for Paris, where she had many friends.

While she was away, Ruth took over Lee's possessions and acted as if the house were now hers. It took a while before Jackson became disillusioned with Ruth's manipulative game-playing and realized Lee's importance. Ultimately, his self-destructive drive exploded, and in a fit of madness, smiling and drunk, he drove around a sharp curve at breakneck speed. His car skidded and flipped over, catapulting Jackson and

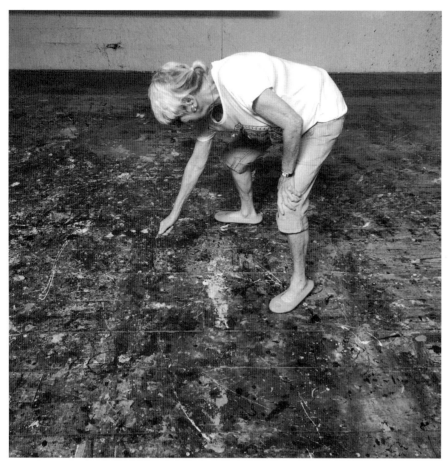

Fig. 11 Audrey Flack interpreting Pollock's drips at the Pollock-Krasner House. Photo courtesy of Audrey Flack.

Ruth into the air, the car landing on top of poor Edith Metzger, Ruth's friend. Ruth was the only survivor.

Lee was in Europe when she heard the news. She wailed, moaned, screamed, and hurled herself against the walls of Paul Jenkins's studio. He feared she would throw herself off the balcony. But Lee returned to New York a transformed woman. She was now the widow of one of the most famous artists of the twentieth century. At the funeral, she sat alone in the front pew of the church and refused to speak to any member of Jackson's family. Jackson died on August 11, 1956.

Three years earlier, in 1953, because of East Hampton's bitterly cold winters, Jackson had insulated his studio floor with Masonite and continued to paint there. Soon the new floor and walls were splattered with his smears and drippings. About a year after his death, Lee packed up

her bedroom studio and moved into Jackson's barn, where she was surrounded by his overpowering energy. His paint cans, brushes, drips, streaks, and strikes were everywhere; his very being infused the walls, the floors, even the air that filtered through the clerestory windows. Using Jackson's studio without whitewashing the walls and floors and creating her own space always felt strange to me.

I wondered why she chose to paint in Jackson's studio when it was so obviously still *his*. Was she trying to conquer him? Was it OK now that he was dead? Was she merging with him? Absorbing his energy? Or was it none, or all, of the above? Did she discuss her options with other women artists? I strongly doubt it. It wasn't until the early '60s that Lee decided to cover over the floors and whitewash the walls.

It seemed to me that none of the Ab Ex women fully trusted one another. Each of them vied for success alone, never as a unit. They rarely helped each other but relied on their respective men to further their careers. It was part of the zeitgeist of the time. Lee wasn't the only woman who stood behind her man. Elaine de Kooning acted similarly with Bill.

The rivalry between Lee and Elaine simmered for years. I never heard it expressed over their own art, but rather over their husbands' work. Each woman planned and schemed for her mate to come out first in the race to see "who was the greatest artist." Jackson Pollock was publicly celebrated as the number one Abstract Expressionist, while Bill de Kooning achieved a degree of fame but was revered mostly by his fellow artists. In spite of the fact that Lee and Elaine were artists in their own right, they stood selflessly behind their husbands, assisting with their work and furthering their careers by throwing loft parties and inviting important members of the art community.

Lee served aromatic black coffee to gallery owners who made afternoon visits and cooked dinners for promising collectors and critics in the evening. These inexpensive spaghetti dinners were served with homemade marinara sauce, fresh garlic bread, and bottles of red wine. The meals, although not elaborate, were always tastefully prepared and carefully presented on rugged wooden tables, which were purchased for a few dollars from the local thrift shop.

Lee was furious at Elaine for taking Bill's name and not keeping her own. Every time she saw me, she repeated her disapproval, spitting out, "Her name is Elaine Fried, not Elaine de Kooning. I never changed my

name, I'm Lee Krasner, not Lee Pollock! You never changed your name, you're Audrey Flack. Look at her, just look at her using his name!"

Elaine never responded to Lee's angry comments. Instead, she named her dog Jackson and took great pleasure in shouting . . . "JACKSON, COME HERE RIGHT NOW! NOW SIT! I SAID SIT!"

During those early years, my questioning of why Elaine and Lee stood in the shadow of their husbands remained unspoken. Only twenty years later, with the onset of the feminist movement, did women begin to shift the paradigm. I attended meetings in the Elizabeth Street loft of Marcia Tucker, then chief curator at the Whitney Museum of American Art and later the creator of the New Museum, and my attitude toward women rapidly changed. These consciousness-raising groups gave me the strength to join with women artists and fight for equal rights and representation in galleries and museums. I stood arm in arm with mothers of autistic children—children like my own daughter Melissa—and fought for their rights, and when the Women's Caucus for Art asked me to recommend someone for their 1980 Lifetime Achievement Award, I immediately agreed. I thought about not only who deserved it but also who would add strength to the organization. The Caucus was a fledgling nonprofit organization dedicated to supporting and promoting women artists, art historians, educators, and museum professionals. I said unequivocally, "Give it to Lee Krasner! She has lived in the shadow of Jackson Pollock far too long. It's time for her to shine."

"But she's not a feminist."

"That doesn't matter!"

"Do you know her personally?"

"Yes, I do, not too well, but I do know her."

"Will you interview her and ask if she will accept the award?"

"Yes, I will."

I called Lee, feeling a bit apprehensive, but she sounded pleased and invited me for tea the following week. Her elegant East Side residence was the furthest thing from what I imagined she would live in. A doorman in white gloves held the door open and ushered me in.

"Lee Krasner?"

"Apartment 14-E, take the elevator to the left."

The elevator operator stood in stiff attendance as we rode up fourteen stories. During those brief moments, it struck me that Lee had become a black widow, the spider who devours her mate and thrives on the remains. I rang the bell, expecting Lee to be her usual caustic and

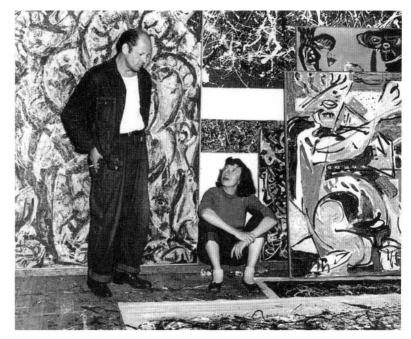

Fig. 12 Lawrence Larkin, photograph of Jackson Pollock and Lee Krasner in Pollock's studio, 1949. Courtesy Pollock-Krasner House and Study Center, East Hampton, New York.

sharp-tongued self, but I was greeted with a handshake and cordial smile.

Was she finally identifying with women?

In her seventies, Lee's face revealed her afflicted life. Two especially deep crevices ran down either side of her mouth, inscribed by the pain she had endured in her embattled relationship with the unfaithful Jackson. She was wildly jealous of Ruth Kligman and deeply hurt by Jackson's philandering. I was afraid to tell Lee that I had inadvertently played a role in connecting them, never dreaming that Ruth would take the crazy chances she did and lack the common decency to not mistreat Lee so blatantly and openly.

The upper-class environment Lee chose to live in was a far cry from the paint-strewn New York loft or rugged fisherman's cottage on Accabonac Harbor. The "artist life" was no longer necessary for Lee. She could now live out an aspect of herself that had been squelched by the bohemian squalor of the 1950s. Now that Jackson was gone, Lee was a wealthy widow, reaping all the benefits of Jackson's fame.

She was being courted by galleries and commanded a newfound sense of power. Jackson had been dead for a while when the Pace Gallery promised an exhibition of her work. The word in the art world was that it was a trade-off; Pace would represent Lee, and she would give

them the Pollock estate. Nevertheless, she comported herself with dignity, a woman in command not only of herself but of a major art-world dynamic. All of Jackson's work was under her control, and for whatever reason, people were beginning to look at her art. As they should. She accumulated wealth with each sale of a major Pollock painting.

Most people, when they age, want a more comfortable life, and certainly Lee deserved it, but her choices were hard to fathom. Why did she buy a fancy apartment on the Upper East Side instead of a spacious loft in SoHo or Chelsea, where she could have had a great studio? Why did she make appointments with famous hairdressers and have her clothing styled by top designers in specialty shops when there were more creative artisans around?

Lee was far from beautiful. Her once young and sexy body was now lumpy and poorly defined. The straight bangs and bowl haircut that the famous Mr. Kenneth gave her were designed for top fashion models like Twiggy and looked ridiculous on her.

Lee walked me through every room of the apartment, pointing out her favorite objects and photographs. I stopped short when we passed the dining room. The oversized round mahogany table was set with blue-and-white china dishes, a matching teapot, small teacups, highly polished silverware, and a three-tiered dessert stand filled with bite-sized pastries and miniature tea sandwiches.

"That's for us, but first I want to show you my studio."

I followed close behind as Lee led me to an average-size bedroom with U-shaped work shelves built around three of the four walls.

"Here's where I work. I store my papers and prints on the shelves below."

She took out a few collages in various stages of completion and pointed to others tacked on the wall.

"Look," she said, "I make these from older prints and gouaches that I cut up and reassemble."

While I was studying them, Lee picked up a few cut-up shapes and held them against a print lying on her worksheet. For a few moments she forgot I was there while she shifted them around to see where she would place them. She was clearly inspired and involved with this new work. Why cut them up? Why not make new work? Was this a creative act of daring or was she cutting up her old life?

I noted the absence of an easel, and there was no empty wall to hang a canvas on. Everything was ordered and neat. No odorous turpentine

fumes, no tubes of dirty oil paint or greasy palettes. Abstract Expressionist action painting was over for her. Lee had already started making assemblages in the '50s, cutting up some of Jackson's old work and using it for her collages. Was it because every scrap of Jackson's work, even his discards, had profound meaning for her? Or was Lee symbolically cutting up Jackson? Or did using Jackson's scraps make her work more valuable?

We left the studio and went to the dining room, where Lee held down the lid of her china teapot and poured hot jasmine tea into the delicate teacups. She was clearly enjoying her role as lady of the house. We sipped tea, took small bites of miniature pastries, and chatted. Lee Krasner and Audrey Flack, the "ladies who lunch."

I complimented her grayish beige dress and the simplicity of its design. It was an A-line linen sheath that went straight to her knees, designed to cover up an aging body. Thinking I might want one, she jotted down "Delle Celle," the name of the Madison Avenue boutique.

"They make all of my clothes. Promise me you'll go there, Audrey, tell them I sent you."

I promised, politely stuffed the note in my jeans pocket, and continued the interview. She offered more advice.

"Your hair looks messy, it needs styling, Audrey. Go to Mr. Kenneth. He cuts my hair and Jackie Kennedy uses him, too." I realize that she's criticizing my hair, just like my mother. We sipped tea and reminisced, and after a while, I gingerly brought up the Women's Caucus Award. I was delighted when Lee graciously agreed to accept it. We shook hands and I took my leave.

It was all so crazy. Lee had been a core member of that group of wild and dangerous artists who lived bohemian lives and scorned middle-class values. The transformation was amazing.

After Lee's death, their home in Springs was turned into a museum called the Pollock-Krasner House, directed by the brilliant Helen Harrison. Years came and went before I could bring myself to visit, but in 2007, after I finished work in my East Hampton studio, I drove up Springs Fireplace Road. The car window was rolled down and a gentle breeze blew into my face as I passed the familiar landmarks.

I took a small detour and drove to the spot where Jackson had crashed. I pulled over, got out, and found myself staring at the grassy area where he had died. I visualized Ruth lying next to him, moaning and bloody, with her friend Edith lying crushed to death a few feet away.

A few miles down the road, I saw the hanging plaque announcing the entrance to the Pollock-Krasner House swinging in the breeze. I parked my car and walked onto the vast lawn where Accabonac Creek lay spread out under a clear cobalt sky. I must have been there five minutes when the flapping of seagulls' wings interrupted my reverie. The moment I stepped into the house, memories engulfed me, and I expected to see Jackson's and Lee's transparent ghosts seeping through the walls.

The furniture, dishes, silverware—every object was intact. Lee's old dining table was in the same place, and the two posts that were left when Jackson chopped down the walls still stood defiantly. But what stunned me most was Jackson's studio, which was now a shrine.

It is a profound experience to visit the Pollock-Krasner House and step into a place where these two major artists lived and worked. Conservators removed the Masonite that Jackson had installed to insulate the floors, and years of accumulated drips, smears, and splattered paint from his painting on the floor were now exposed. Foam slippers are required before you step into the sacred space.

Jackson's and Lee's waste and discards are now relics in a museum. Jackson's paint cans, with stiff bristle brushes jammed into them, have been encased in a Lucite box and enshrined on a shelf. I remembered our lives in the 1950s and marveled at what it had all come to.

After Jackson died, Lee made a tracing of his signature and had it engraved on a rectangular bronze plaque. She mounted it on a huge rough-hewn rock extracted from the East Hampton terrain they both loved and placed it as the marker for his grave. It quietly stands out on a small plot in Green River Cemetery, close to their home. Lee brilliantly branded Jackson's signature, promoting her husband even at the moment of his death.

Upon her death, Ron Stein, Lee's nephew and an executor of her estate, re-created the tombstone for her, only on a small, inconsequential scale, and installed it at Jackson's feet. In effect, this placement said, "She was only an artist's wife, after all."

Elaine de Kooning and Bill's Demise

The next morning, as I took my seat on the Broadway bench, it was easy for me to think about Elaine de Kooning. Elaine and Lee were linked together, not as artists but as the wives of two men who were vying for first place in the art world. Elaine married Bill de Kooning and I believed

she loved him, but that didn't stop her from having affairs with men who held prominent and influential positions.

Elaine thought nothing of leaving Bill for weeks and months at a time for vacations with lovers. Tom Hess, editor in chief of *Art News* and chief consultant for twentieth-century art at the Metropolitan Museum, was a prime example. Elaine was in the center of a new and exciting art movement, and she had a fine command of art history. Hess thought she would make a perfect editorial assistant and hired her to write reviews and articles for *Art News*. It was a powerful position that she used to promote her husband, friends, and lovers.

Bill only wanted to paint. He was a solitary man who did not care much for travel, but Elaine needed the adventure and excitement. Elaine was the love of Bill's life, and while she was away he would stay home, paint, and wait for her to return.

Elaine, along with many other Abstract Expressionist women, refused to have children, stay home, cook, shop, or clean. But as time went on, Bill, not to be undone by Elaine, had more than his share of lovers. They came and went in droves. Some were short flings during drunken binges; others were serious and meaningful relationships.

Another of Elaine's conquests was Harold Rosenberg, the art critic who coined the term "action painting" in his pioneering 1952 essay entitled "The American Action Painters." It was to become one of the most important articles defining the Abstract Expressionist movement.

Next was Charlie Egan, a good-looking gallery owner who took chances by exhibiting avant-garde artists. Through Elaine's "efforts," Charlie gave Bill his first exhibition. The only problem was that Charlie was an alcoholic who drank up the profits the minute he sold a painting.

Elaine painted in her own figurative expressionist style, but like Lee Krasner, her life and work took second place in order for her to promote and propagate Bill's status as a genius. It wasn't until years later, when she stopped drinking and moved to East Hampton, that we would become close friends. In the summer, Elaine, Connie Fox, and I spent glorious sun-filled days painting plein-air watercolors together. We piled into a car and drove up and down the bumpy back roads and watery inlets of Napeague, Montauk, and Amagansett until we found a site we all agreed on. We unloaded our equipment, set up

makeshift easels along the beaches, dunes, and fishing docks, and painted away.

After years of working alone in my studio, I relished being outdoors and inhaling the salty ocean air and negative ions that rolled in with each crashing wave. But even more than that, I enjoyed the company of other artists.

We stopped to share a lunch of sandwiches and a thermos of hot coffee and were eager to get back to work. To finish a watercolor in one day after spending a year on one painting was a thrill for me. I felt cleansed and refreshed.

Connie's and Elaine's methods were essentially Abstract Expressionist, spontaneous and fast. I could hear Elaine swish and splash her brushes as she furiously worked away, ripping page after page off her pad as she tossed off each study. Some days Elaine would finish as many as five or six watercolors while I worked as fast as I could to complete one.

"Hurry up, Audrey," she chided, flashing her batch of watercolors in front of my face and laughing.

"Hold it, Elaine, I need more time to catch the reflections in the water before the sun goes down." But five minutes per watercolor was all she needed. She honked the horn and revved the engine until I packed up and scurried to the car with my dripping watercolor in hand.

In the winter, when it was too cold to work outside, Elaine and I met at Eddie's, a hole-in-the-wall luncheonette on Newtown Lane. We had intense and exciting conversations about art. The one I remember best was about motivation.

"Some artists work out of anger," she said. "Van Gogh, Bill de Kooning, Michelangelo."

"Some work out of joy," I replied. "Frans Hals, Judith Leyster, Rubens."

"Some out of self-indulgence," she said. "Chagall, Fragonard, Miró."

"Some out of peace," I replied. "Fra Angelico, Fra Filippo Lippi, Piero della Francesca."

On and on we went, going through the centuries up to the present, discussing our artist friends' work. And between each sentence, like a punctuation mark, Elaine took a puff on her lit cigarette and blew out a billow of smoke with her pinky in the air like Bette Davis. I did not know during those great discussions that Elaine was dying of lung cancer. She told no one and continued to smoke even in her Southampton hospital bed.

Fig. 13 Audrey Flack remembering Elaine de Kooning. Photo courtesy of Audrey Flack.

Elaine and Bill had been separated for many years, and during that time he fathered a child with Joan Ward, an artist who lived close by in Springs. Joan and I hired models and sketched together in the living room of her small house, but she always seemed a bit out of it to me. I didn't know it then, but Joan drank too much and most likely had a few drinks in the morning before we started to draw. Except for their daughter Lisa, her influence on Bill's life seemed slight.

Women sought Bill out. He was a famous, handsome art star, and he liked women. The list is long, including Ruth Kligman, but the women he was most attracted to were monied, educated, refined, and stylish. Emilie (Mimi) Kilgore, who was married to a venture capitalist, became the love of his life in later years. She was a member of the elite East Hampton Maidstone Club, an old monied WASP group that excluded Jews and Black people and other people of color. His other serious love was Susan Brockman, a wealthy Smith graduate and French instructor. De Kooning said, "I liked these classy dames."

The third member of this exclusive group was my friend Molly Barnes, a pretty platinum blonde whose watery-blue eyes and chiseled features were enhanced by a short pixie haircut. Slender and trim in a sleek black pantsuit, she was a California woman with money, style, and a Hollywood pedigree. Enthralled with the New York art scene, Molly

was intent on meeting de Kooning and rented a house in East Hampton near Bill's studio. She positioned herself in places where he would notice her, and her plan worked. They became lovers.

One of the most incredible stories Molly told me was of the night they were drinking at Friedel Dzubas's party in Springs. It was two or three in the morning and time to go home, but Bill insisted on wandering over to Green River Cemetery nearby. The two of them stumbled their way through the gravestones until Bill found what he was searching for: Jackson Pollock's grave. He pulled Molly down and fucked her on top of Jackson. Such was the fierce competition, love, and hate between these two great and troubled artists who must have sensed the similarity of their talents and tormented souls.

People found it difficult to compete with Elaine's brilliance and sharp-witted tongue. She was Bill's wife. They had never divorced, and now that Bill was ill and had been hospitalized several times with diseases associated with drinking, Elaine moved to East Hampton and took charge. Bill's studio was big enough to house an airplane, yet there was no room for Elaine to work. She could have painted in a bedroom (like Lee), but Elaine needed her own space. She bought an acre of land and built a house in Northwest Woods on Alewive Brook Road with an impressive studio. It was nowhere near the size of Bill's, but big enough.

Elaine was not a feminist, but change was in the air. This was her last chance to assert herself, and she took it. Now near enough to Bill to supervise his life, she threw out his drinking buddies, banned alcohol, and hired a series of new assistants. Among them were Larry Castagna and Cathy Fisher, both former assistants of mine. Cathy was a potter, but she shopped, cooked, and ran Bill's house, while Larry oversaw the workings of the studio. Elaine was a tough, smart woman, but she was also an artist's wife, and like Lee Krasner, she knew the value of her ailing husband's estate.

Elaine had many sides to her. She could be kind and caring, but she could also be cold, aloof, and quietly scheming. By the time Elaine moved back to take charge of Bill's life, his daughter Lisa had a full-blown alcohol and drug dependency problem. She was hanging out with druggies and gang members. One of her boyfriends was the president of the New York chapter of Hells Angels. She collected exotic animals; horses, ponies, pigs, and an ostrich were all housed on the property. A boa constrictor lived in her bedroom.

She got little support from her severely dysfunctional family, so she sought help from a psychotherapist who had a basement office in a remote section of Noyac Road. I went to that same therapist. I wanted privacy and thought no one would see me in that faraway basement. But there was Lisa: she had the session before mine, with the same idea in mind. We greeted each other and laughed at the comic irony.

Sadly, at the age of fifty-six, after a series of drug-related incidents, Lisa died of unknown causes—most likely an overdose—in her vacation home in St. John in the US Virgin Islands.

Almost nothing has been written about de Kooning's role as a father. Society tends to focus on the "bad mothers." Even though Bill loved her, I can only imagine how Lisa was affected by watching her father rage, stagger, fall to the floor, and pass out.

Shortly after Elaine settled back in, she began to keep people away from Bill. An air of secrecy was beginning to surround the enclave. Even his closest friends were kept from him. East Hampton artists, including old friends like Ibram and Ernestine Lassaw, were turned away. I, too, had asked to see him and was continually put off. In the early 1980s, I made yet another request and was surprised and delighted when Elaine set a date for the three of us to have lunch at Bill's studio.

I knew he liked chocolate and decided to buy a cake at the elegant, pricey Barefoot Contessa on Newtown Lane. There, on a glass shelf, sat a chocolate mousse cake shaped like a bowler hat—or a German helmet. A thick coating of black chocolate was poured over the top. It looked degenerate and delicious at the same time, like something from a 1939 Berlin Kaffeehaus, and I bought it thinking it would make Bill laugh. I also brought my book *On Painting*, which had just been published by Abrams Art Publishers. I was about to leave for Bill's when the phone rang. It was Elaine, saying that she had a bad cold. I thought our lunch would be cancelled, but much to my surprise, Elaine asked if I would mind visiting Bill alone. "No problem at all," I said, happy to be able to see Bill under any circumstances.

I drove up Springs Fireplace Road, made a left onto Sandra Lane and another left past Bill's oversized mailbox, and pulled into his driveway. Cathy opened the door. Bill was waiting inside in the front of his vast studio . . . his studio *was* the house. The rest was just a living room and kitchen and a couple of upstairs bedrooms.

"Hello Bill, I'm so glad to see you!"

We hugged and he smiled, looking as handsome as ever, white hair, ruddy skin, twinkling blue eyes. I handed him the cake, now boxed and ribboned, as well as my book. He put the cake on the kitchen table without bothering to look inside. But he opened the book and immediately began thumbing through it, closely examining every page. He stopped, looked at me, and asked, "Vot kind of paints are you using? The colors are bright, strong."

"Acrylics," I said. "It's a new medium. The pigment is not as dense or rich as oil paint but the colors are intense and reflect light in an entirely different way. The paint dries fast so you can work on top of a freshly painted area without having to wait too long. If you like, I'll bring you some tubes."

"I vould like dat," he replied, nodding his head.

His new assistant, who Elaine had hired, interceded, "He doesn't want to use that paint."

Bill did not answer. Perhaps he didn't hear him, I thought. He looked back at the book, carefully studying my Photorealist paintings. He got a faraway look in his eyes and began talking about the academic training he received at the Rotterdam Art Academy in Holland. He walked over to his flat file, and I followed. He opened a few drawers until he found two tightly rendered pencil drawings of female nudes.

"I did these years ago in life class. You see, I vorked like dat too at the Academy."

"They're beautiful," I said, thinking about how much I would like to have one of them. "If you want to do some life drawing, I have a model coming this week, I'll bring her here or I'll pick you up. We'll draw together."

"No, he doesn't want to work from the model." The assistant interrupted before Bill could answer.

Once again Bill said nothing. This wasn't the man I knew. *Why didn't he protest?* Clearly something was wrong. He seemed weak, almost childlike, and easily directed. It was clear that others were already controlling his life. *Instructions from Elaine?* Bill would have really enjoyed drawing from the nude again. He might have returned to realism given the chance. I felt that way about Pollock, too. When you go too far out, realism brings you back. It is grounding; it restructures the brain.

It was time for lunch. We sat at the rough country pine dining table and were served delicious omelets infused with aromatic herbs, French bread, and fresh-brewed coffee, all prepared by Cathy. The table was

cleared, and Cathy brought out my chocolate bowler-hat cake. That's
when I noticed even more odd behavior. The person to my right was the
registrar who had been living there for the past three months catalog-
ing his work. Bill turned to me and whispered, "Who is dot woman?"

A loss of short-term memory, I thought, probably from drinking
too much for too long. I didn't want anything to be wrong with him. I
let it pass. Bill cut into the hard chocolate icing and we all enjoyed the
obscenely rich cake. The registrar went back to work, and Bill invited me
into the studio to see his new paintings. I couldn't wait. The sheer size
of the room and the reverence I had for Bill made me feel I was enter-
ing a cathedral.

Two oversized Adirondack rocking chairs rested against the back
wall. Bill sat down and beckoned me over to sit next to him, but before
I did, I walked over to his easel to get a closer look at the electronic
contraption Elaine's brother Conrad had devised for working on huge
canvases. It could even spin canvases around so Bill could work at any
angle. Conrad also cut a long narrow slot into the floor that went down
to the basement. It was both long and wide enough to raise and lower
the canvases. This gave Bill the freedom to apply his gestural markings.
He no longer had to stand on a ladder to reach the top of a painting. All
he had to do was press a button and set the canvas to a lower position.
At the opposite end, he could raise the canvas and not have to lie on his
stomach to paint the bottom, like I did in my *Vanitas* series.

"This invention is brilliant!" I said as I took my seat in the rocker
beside him.

Bill, Jackson, and Franz had been my idols. They represented truth,
integrity, and incorruptibility. Nothing mattered but the uncompromis-
ing truth of art. De Kooning's two masterpieces, *Excavation* and *Attic*,
had altered my vision and enriched my life, but the painting on the easel
and the two others beside it made my jaw drop. What the hell had hap-
pened? These paintings were ridiculously simple. A few straight lines
and one or two curved ones wobbled across the canvas—one red, one
blue, occasionally one yellow. They were applied with one long brush-
stroke. At times an edge was smeared in places where the brush had
dragged over the wet ground that had been prepared by the studio assis-
tant. The work was incomplete, vague, and without substance, not at all
like the de Kooning I knew and respected. Paintings from the '60s and
'70s were stacked around the studio. The contrast was dramatic and dis-
turbing. And why only the three primary colors, red, yellow, and blue?

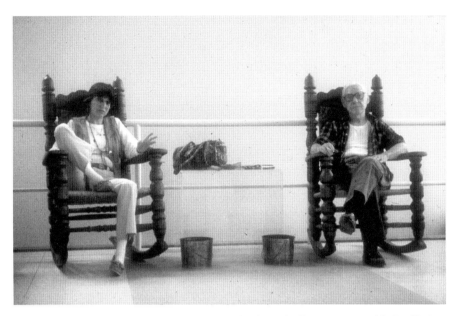

Figs. 14 and 15 Audrey Flack and Willem de Kooning in his studio. Photos courtesy of Audrey Flack.

Was it because that was all his scrambled brain could manage? The de Kooning I knew was excited by complex juxtapositions of color, texture, shape, space, and gesture. That was his norm, not repetitive, simplistic, puerile streaks. These paintings were little more than the visual representation of the deconstruction of his brain. I sat there in stunned silence.

"Vat do you tink?"

I was upset and didn't know what to say. All I could come up with was, "Are they finished, Bill?"

"No, I can vork on them more but I can sell these and paint others."

He looked at me, raised his shoulders, and silently chuckled. I was shocked and saddened. Were these Elaine's words he was voicing? Was she getting as much work out of him as she could? As long as he could move his arm and paint on instinct, even with half a brain, he could produce. Much of the work was stored downstairs in what we called "the bunker." Bill continued to paint by rote, producing what dealers call his last and best works. It seemed that Bill's only desire was to always be working, so his assistants held up his early works for him to copy or be inspired by. They set out his tubes of paint, unscrewed the caps, handed him his brushes. There were also rumors that they projected his old paintings on the canvas for him to paint over.

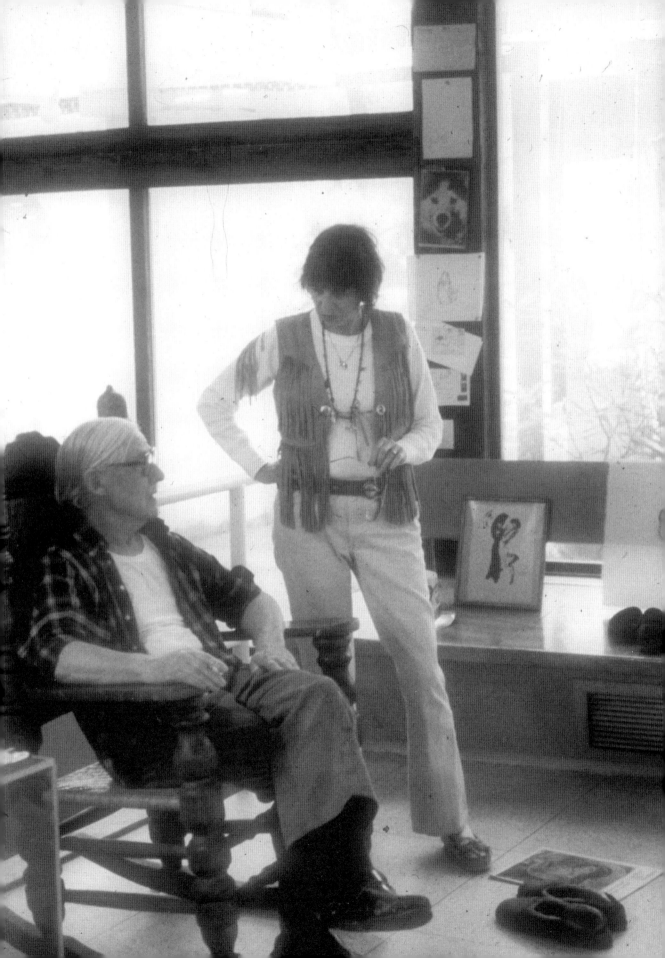

His dementia/Alzheimer's was being hidden from the public, since it would affect his career and the prices of his new work. Soon after that, no one was allowed to visit him. Mine was one of the last studio visits he was allowed to have. Explanations and theoretical formulations were conjured up by dealers, pulled like threads from wisps of thin air. These works were presented to collectors to impart the complexity of what wasn't there so that they could be sold for high prices. I heard that in some cases collectors could only buy a classic de Kooning if they first bought an "Alzheimer's painting."

I feel a sense of betrayal in saying or even thinking anything negative about Bill's late work, but I believe not to tell the truth is a disservice to what he stood for. There are essential differences between the machinery that drives the purity of great art and the machinery that drives the art market. One is driven by the highest ideals, the voice of truth within the individual, and the other by money, power, fame, celebrity, and greed.

As for Elaine, after years of being second to her mate, promoting his career, and taking the back seat, she now had the command and stature she could never achieve as a woman artist on her own. She had control of one of the most powerful and sought-after artists in the modern era, but it was short-lived. After a few years of high living, flying around in the private jets of wealthy collectors, accepting awards and acclaim for her world-famous husband, Elaine died of lung cancer in 1989. Had Elaine outlived Bill, she and Bill's daughter, Lisa, would have inherited the entire estate.

I thought back to the summers when we painted watercolors together, she with a cigarette in one hand and a brush in the other. And at our winter lunches at Eddie's luncheonette, Elaine puffed away, knowing full well the seriousness of her illness but not telling me or anyone else. I would have put my arm around her, comforted her, but there was a toughness about Elaine that let no one in.

Time unravels and unveils truth, and when I look back at those days, I see that Elaine, Grace, and Lee had developed rhinoceros hides that were stronger and tougher than any of the men. It was that same tough skin that allowed Elaine to continue making those terrific representational portraits like the ones she painted of President John F. Kennedy at the White House. Her work has yet to receive the full acknowledgment it deserves.

Bill staggered on, with his fogged-over brain getting more and more confused, until he passed away in 1997. His ashes are not buried in Green

River Cemetery, the resting place for all of his artist friends, but reside on a mantel in his house on Woodbine Drive. Even though Elaine took charge of his existing artworks, oversaw his production of paintings, prints, and sculpture, and saved his life, she never achieved the status, power, and wealth that her nemesis Lee Krasner did. Elaine's talents are now being recognized. Museums, galleries, and collectors are clamoring for her work. Historians are reevaluating it and her market prices are soaring. I wish Elaine was around so we could toast her success.

Grace Hartigan

My Broadway bench had become a noisy open-air asylum for me, a place where I could perform isolated self-analysis. I tilted my head up to catch the morning rays of the sun and a scattering of Grace Hartigan memories filtered down.

I knew Grace well, yet to this day she still remains a mystery. Her drinking, slew of marriages, divorces, ebullient love affairs, one-night stands, and tough demeanor were brash and openly exposed, but there was a side to her that remained hidden. It was a side that Grace herself didn't acknowledge, a side she showed sparingly and only in bits and pieces, if at all.

Grace and I knew each other from the downtown scene, but we only became close after life had taken its toll on both of us. In 1972 we spent a weekend together in Detroit, where I was giving a lecture at the University of Michigan and Grace was having an exhibition at the Gertrude Kasle Gallery. We were invited to stay at the home of the gallery owner, whose house was filled with great Abstract Expressionist paintings.

Oddly enough, I had met Gertrude Kasle when I was fifteen years old and had just won a summer scholarship to the Cranbrook Academy of Art in Bloomfield Hills, Michigan. For a city girl who painted in a corner of the bedroom I shared with my brother, Cranbrook was sheer paradise! I was given my own studio and served breakfast, lunch, and dinner in a beautifully landscaped setting, with fountains spouting water from Wilhelm Lehmbruck statues. My dream was shattered when I was forced to share my studio with a wealthy and very beautiful older woman whose husband owned steel mills in Detroit. My resentment

Fig. 16 Marty Katz, photograph of Grace Hartigan, 1993. Courtesy of Marty Katz.

was palpable, but the die was cast. Gertrude Kasle remained my studio mate for the summer. She turned out to be a lovely and kind woman who spent little time there and eventually won me over.

And here I was, twenty-six years later, sleeping in Gertrude's house and waking up early to get another look at the de Kooning hanging over her living-room sofa. Still in my pajamas, I tiptoed down the stairs, stood before the painting, and marveled at Bill's incredible brushwork. I found my way to the kitchen. It was 7:30 am; the sun was streaming through the windows, birds were chirping in the garden, and much to my surprise, Grace was sitting at the kitchen table drinking a tall glass of water. I said good morning and, feeling thirsty, took a sip. The bitter

taste of vodka made me spit out a spray that splattered all over the table. Grace had been drinking straight vodka for who knows how long.

"You're killing yourself like all of those guys," I blurted out. "You have to stop!"

I couldn't help myself; I liked Grace, and I wanted her friendship. But Grace said that drinking and high drama were necessary for her work, that she had to take risks and be thrown into chaos, that she had to lose her way in order to paint, that she had to destroy the painting over and over again. That the process of creation was more important than the work itself.

Years later, Grace stopped drinking and became an avid and outspoken member of Alcoholics Anonymous. In the interim and for long afterward, we continued our friendship. I valued it.

We chatted in the kitchen, Grace swallowing her vodka, me sipping a glass of cold water. Grace reminisced about her love affair with Franz Kline and the night they spent drinking at the Cedar Bar.

"We wound up in Franz's studio and made love on a mattress on the floor."

"Was that you on the floor with Franz the day I knocked on the door and couldn't get in? Was the sex good?"

"Franz was one of my best lovers."

She leaned close to me, and with a sly smile, whispered, "He pulled out my diaphragm before we had sex."

My eyebrows raised and my eyes opened wide.

"Why did you let him do that? And why *did* he do that?"

Franz's wife was mentally ill and had been institutionalized; there was no chance of having a family.

Did Franz secretly want a child, or was it the same male dominance exerting control over female artists?

Grace laughed and took another drink. This kind of behavior was hard for me to fathom, because I knew the risks. Multiple abortions were part of the scene.

To have children meant you were not taken seriously. Children were considered a burden, a hindrance, something that diminished your art. They were either hidden or sent away, or you just didn't have any. There were a few Ab Ex women artists who had families, took care of them, and continued working, and I commend them. But I am referring to the art stars who fell into the male-oriented trap and are being mythologized

for it. Lee Krasner, Elaine de Kooning, Joan Mitchell, and Helen Fran-kenthaler—they didn't have children, and it is perfectly fine not to have children. But Grace had given birth to a son. She knew it was a man's world and fell into the trap of believing she had to abandon her child in order to succeed. Yet Grace was the only one with whom I felt comfortable talking about my children, particularly my daughter Melissa, whose problems had consumed me.

Lee Krasner felt a child would interfere with her career, even though Jackson desperately wanted one. Besides, Jackson was her child. She watched over him, fed him, comforted him, and kept him from drinking for long periods of time, enabling him to paint some of his best works. Having a child was a bone of contention that caused problems in their marriage and fights that drove Jackson into violent rages. Elaine rejected having children for similar reasons.

Years later, she had a false pregnancy. *Did she want a baby after all?*

Yet the image of tough, hard-drinking Jackson Pollock diapering a baby or pushing a stroller is unthinkable. And the Abstract Expressionist women imitated their men. It was in the air and you adapted to it or you were out. Feminine qualities like compromise, compassion, forgiveness, reason, and loving kindness were considered weak, and so too was having children.

The Ab Ex women broke from society's expectations that they get married, have babies, and stay homebound. Instead they created a new extreme—that of career-oriented freedom. They were behaving as men had for centuries. The "brutal brushstroke," with its oversized canvases, became the new norm.

Grace Hartigan felt that her son, Jeff, was a nuisance and she paid little attention to him. She kept Jeff with her on and off until he was nine years old, when she sent him to live permanently with his paternal grandparents. She told me that she listened to him cry all night and that there was nothing she could do to console him. She concluded, "He had his tragedies defined for him at an early age."

Opinions vary in the feminist movement. One ardent writer stated that raising children and caring for a family were "unhealthy servitude." She expressed great admiration for Grace's abandoning her child. As far as I am concerned, sacrificing a child is irresponsible and narcissistic, and servitude to motherhood is not the only solution to raising a family. Abandoning a child to indulge in drinking, painting, travelling, and

love affairs is impossible to justify, let alone admire. Yet here was Grace doing just that, openly, for everyone to see. No one questioned her.

I sometimes think Grace was an innocent, acting out a childlike fantasy with no thought of the consequences. Strangely enough, Grace's maternal instincts showed up when she nursed Larry Rivers after he slit his wrists. She fed him and nurtured him until he recovered. A wonderful thing to do—but where was Jeff?

Growing up without his mother, Jeff eventually married and had children of his own. Grace handed me a postcard he sent to her with pictures of his children. On the back he wrote, "These are your grandchildren, you'll never see them." Jeff followed in his mother's footsteps and became an alcoholic and heroin addict. He died at the age of sixty-four, long before Grace. Some say it was liver failure or an overdose; others say it was suicide.

Grace kept up the bravado, the lifestyle, the surety of her path, but I suspect that underneath were layers of guilt and pain. If she had second thoughts, they were never expressed. Grace was tough but she was not a monster. I was privy to the suffering and heavy toll Grace paid for independence and acknowledgment.

For centuries, artists had children who worked in their parents' studios. Since there were no art schools, knowledge was passed on from father to son and, in rare cases, to daughters. Jacopo Bellini had a flourishing studio in fifteenth-century Venice. He was the father-in-law of Andrea Mantegna, and his sons Gentile and Giovanni were trained in his workshop. This was a family affair.

In Flanders during the sixteenth and seventeenth centuries, Pieter Brueghel the Elder trained his two sons, Pieter the younger and Jan. The sons, in turn, had children who also became artists.

Artemisia Gentileschi was raped by her father Orazio's assistant, Agostino Tassi. She suffered and finally successfully won a rape trial, after which she was quickly married to another man to save her honor. Artemisia had a daughter and moved to Florence, where she became a highly celebrated artist. She never stopped painting, nor did she abandon her child.

Luisa Roldán, an amazing seventeenth-century sculptor, was the daughter of Pedro Roldán. She eventually surpassed her father and became court sculptor to the king of Spain. Luisa developed a flourishing studio, put her husband to work for her, and had several children.

Being a woman, she was grossly underpaid. A letter was found written by her—in weak and shaky handwriting—addressed to the king, begging for money to support and feed her children.

These women and many others did not abandon their children in order to create their art. There is no shame involved with having children as there was with the Abstract Expressionists.

Grace felt that feminists were essentially bad artists who used feminism to further their careers. But in later years she joined NOW, the National Organization for Women. She did not care much for its goals but accepted backing and support from them. She did advocate for their position on equal pay for women.

Grace roller-coasted through two frivolous and two serious marriages, a slew of one-night stands, and multiple love affairs. Among her lovers was the painter Alfred Leslie as well as the photographer Walter Silver. After having had an incredibly successful career, Grace was now on a downward swing. Her last show was referred to by a critic as a "comeback, like Gloria Swanson in *Sunset Boulevard*."

Her spirits lifted when she met the man of her dreams, Winston Price. Price was an epidemiologist at the Johns Hopkins School of Hygiene and Public Health, where he was developing vaccines. The *New York Times*, *Life*, and *Time* reported that Price had isolated the virus for the common cold. But even more intriguing for Grace was that Price was a known collector who traveled in the higher echelon of art circles and had already purchased one of her paintings.

By 1958 Price had grown restless at Johns Hopkins and was ready to move on. There was talk about his joining the NIH (National Institutes of Health) when he decided to reach out and telephone Grace. She told him about several paintings in her New York studio that she wanted him to see. Price traveled to Manhattan, took a suite at the posh Sherry-Netherland hotel on Fifth Avenue, and invited Grace for a drink that turned into an intimate, passionate three-day affair. Without time for discussion or mediation, Grace contacted her third husband (they had been married for only four months) and told him that she never loved him and was going to leave him. She referred to him as her "meatloaf" husband.

Grace felt that she was, for the first time, really in love. Price was enamored but also married and reluctant to leave his wife. Grace was eventually able to convince him to get a divorce and marry her. She

herself got an annulment. Price wanted to move to Baltimore to be near his new job at the NIH, and Grace agreed, reluctantly: there was no contemporary art scene, no Cedar Bar, and no artist friends. She rented a great studio in a waterfront industrial building and got a job teaching at the Maryland School of Art. Grace was a devoted teacher and treated her students in a way that was both impresario-like and motherly.

Over the years, Grace, Price, my husband Bob, and I had many dinners together, some in Baltimore, but mostly in New York when they visited. I was deeply touched when Grace offered to speak to Price about having the NIH do research on the little-understood condition that afflicted my daughter Melissa. He seemed excited by the idea, and Grace kept after him. Grace and I became closer as I shared my fears, concerns, and the many travails that I faced with Melissa over the years.

Price appeared to be more stable than Grace's crazy artist and poet lovers. He was reserved and quiet, not flashy and quick-witted like the type of man she typically went for. Perhaps it was the sense of security she was attracted to, but Price was also a collector, hobnobbing with art-world potentates who could advance her career. He was well built and distinguished looking, with gray sideburns. But Price had been experimenting with vaccines for encephalitis and began testing them on himself, following a long line of scientists who tested their theories by self-injecting. The serum had a lethal effect, resulting in a long, slow, debilitating mental and physical illness. He became overweight and developed a skin condition so bad that his skin peeled off and his hands bled. After that, Price wore white bandage gloves when we had dinner. He also became lethargic, ate rich foods, became corpulent, and had a stroke. His physical decline led Grace to have affairs with other men, which she didn't hide from him.

It was shocking to find out that Price had been lying to all of us. There was no job, no research on my daughter's behalf. It had all been a sham. He lied to Grace; he lied to me. He hired a taxi and left for work every morning, pretending to have the job at the NIH, but he never did. I was devastated, but poor Grace was brought to her knees.

While Grace's concern for my children felt genuine at the time, it pains me to think that her interest was perhaps not authentic. Did it come from an underlying guilt over her own child, Jeff, or did she feel

guilt about him at all? Or was it fierce ambition that drove her? Grace was unstoppable and multifaceted. I remain extremely grateful for her efforts and friendship, no matter what their source.

After years of living in Baltimore, Grace was at the lowest point of her career. She exhibited at Grimaldis, a small Baltimore gallery, but was without New York representation. She would often bemoan this fact to me over the phone and I said I would try to help her. And I did, by throwing a dinner party for her and inviting Jeffrey Bergen, owner of the ACA Gallery. Grace drove in from Baltimore. She even wore a dress. The dinner went well and the gallery took her on that very evening.

In 2013 I was interviewed by Cathy Curtis for *Restless Ambition*, her insightful book on Grace Hartigan. In it, Alfred Leslie, one of Grace's lovers, writes poignantly about his last meeting with Grace. He saw a woman at an airport who "looked bloated (and) had a terrible limp." Passing her in the terminal, he turned his head away, trying not to stare at the stranger. Then Grace called his name. "When I walked over," he said, "we were this close and I didn't recognize her. She seemed to be heavily medicated. And she was very angry with me, that I didn't recognize her. . . . I [had] never [seen] her wounded in the way she was wounded then. I didn't know how to make it up to her. I would have liked to, because we were good friends, always. But that was it."

It wasn't until Grace and Elaine stopped drinking that they recognized the importance of women. And when Lee's career was waning, when she was treated as nothing more than an artist's wife, only then did she finally accept help from feminist organizations.

I remember seeing a group of women protesting in front of Christie's just before an auction of Abstract Expressionist paintings. They handed out leaflets and chanted, "Women artists' work will sell for less than men's even if their paintings are better." And that is exactly what happened.

Sadly, it wasn't until years after Lee, Elaine, and Grace died that their work achieved status and recognition. The value and market prices of their art remain lower than those of their male counterparts but continue to rise. Similarly, there has been a recent surge in demand for my Abstract Expressionist work that the Hollis Taggart gallery has been exhibiting. These paintings were stored in my studio closet for nearly seventy years, and in a matter of a few short months, they have completely sold out.

Alice and I lived two blocks from each other. I lived on 104th Street, and Alice was on 106th. We saw each other in the neighborhood and at gallery openings, and chatted on the phone, but never became friends. Alice didn't have women friends and she was not a feminist, but toward the end of her life she became bitter about not being sufficiently recognized and accepted any help she could get from feminist groups.

An independent collective of young women artists had just put on their inaugural exhibition and invited Alice and me to the opening as honored guests. When I entered the gallery I spotted Alice, seated on a thronelike chair, holding court. Thirty young women were sitting cross-legged at her feet, looking up at her with reverence.

Alice was wearing her usual old lady lace-up shoes with square heels. Her long black skirt hung between her spread-apart legs. Alice's round face, rosy cheeks, and downy white hair gave her a kindly old Irish grandmother look, but in fact she could be more vicious than anyone I had ever known. It didn't take more than a few seconds for Alice to spot me and begin her attack. She pointed her wooden cane at me, waved it around in circles, made jabbing motions as if to stab me, and yelled across the room, "You whippersnapper! You're in all the museums and I'm not, and I am a better artist than you!"

Conversation stopped and all eyes turned toward me, anticipating my response. Even though I knew Alice's nasty nature, I was still taken aback by her hostile outburst. I pulled myself together, walked up to her, and said, "Behave yourself, Alice. You are a good artist and so am I! Now put your cane down and shut up!"

Shortly after that incident Alice began to acquire honors and recognition. She received the Benjamin Altman Prize from the National Academy of Design in 1971 and was elected to the National Institute of Arts and Letters in 1976.

About seven years later, my phone rang at 6:45 in the morning. When the phone rings too early or too late, I think something terrible has happened. I answered with trepidation.

"Hello?"

"Is this Audrey?"

"Yes."

"It's Alice. I'm sorry!" Click.

Before I had a chance to say anything, she hung up. I sat up in bed shocked once again by Alice. She had been carrying her anger and

jealousy around for years and finally could let it go. I was glad she was able to make that call, both for her and for me. Alice died shortly after that.

In September 2021, I wrote to Kelly Baum, chief curator of the Alice Neel retrospective at the Metropolitan Museum of Art, congratulating her on the exhibition. Kelly wrote back a few days later saying that she was just at Alice's 106th Street apartment and saw my book *On Painting* on her work table. The connection between us was still there after all that time.

Yale University and Josef Albers

It was 1983, and the November weather was changing. It was getting cold and I was bundled up, sitting on the bench with my wool hat pulled over my ears, insulated gloves, and a wraparound scarf. I stayed warm long enough for my memories to wander back to my senior year at Cooper Union, when I was slinging paint at the canvas from twenty feet away, wielding the brush like a fencer and moving back and forth, completely immersed.

I felt a tap on my shoulder. It was Professor Dowden instructing me to report to the dean's office immediately. More trouble, I thought. I cleaned my brushes, washed my hands, and made my way to a private sector that was off-limits to students. I scanned the room and momentarily became speechless, for there before me was an apparition. Sitting in an easy chair facing Dean Shaw was Josef Albers himself. I recognized him instantly.

Albers was a member of the renowned German Bauhaus school that instituted one of the most influential movements in Modernist architecture and design. The author of many books on color theory and painter of the historic *Homage to the Square* series, he was an art-world legend. Albers's form of Modernism meant tight control, geometric simplification, and strict order. I couldn't imagine what he wanted with me, an avant-garde paint-slinging Abstract Expressionist.

Albers had recently left his position at Black Mountain College to become chair of art at Yale, but he was having difficulties. He had inherited students who painted in a highly academic style. They didn't

understand his language, the language of Modernism. He'd struggled for two years but was not able to reach them.

Desperate to save the failing school and his job as well, he decided to import one or two avant-garde art students from Cooper Union to help him revolutionize the school. He asked for the names of the "enfants terribles," and mine was the first one on the list. Albers knew those academic students would have a hard time making tight-assed paintings with someone like me dripping and pouring paint from buckets right next to them.

But first, the venerable Josef Albers had to see my work and judge if I was worthy. He told me to bring my paintings to Yale.

Once again, my father came through for me. Selecting ten of my best works, I stacked them in the back seat and trunk of his old two-toned Buick Riviera. We drove up the West Side Highway with the windows wide open, headed for New Haven. I felt alive and happy, dreaming about the possibility of going to Yale as the cool breeze brushed against my cheeks. Luckily, we found a parking spot in front of the art school building and carried my work up the steep steps. Too intimidated to enter the building, my father waited in the car. The secretary instructed me to set my paintings in a room that was empty except for two Stickley chairs. The only light was from a milk-glass fixture hanging from a spoke in the center of the ceiling and two leaded-glass windows. I nervously rearranged my paintings, tilting them at varied angles to catch the dim filtered light.

I waited in that room for a solid hour before Albers burst through the door and walked right past me. His head was bent forward, his hands clasped behind his back. I was struck by his white hair, white suit, and Bavarian pink cheeks. He paced the room, scrutinizing each painting with no regard for my presence. He had no intention of putting me at ease. Albers turned around, thrust his face at me, and snapped, "You are committed to your vork?"

"Yes, absolutely!" I shot back.

"You prime your own canvases, ya?"

"Yes, I do. First, I boil chunks of dried rabbit skin until the concoction melts and becomes gluey. The whole studio reeks of the putrid smell. When I get the right consistency, I paint it onto the raw canvas with a wide brush, and when it's dry I apply two coats of white gesso on top of it."

"Vat about Pollock, de Kooning, and Kline, you know them?"

"Yes, I have a studio on Eighth Street and Third Avenue. I see them in the neighborhood and at the Cedar Bar."

There was a minute of silence, after which he said, "Ya, ya, your vork is good. You vill go to Yale."

As my father drove us back to the city, I stared out the car window, aglow with dreams of my future at Yale. The day I received the paperwork confirming my acceptance, I ran into the kitchen and blurted out the news to my mother. She turned away and grabbed a dishtowel. She was crying. I thought they were tears of joy, but they weren't. She was upset.

"Too much education spoils a girl's chance of getting married," she repeated for the umpteenth time.

On a crisp September morning, I left the squalor of the Bowery and the smoke-filled haze of the Cedar Bar to live and study in the ivy-covered halls of Yale University. I took one valise, two blankets, one pillow, my sketchbooks, assorted brushes, and a paint box loaded with tubes of oil paint. This was my first real time away from home. I was walking on air, bursting at the seams, living a miracle.

The sky was clear, autumn leaves rustled in the trees, and the air was so fresh, it smelled like change. I was far from home on a beautiful campus where much learning was offered. I meandered through the moss-covered walkways, grassy courtyards, and rich environment, relishing my first taste of freedom.

I wound my way through the campus and arrived at the art school on Chapel Street, ready to officially register. At that time, Yale was an all-male school with the exception of a few female graduate students like myself. The secretary asked me to fill out an official form. I was confronted with questions about race, religion, and sex. That was when I realized Yale had a quota system for Black people, Hispanics, and Jews. Clearly, I was white and female, but I was also Jewish. I left those questions blank and handed the forms back. The secretary insisted she could not admit me without my answering all of the questions. This was my personal protest; I refused. Taken aback, the secretary said she had to notify the president of Yale, who was in a distant building. This turned out to be a bigger problem than I expected. I nervously sat on a hard bench in the admissions office from 10:00 in the morning to 4:30 that afternoon, certain I had ruined my chances, certain I would be thrown out. I was upset with myself when a messenger arrived with a pink

slip granting me entry. "You can leave now," she said. I jumped up and bounded out the door overjoyed.

I felt different from the other students, and the difference was quite obvious. There weren't other young women strutting around in tight-fitting jeans, a black turtleneck sweater, and a leather bomber jacket in an all-male school. Yalies wore khaki pants, saddle shoes, and pastel sweaters casually tied around their shoulders. As I walked to my room, I noticed a group of Yalies playing a game of touch football on a quadrangle of muddy grass. One after another, they tumbled onto the grass, not caring how smeared with mud their expensive Shetland sweaters got. Who were these boys? They were certainly like none I had ever met.

A few weeks into the semester, a mysterious law was handed down forbidding women to wear jeans. Since I was the only woman on campus who wore them, I knew the administration meant me. It seemed ridiculous, so I ignored it and continued to walk the campus in my sexy button-fly denims. Albers wasn't much better. He wanted me to paint in a white smock like he did. He never got paint on his clothing. It would have been impossible for me to paint dressed like that, so I ignored his request as well as the official decree forbidding jeans.

The art students worked in a huge room that was subdivided into cubicles. Some of them were double-sized and meant to be shared. I chose to share a large corner studio, because its configurations allowed me to step back thirty feet. I needed the distance for my new technique, which was to load my brush with dripping paint and fling it across the room. The viscous paint would land on the canvas and leave a splatter that looked like a sunburst explosion. I was attempting to go further than my hero Jackson Pollock. I painted all day and used a special key to enter the building at night, where I worked until two in the morning. Life couldn't get better.

I spent the first half of the semester feverishly developing my new technique and finally felt ready to take the plunge. I mixed a fresh bucket of cadmium red and diluted it with a resin oil varnish. I stood twenty feet away and took my position, like a gladiator about to throw a spear. I was working on a large painting called *Abstract Force* and it was looking powerful. I didn't want to ruin it. The paint consistency had to be perfect and it had to land in the right place. I dipped my brush in the bucket, took aim, and flung it at the canvas. But the greasy brush handle slipped out of my hand, flew through the air like a missile, and punctured

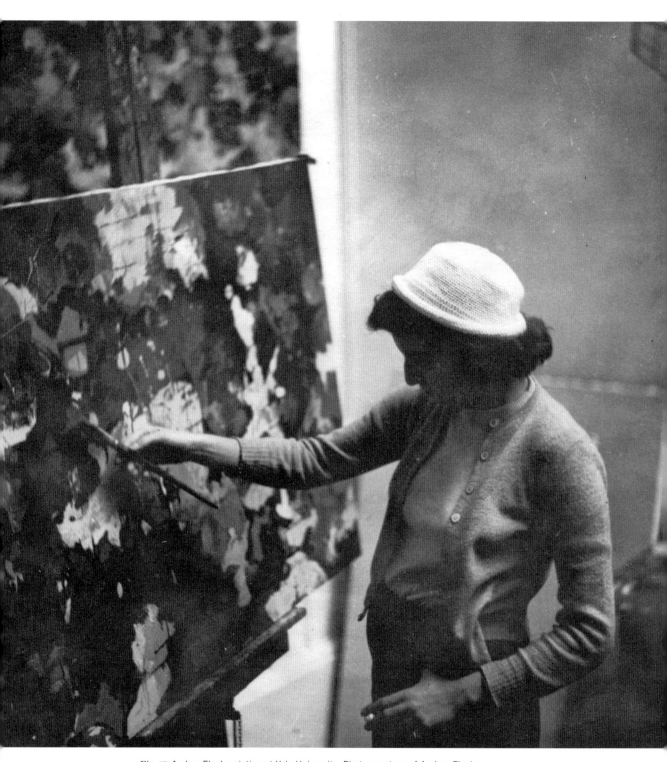

Fig. 17 Audrey Flack painting at Yale University. Photo courtesy of Audrey Flack.

a hole in the bottom of the canvas. I had harpooned my own painting. My studio partner laughed when he saw the brush sticking out of the painting. That painting, *Abstract Force (Homage to Franz Kline)*, still has the hole in the same exact spot. I did not want to repair it; the hole is part of the zeitgeist of the work.

Albers was a strict, rigid Bauhaus theoretician who wanted his students to paint squares like he did. While his squares were sophisticated and often exquisite in their understanding of color theory, I was not about to give up my freewheeling Abstract Expressionist techniques for tight-assed, geometric, flat graphic design.

I was developing ideas about space and depth that were to become my thesis at Yale. I wanted to define space by positioning colors in back and in front of a grid. So I ruled a grid of squares all over a blank canvas; it looked like a giant sheet of graph paper. Albers passed by, saw the gridded canvas, and got excited, thinking I had converted to his style of abstraction.

"Ah ha, sqvares," he said. He pulled over a chair, sat down, and patted the seat next to him. "Come, sit."

He began a discourse on the importance of the square. At that time Albers was working on his *Homage to the Square* series. I listened to his explication of Bauhaus doctrine and wondered how I could resist this powerful man and keep my individuality without getting kicked out.

But I was having a hard time concentrating, because he was sitting too close. I was about to get up when I felt his hand on my knee. He kept it there as he gestured at the painting. He's just being friendly, I told myself; this is Yale; this is not happening. Still looking straight ahead, he let his hand slowly creep up my thigh. I was used to this kind of behavior at Cooper Union. Those teachers were artists who drank, wore paint-stained jeans, and lived life without restraint. But Albers wore white suits and represented a movement that was contained, strict, ordered, and controlled.

Albers never took his eyes off the canvas while his hand made its way up my thigh until his fingers reached between my legs. Reality registered and I jumped up, accidentally knocking over the chair. I stood there, shocked and silent. Albers quietly left. I never spoke to him again. Underneath the venerable exterior, Josef Albers was just like the rest of them.

The next time he visited my studio I stood near the door. We didn't speak, but I was aware of his presence and felt his sharp critical eye on my back. Several times I caught him glancing at my work from afar. I

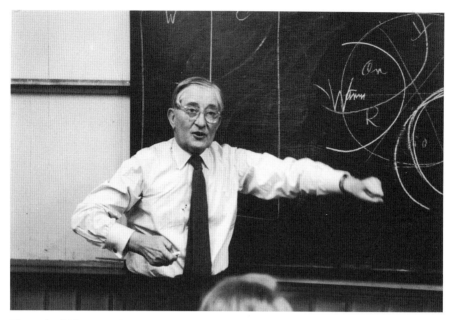

Fig. 18 Josef Albers teaching at Yale University, 1955–56. Photo: John Cohen. Courtesy of the Josef and Anni Albers Foundation.

knew I had to meet his standards even if I wouldn't follow his rigid rules. I also knew I was required to revolutionize the school, and I did that for him. To his credit he allowed me to work without interference and continued my partial scholarship, for which I was grateful.

Albers did not allow life drawing, and anatomy, representational art, and specifically figuration were "verboten." Life drawing taught at Cooper Union had been more expressionist-oriented and lacked the discipline and depth of a more academic approach. My urge to pursue the techniques of the masters persisted. I copied Tintoretto, Raphael, Rembrandt, and Michelangelo in my dorm room, spending hours rendering figures in terracotta Prismacolor pencil, while during the day I would toss paint, drip, and splatter. It wasn't until after graduation that I was able to fulfill my lifelong ambition and study anatomy at the Art Students League with Robert Beverly Hale.

Yale offered brilliant art history and aesthetic courses. I signed up for as many as I could: Renaissance art with the great Charles Seymour Jr., Impressionism and Modernism with George Heard Hamilton, aesthetics with Timothy Green, and iconography of the Bible with Alice Elizabeth Chase. She was the only woman teacher I had. Her course inspired in me a love of iconography that I use to this day.

By the end of the year, we knew that Albers's experiment had worked. The school was radicalized. There was a buzz of activity in the air. Albers had succeeded in converting the students to Modernism. My paint slinging had worked; it loosened the atmosphere, stirring excitement. Albers regained control and went on to establish a powerful and impressive art school.

After graduation I packed up my paintings, drawings, and watercolors and brought them home to our small Washington Heights apartment. I stacked them against the walls, in closets, and under my bed. My work filled the apartment, and my mother became irritated.

"How many paintings do you need, fifty, sixty, one hundred? Name a number, then stop!"

She had no concept of art as a way of life.

I needed to move out and I needed a job. The only thing I was prepared to do was teach, but university teaching positions were nearly impossible to come by, especially for women. So I took a series of repellent office jobs. I was a typist in an insurance company on Wall Street and then a Dictaphone operator in the Berlin and Jones envelope factory in the Starrett-Lehigh building on Twenty-Sixth Street. I sat at a tiny desk next to a huge glue applicator machine whose jaws continuously opened and closed as it applied snotty yellow gum to the edges of envelopes.

I worked for an obsessive-compulsive accountant in an income tax office, where I sat at a desk with a gooseneck lamp and added up numbers all day, pages and pages of numbers stacked in never-ending columns. It didn't seem important to me if there were discrepancies; after all, I explained, it was only a few pennies or a couple of dollars in question. The accountant thought I was being a smart-ass. It blew a fuse in his rigid brain and triggered a spasm in his heart. He turned purple, clutched his chest, and fired me as the paramedics carried him away on a stretcher.

Of course, I was fired from every one of those jobs.

Things improved when I took a job painting pink and red roses on "Gone With the Wind" hurricane-style glass lampshades in a dilapidated wooden building in Astoria, Queens. A real firetrap, I thought, as I lined six of them up at a time and painted petal after petal. I had to work fast, daubing short strokes of white into the wet red paint to create the illusion of fresh pink petals. When I finished painting the flowers, buds, and leaves, I had to wire the lamps.

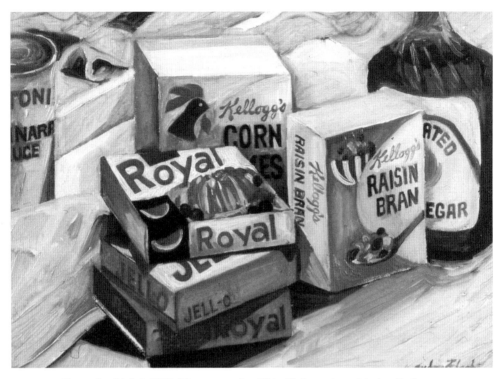

Fig. 19 *Royal Jell-O*, 1962. Oil on canvas, 9 × 12 in. Photo courtesy of Audrey Flack.

Except for me, all of the factory workers were Mexican immigrants who spoke only a few words of broken English. I knew enough Spanish to chat with them during our half-hour lunch break and find out that they were being unconscionably cheated. They were all being paid far below the legal minimum wage. I explained their rights, but they were poor, frightened, and didn't know what to do, so I called the authorities. Shortly after that, a government official showed up at the factory, inspected the books, and ordered the company to pay everyone minimum wage.

At the next payday, they opened their envelopes and were thrilled with their bit of extra money. I opened my envelope and found a pink slip. I had been fired. On the day of my departure, a group of Mexican workers handed me a cupcake as a token of gratitude. I packed up my brushes and waved goodbye.

Next, I designed toy box covers for the Ideal Toy Company. It was better than the lampshade factory—I worked in a real office building in downtown Manhattan—but it was not well paid, and I felt extremely pressured. I illustrated box after box until I had to draw a boy smiling while he dropped a bomb on a city below. I was tired of illustrating

toys; this was a good excuse to quit. I found a job at a small advertising agency where I helped design the new Royal gelatin box. I did a painting of that box years later.

But when Phil Pearlstein, a noted Realist painter, called and said he was leaving his job doing layouts and paste-ups for the famous designer Ladislav Sutnar and offered it to me, I grabbed it. Sutnar was a high-level graphic artist. While I was with him I helped create the logo for Vera scarves, but the rest of the job was excruciatingly tight and exacting. I had to measure every line with a millimeter ruler, square every corner with a right angle, and draw with a 6H pencil. I was a free spirit used to moving paint around without restriction. I became frustrated, my work became looser, and Sutnar became exasperated. He fired me. It was annoying to be fired, but it was all part of the adventure. I was young and independent. What I really cared about was art, artists, the world, and the people in it. These jobs allowed me to survive and would hopefully be only a temporary phase on my way to becoming an exhibiting full-time artist.

Galleries,
Studios,
and Other
Players

A year had gone by since I stopped painting. On another chilly November afternoon—this time in 1984—I sat on the Broadway bench wearing my old, beat-up brown leather jacket. I silently drifted back to when there were only three major galleries exhibiting Ab Ex: Sidney Janis, Samuel Kootz, and Charles Egan. Betty Parsons opened later. I got to know Sidney Janis and Charlie Egan while I was a student at Cooper Union writing art columns for *The Pioneer*, the school newspaper.

Sidney Janis's Gallery

The Sidney Janis Gallery was the most prestigious, located on East Fifty-Seventh Street. It opened in 1948 and quickly became a beacon for New York's avant-garde artists, especially the new Abstract Expressionist painters. It was elegant yet welcoming and accessible, with two comfortable brown leather armchairs resting against the back wall. I eased myself into one of them and noted how effortlessly my rough denim jeans slid against the smooth polished leather as I took notes and wrote reviews of the works on exhibit. I stayed far longer than necessary because I was thrilled to be so close to Sidney Janis and privy to

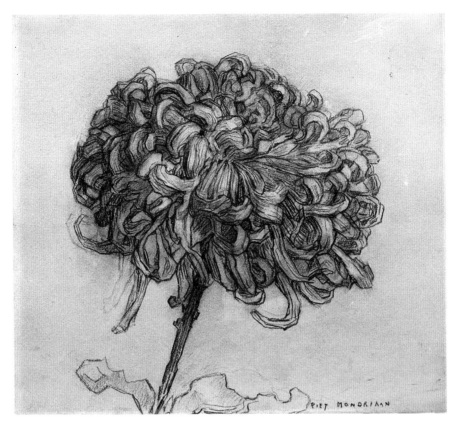

Fig. 20 Piet Mondrian, *Chrysanthemum*, ca. 1908–9. Charcoal on paper, 10 × 11²/₁₀ in. Photo courtesy of Audrey Flack.

the exciting art he exhibited, and Janis didn't seem to mind at all. Curious to get a glimpse into the secret world of high art, I craned my neck when Janis emerged from his inner sanctum, hoping to get a peek at his private showroom.

When the gallery was empty Janis would amble over, sit in the other brown leather chair, and chat. It was at one of those meetings that Janis asked me to interview Lisette Model, an Austrian-born American photographer who was to have the next show at the gallery. Diane Arbus had been one of her students.

Janis was a snappy, elegant dresser: crisp white shirt, stylish black suit, and floppy silk polka-dot bow tie. The soles of his shiny black leather shoes clicked, because he loved to dance and hurried off to the sleazy Roseland Ballroom on Fifty-Second Street after the gallery closed.

I was sitting cross-legged in the brown leather chair the day Piet Mondrian's *Chrysanthemum* arrived. Janis emerged from the back room all aglow and beckoned to me.

"Want to see something, Audrey?"

"Of course," I said excitedly.

"Follow me."

I traipsed behind him and was ushered into his private showroom, where masterpieces were displayed and deals were made. Mondrian's drawing was sitting on an easel, the likes of which I had never seen before—it looked like a small chair covered in gray velvet. The drawing cast an ethereal beauty over the entire chamber and exuded a radiance that caused me to gasp. I caught my breath and moved in close. The chrysanthemum was in full bloom, at the peak of its glory. Mondrian had analyzed every petal of this complex flower, deconstructing and reconstructing every angle and shadow, dark and light. This artist had achieved the sublime, and I inhaled it and let it directly into my very being.

A year or two had passed and I was making my usual round of galleries when Janis was hanging his first Jackson Pollock exhibition. Stanley Glowacki, a composer friend from Yale, was with me. *Number 11*, the largest and most dynamic painting in the exhibit, was already installed and pulled me toward it with such force that I couldn't speak. I obeyed the painting's command, walked up to it, and felt as if I had been slapped. I felt confused, upset, bowled over. I stood there awestruck.

I felt a well of anger rising up, anger at what the painting was doing to me. It took a few minutes to get over the shock and actually look at Pollock's sweeping arabesques of dripping paint. The entire canvas was a swirling galaxy. Jackson had broken the code. I was studying the dark vertical lines, not sure what to make of them, when Janis walked over.

"What do you think, Audrey?"

For a moment I was speechless; the work was so powerful I couldn't talk. I hated it; I loved it. It stunned me. After a few moments I answered, "It's wild! Actually, I think it's great!"

But then I blurted out, "I don't like number names for paintings."

"Neither do I. Do you have a better title?"

"I don't know, but all of those vertical poles dominate the canvas.... Maybe it should be called *Vertical Poles* or *Black Poles*." But then I noticed that Jackson had mixed ultramarine and thalo blue with the black and said, "*Blue Poles* would be better."

Maybe Janis was teasing me, maybe not. He may have already thought of the name, but soon after our encounter, *Number 11* was retitled *Blue Poles*. Stanley insisted that I named it.

Unlike the impressive Janis and Kootz galleries, the Charles Egan gallery was a stark and empty room on the fifth floor of a narrow building squeezed into 63 East Fifty-Seventh Street. The gallery walls blazed stark white to call attention to nothing but the art, and Egan could always be found sitting slouched in a slatted wooden chair in the far corner of the room, staring at the door. Unlike the moneyed Janis, Charlie Egan was basically broke, but he exhibited the Ab Ex artists long before Janis came on the scene. They were his friends from the Waldorf Cafeteria. Isamu Noguchi installed the lighting. Bill de Kooning and Franz Kline helped paint the gallery.

The gallery elevator was so small it could barely hold two passengers besides the elevator operator, who was a painfully thin, gray-haired, Black man who cranked the iron handle back and forth until the ancient machine hiccupped its way up to the fifth floor. In order to exit the stifling space, you had to wait for him to open the scissor gates with his one black leather glove.

I showed up one day and spotted Egan sitting across the room, slumped in his stiff chair, his legs stretched out before him.

"Hey, Audrey, come here. Sit here and watch the gallery."

Egan left and didn't come back, leaving me alone with an exhibition of magical Joseph Cornell boxes. He probably went for a drink. I guarded the gallery for the rest of the afternoon, during which time only one or two visitors came. I struggled until closing time, resisting the urge to steal one of the boxes. Later, Egan moved to a large new space in the Fuller Building at 41 East Fifty-Seventh Street, and he exhibited the works of de Kooning, Noguchi, Kline, and Philip Guston.

Charlie Egan launched de Kooning's career by giving him his first solo show in 1948. De Kooning was forty-four years old and had been struggling in New York for over two decades. Perhaps Charlie did so because of his long-lasting affair with Elaine de Kooning. But Egan believed in de Kooning's work and continued to show him. The rumor around the art world was that whenever a work sold, Egan squandered the money and couldn't pay his artists, so one by one they left him. De Kooning was lured away by Sidney Janis.

Egan, Janis, Kootz, Betty Parsons, and Pierre Matisse were located on the opulent Fifty-Seventh Street and run by wealthy art dealers. They

Fig. 21 Assembled artists on East Tenth Street in front of the Tanager Gallery, 1956. Photo: James Burke / The LIFE Pictures Collection / Shutterstock.com.

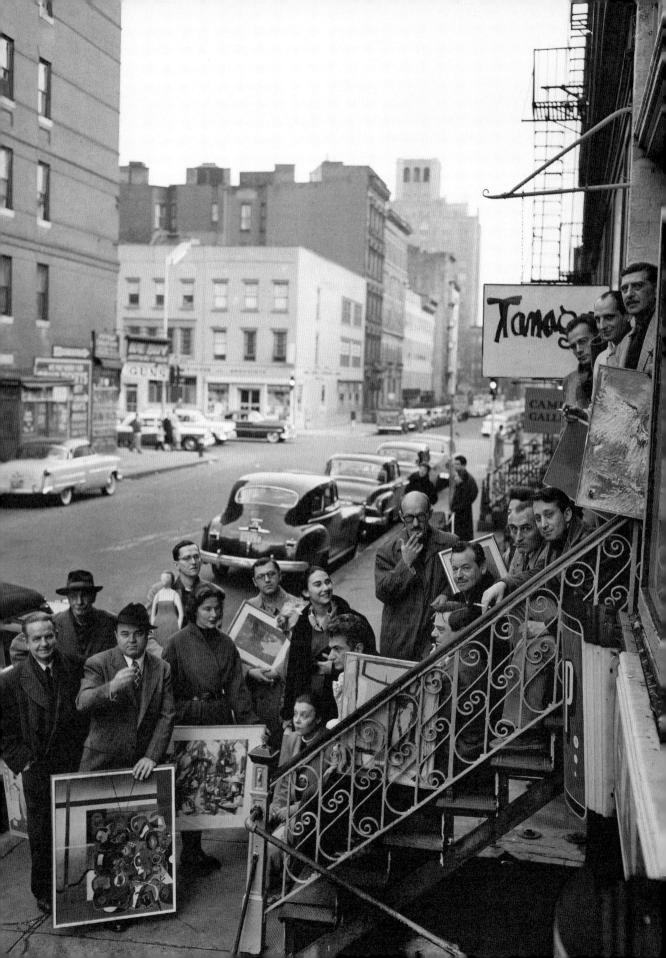

only showed well-known, established artists; there was no place for up-and-coming young artists to exhibit, and the Lower East Side was teeming with them. Desperate to exhibit their work, small groups of artists formed their own collective spaces. One after another, co-op galleries started to spring up on Tenth Street next to the artists' studios.

The Tanager

The Tanager Gallery was the first and most prestigious to break ground in 1952. The founding members chipped in enough money to rent a modest one-room storefront space at 90 East Tenth Street, between Third and Fourth Avenues, right next door to de Kooning's studio. The entire area was filled with hardware stores, plumbing supply shops, pawnbrokers, and decrepit tenement buildings. But the Tanager had installed a glass door, and the walls and ceiling were painted fresh, stark white. It glowed. Finally, young artists had a place to exhibit. The Tanager was soon followed by the Camino, Brata, Hansa, and March galleries.

Monthly dues were collected to pay for the rent and the gallon jugs of cheap wine for the openings. Track lights were installed, and cracks and holes in the pitted walls were plastered and painted white. The stark, clean spaces served as honest, uncluttered showcases for serious work. Members took turns sitting at a small desk near the door and handling an occasional sale. At one point, Irving Sandler ran the Tanager. He could always be found leaning against the front door, pad in hand, jotting down notes. He was a chronicler and later became a critic, art historian, and author. Sandler wrote a book on the Abstract Expressionists but refused to mention any women. This infuriated many artists, especially Elaine and Bill de Kooning. To Irv's credit, over the years he relented and in 2015 wrote an introduction for the catalog of my Abstract Expressionist exhibition at the Hollis Taggart gallery.

The Tanager exhibited Phil Pearlstein, Charles Cajori, Sidney Geist, Lois Dodd, Bill King, Angelo Ippolito, Alice Neel, Elaine de Kooning, Alex Katz, and many others.

Tuesday-night openings were like giant block parties, with every artist in the city milling around, blocking the streets, and filling the sidewalks, sipping wine in plastic cups and munching on salted Planters peanuts. It was a silent agreement that Tuesday night belonged to the artists. Cars and trucks automatically rerouted themselves. Tenth Street was ours. You could find Bill and Elaine de Kooning, Phil Pearlstein,

Alex Katz, Allan Kaprow, Wolf Kahn, Philip Guston, Milton Resnick, Pat Passlof, Rudy Burckhardt, Yvonne Jacquette, George Segal, Jan Muller, and hundreds of others, socializing and exchanging ideas.

The Stable Gallery

Around 1954, a group of Abstract Expressionists decided to put on a large group exhibition at the Stable Gallery. (The gallery got the name because it had formerly been a stable for horses, located near Central Park between Fifty-Seventh and Fifty-Eighth Streets and Seventh Avenue.) They called it the *Stable Annual*, and it was strictly for Abstract Expressionist painters. Nick Marsicano recommended my work, and I was thrilled to be invited to participate in the 1956 Annual. These artists hated any work with figurative content, and I was just beginning to introduce figuration into my paintings. My new painting *Lady with a Pink* was based in Ab Ex, but you could easily make out her features and figure. I decided to take a chance, break the code, and show it.

I was overjoyed to see it hanging in a prominent spot on the first floor, between Lee Krasner and Milton Avery. After several days, the dreaded figurative painting was spotted, and it was relegated to a dark corner on the second floor. It was the only figurative work in the 1956 *Stable Annual*. After sixty-six years in my studio storage closet, *Lady with a Pink* has reawakened and is now in the collection of the Smithsonian American Art Museum.

In 1957, the Tanager invited me to show several of my paintings in a group show. Artists were getting frustrated about the domination of Abstract Expressionism, and representation was moving in. So I had no trouble showing my new still life paintings. I was studying Cézanne and his complex fracturing of light and also Franz Kline's ability to turn black and white paint into dynamic positive and negative forces. One of my paintings, *Chrysanthemums & Rose*, had echoes of both these artists.

A buzz went around when Kline showed up at the Tanager. Artists greeted him respectfully, and some followed him in as he entered the gallery. He scanned the room and after a few minutes made his way over to *Chrysanthemums & Rose*. Intrigued by Franz's "black and white" paintings, I had been moved to explore the incredible variety of subtle differences between flake, ivory, lead, and titanium white as well as ivory, mars, and lamp black. I infused them with color by mixing blue-whites, yellow-whites, blue-blacks, brown-blacks, and so on, so that while the

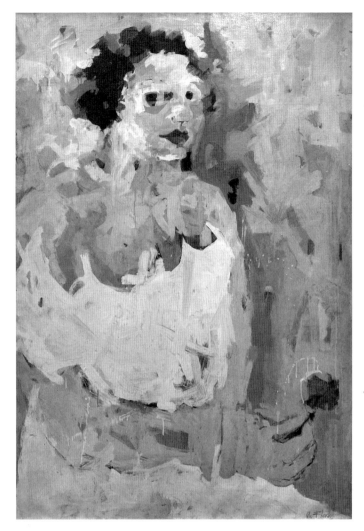

Fig. 22 Lady with a Pink, 1952. Oil on canvas, 49 × 33 in. Photo courtesy of Audrey Flack.

painting was officially black and white, it was rich and rife with subtle overtones of color.

I sidled up to Kline and waited for his reaction. He said nothing, yet he didn't walk away; he kept looking. After a while I couldn't help myself. "What do you think, Franz?"

He turned to me and said in a very soft voice, "Audrey, that painting is damned good . . . really good!"

My spirits soared. At a time when artists were discussing and evaluating each other's work, approval from a respected master meant more than the words of any critic or collector.

A few months later I was sitting next to him at the Cedar Bar. We chatted for a while and I decided to come out with it, to ask him a

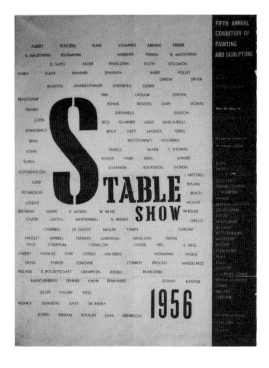

Fig. 23 1956 *Stable Annual* poster. Photo courtesy of Audrey Flack.

question I had been wanting to ask for a long time: "Franz, have you thought about using color?"

He stared at me, gulped down the rest of his scotch, and said, "Maybe yellow."

Ruth Kligman and the Big Sale

Still unable to paint, I walked to Broadway, as was my usual routine. My feet were on autopilot, having made the same trip so many times before. That January morning in 1985, Bob was already at work, my children no longer lived at home, and I was back on my usual spot. I thought about being a wife and mother. Without painting, would I lose the title of artist? Would I lose my identity?

I knew the trajectory of my life was to make great art and find a way to show it, but back then, there were few places for young artists to exhibit. All of us scrambled just to get seen. We entered competitions, went to fly-by-night, hole-in-the-wall galleries, and sought out co-ops on the Lower East Side. It followed that when the City Center, the most

prestigious performing arts venue in New York, opened a new gallery and announced a juried competition, I immediately submitted my work. The internet did not exist then, nor did slide transparencies. Artists had to deliver their paintings by hand, so I wrapped up two of my best works and got them to the designated site. A month passed before I was notified that they were accepted. I was elated.

The City Center Gallery was nothing more than a long, narrow vestibule where people smoked during intermission, but it was the closest to the big time that I had come. Artists have no control over where their work is hung in a juried show, and your worst fear is that it will be hidden in a dark corner and poorly lit. On the opening night, I was thrilled to see my paintings hanging on a center wall of the gallery and brilliantly lit. During the fifteen-minute intermission, theatergoers, mostly smokers, jammed into the narrow space and quickly puffed on their cigarettes before the curtain bell sounded. A few looked at the paintings.

The following week, a review by Emily Genauer, chief art critic for the *New York Herald Tribune*, appeared in the Sunday paper. Much to my amazement, Genauer singled out my work with a terrific review. A young woman named Ruth Kligman read that review and telephoned me the next morning.

"I'm the assistant director of the Collectors Gallery. I read the *New York Tribune* review and want to see your work."

At that point, I had never heard of Ruth Kligman or her gallery. But this was an opportunity to exhibit, so I gave her my address and set a time for her visit the next day.

Ruth clopped up the five flights in her high-heeled shoes and waltzed into my Chelsea apartment looking like a 1950s Hollywood starlet: bright red lip-smacking lipstick, white-rimmed sunglasses, sexy low-cut polyester polka dot blouse (showing full cleavage), and a tight-fitting black rayon skirt. Her beauty was astonishing, her presence overpowering, and her musky sexuality literally reeked.

Ruth sat down, crossed her legs, and explained her mission. She was curating a show for the Collectors Gallery, which was located on Fifty-Eighth Street, only one block from Fifty-Seventh Street, where all of the major galleries were located. But I knew better; even if the Collectors Gallery was around the corner, it might as well have been in Alaska, because no one knew about it and no one went there.

Still, it was a place to exhibit. I showed Ruth my latest paintings, and she examined them with great care and intensity. Ruth had "a good

eye," which meant that she recognized a good painting when she saw one. She stood up and moved her hands about as she began rhapsodizing about the merits of my work. It was as if I wasn't there—or as if I were a collector she was convincing to buy the work. Her discourse on my use of color, composition, and content wove a spell and mesmerized even me. Later she would do the same with Jackson Pollock. She was a seductress, a muse, a spinmeister.

The gallery took up the parlor floor of a beat-up brownstone with a scratched plate-glass window facing the street. If you strained your neck, you could get a glimpse of one or two paintings displayed on the inside wall. Years later, the owner, David Greer, would open a new and impressive gallery on Fifty-Third Street, a few doors down from the Museum of Modern Art, but back then the Collectors Gallery was stuck on a side street, and Ruth used all of her contacts and crafty ways to bring people in. Having just moved to Manhattan from New Jersey, she knew little of the New York art scene.

"Teach me," she said, and I did.

I took her to galleries and told her about the new movement called Abstract Expressionism. She was eager to learn. I explained its philosophies, belief systems, and methods of painting. She wanted to know who the artists were, where they lived and congregated.

"What are their names, and who is the most important one?" she asked.

I thought about it for a minute. I loved Bill de Kooning and Franz Kline, but Pollock was the star, the wild one who broke all the rules and created magic.

"Jackson Pollock, without a doubt!"

"Who else?"

"Willem de Kooning, then Franz Kline."

"In that order?"

"Yes, in that order; Pollock is first."

"Where can I meet him?"

"They congregate at the Cedar Bar."

"Take me there, introduce me."

Ruth was not only ambitious; she was ruthless, determined to inveigle her way into the inner circle of art stars and climb to the top of the ladder.

"Let's go tonight." She batted her eyelashes and gave me the come-on.

"No, Ruth, I'm through with that part of my life, but I'll give you directions. Jackson usually sits at the far end of the bar."

After my last encounter with Jackson I had vowed never to go to the Cedar Bar again, but I was not going to tell Ruth about it. Ruth was unsure about getting there, so I drew a map for her. I even walked her down the five flights of stairs and pointed her in the right direction.

"Walk east, past Seventh and Sixth Ave., and when you get to Fifth Avenue, turn right and head downtown 'til you get to Eleventh Street. The bar is on the right. Got it?"

"Yup, buh-bye." She waved goodbye with the map in her hand and sauntered down Twenty-First Street, headed for her destiny.

I heard that Ruth shimmied into the Cedar Bar looking like a Rita Hayworth double; busty and flirty, her thick black hair bouncing with every step she took. Every head turned to follow her rotating, curvy hips as she perambulated past the crowded bar to where Jackson was sitting alone at the very end, exactly where I said he would be. Her moment had arrived. Ruth caught his eye, smiled, and ambled over to him. Her incredible beauty and flirtatious manner worked instantly. She'd hit him at the right time. He was weak, vulnerable, depressed, drunk, and disillusioned.

At that instant, Ruth Kligman became Jackson Pollock's girlfriend. I often wondered how she could have kissed his alcohol-soaked mouth or made love to his debilitated body. Soon she became a notorious figure in the New York art scene.

On the opening night of my exhibition at the Collectors Gallery, Ruth delivered: she sold one of my paintings to Marcel Marceau, the French mime, for 500 dollars. I was twenty-five years old and had just made the biggest sale of my life. Even though the gallery took half as its commission, it was still a 250-dollar bonanza. Suddenly I could afford a ticket to Europe. I could see all the paintings I had studied in art history classes and pored over in books.

I booked passage on the *Castel Felice*, a crotchety old cargo ship that took on a few passengers and slowly chugged its way across the ocean, dropping off cargo before reaching its final destination, the port of Le Havre, France. The fare was so cheap that I had enough money left for food and lodging for most of the summer as well as a return trip home. While I was away, Ruth quickly climbed her infamous ladder and ensnared Jackson, who by this time was smitten.

After a few weeks of living together and socializing, he couldn't stand her cheap outfits and spent a good deal of money clothing her in stylish, tasteful jackets and silk dresses. Jackson liked the idea of a beautiful woman on his arm instead of his homely wife. Ruth fed him unrealistic fantasies of everlasting fairytale love, and his badly damaged soul ate it up. She created a perfect storm for the tragedy that was to come.

That was the summer Ruth slept with Jackson in the house while Lee was there—the same summer Lee left for Paris in a despondent rage. That same summer, Alfonso Ossorio gave a fabulous party, and Ruth desperately wanted to go. She persuaded Jackson to attend and invited her friend Edith Metzger to come along; they would all go together.

The two women arrived at the East Hampton train station with overnight luggage, and the first thing they saw was Jackson brooding in his 1950s green Oldsmobile convertible, angry-faced and drunk. The timid Edith was reluctant to get in the car, but Ruth convinced her to go against her better judgment. Luckily, nothing happened on the way to Lee and Jackson's house, but the stage was set. Later that evening, Ruth slipped into a low-cut dress and they all headed for Ossorio's. Jackson was behind the wheel, Ruth sat next to him, and Edith was in the back seat. Neither of the women could drive.

Jackson was drunk and driving erratically. Edith pleaded to get out, but Ruth told her to be quiet, saying that she was upsetting him. Nothing would stop Jackson from meeting his suicidal destiny. The car swerved and crashed head-on into a tree. Death came instantly to Jackson and poor Edith, but Ruth was the lucky one: she lay there with a broken pelvis, ribs, and cracked bones until the volunteer ambulance arrived. I was only a few roads away from the accident, living in a small shack on Neck Path.

News traveled fast that night, and I was left with a feeling of enormous, tragic loss, a feeling that was shared by the entire art community. Miraculously, Ruth survived the horrible event and, in typical Ruth fashion, went on to further infamy. As was her plan, she became lover and mistress to William de Kooning and then to Franz Kline, in the exact order I had written down for her on that fateful night in Chelsea.

I would not see Ruth again until 1977. I was visiting my friend Robert Birmelin's studio on Fourteenth Street and Seventh Avenue and remembered that Ruth was living down the block in Franz Kline's studio. (She had taken it over after he died.) We had not spoken for several

years, and I thought it would be interesting to reconnect. I dialed the number. Ruth answered.

"It's Audrey. I'm one avenue away on Fourteenth Street. Would you like a visit?"

"It's been far too long. Come on over, I'll get dressed."

Twenty minutes later, I walked up the rusty metal steps of a commercial brownstone where Franz had lived and worked. It was the parlor floor, and Franz had draped a large bedsheet over the glass storefront window for privacy. I rang the bell and waited. When there was no response, I started back down the steps and then heard the door open. I turned around and was momentarily frozen in place by the sight of Ruth. Her face was puffy, and her lush, bouncy hair was brittle and dyed a harsh auburn red. She smiled and her teeth were even more of an eyesore; they were either artificially capped by an incompetent dentist or she was wearing a full set of dentures.

Ruth was wrapped in a short silk kimono and led me through the hallway to the kitchen, where she had prepared espresso. We chatted and tried to catch up, but I was always reserved around Ruth because I didn't trust her. She asked if I would like to see the rest of the loft, which of course I did. We walked toward the back, but something bizarre happened when we passed the bedroom. Ruth stopped in front of the bed, which was nothing but a simple mattress and box spring lying on the wooden floor. I was surprised by the lavender satin sheets and matching pillow cases. They were turned down and ready for use. Ruth smiled, untied her belt, dropped her silk kimono, and stood before me stark naked. Flabbergasted, I wondered if she was trying to seduce me. And if so, why?

It took a minute for me to regain my senses and say, "Pick up your kimono and tie your belt, Ruth."

With a coy smile, she obediently slipped on her robe and asked if I wanted to see her paintings. "Yes, of course," I said politely.

One by one she pulled out her rehashed Abstract Expressionist canvases that were mediocre at best. She stacked them against the wall and pointed to the ceiling.

"That's where I hide the painting Jackson gave me."

She pulled down a paisley Indian madras sheet revealing two wooden slats holding up the sacred canvas.

"Jackson's painting?"

"I'd show it to you but I need a ladder to take it down. But Audrey, I stood next to him and watched him paint it. It was a very joyous moment

for us both. Above all, it was an intensely personal gift from Jackson to me."

I silently fumed.

Years later I saw *Red, Black, and Silver* when Ruth tried to sell it, declaring that it was painted especially for her in 1956, shortly before Jackson died. An expert found bits of hair from a polar bear rug in the house, as well as strands of Jackson's hair, in the painting, and sand from where it was executed. Ruth used this to prove its authenticity.

To me it looked small and sad, with a few Pollock-like drips. The way I see it happening is that Ruth wanted her share of the spoils—at least a painting.

"C'mon, Jackson sweetie, make me a painting," I imagined her saying as she bared her legs and breasts.

And Jackson, in a drunken stupor, let her drag him out into the field, where she held his hand and guided it as he dripped paint over her canvas.

Ruth only knew Jackson for five months. It is amazing to realize the wreckage she left behind during that brief period of time.

The Jack Prince Studio

Ruth's sale of my painting brought me a summer of splendor and wonder. I carried my sketchbooks with me as I sailed back to New York on the *Castel Felice*. They were filled with watercolors and sketches of Old Master drawings, paintings, and other works of art I had seen. I was walking on air, my head up in the clouds.

Settling back into the city, I sold a painting here and there, but it wasn't enough to support myself. I needed a job. Earning a living through art—even commercial art—had been an improvement over office work. So I applied for a job as a freelance textile designer in the Jack Prince design studio.

Freelancing meant that I could work as many or as few hours as I wanted, as long as my designs sold. Jack Prince was a legend in the textile field, styling lines and setting trends for the top couturiers in the fashion industry. I set my portfolio on his desk and waited for his response.

"Well, darling, you have possibilities; I'll give you a try," he said, waving his pinky. "Show up tomorrow with your supplies and we'll see what happens."

I arrived at nine o'clock sharp with my Winsor & Newton sable brushes, tubes of watercolors, jars of tempera, a porcelain palette, and several sheets of hot-pressed Arches paper.

"Sit there." He pointed to a drafting table between Joseph Raffael and Paul Thek. They were painters, too, and later became successful exhibiting artists. Paul's features—his sun-washed, long, silky hair and soulful eyes—were so beautiful I sometimes caught myself staring at him. There was a quietude, a sadness, and an inner power that cast an aura around him. I felt he was destined for greatness, and he was.

Paul was interested in a form of grotesque realism later referred to as his "meat pieces." He made startlingly realistic replicas of chunks of meat and sides of beef, with individual hairs embedded into the fatty part covering the flesh. The whole blood-soaked entity was painted with astonishing accuracy.

His famous meat pieces began with his plaster cast of my left index finger. Together, we painted the bone, blood, and sinews at the cut-off end. Paul placed the finger in a glass-covered butter dish. I loved it. He then made a beeswax version of my finger, but it seems to have disappeared. I looked for it in his retrospective at the Whitney Museum in November of 2010, but it wasn't there. Luckily, I kept the first trial casting in my own butter dish on my studio table. I drilled a hole and put a hook in the cut-off end so I could wear it as a necklace. It is now part of Robert Wilson's collection of Paul Thek's work at the Watermill Center in Bridgehampton.

The Jack Prince studio was near my father's factory in the Garment District. Situated on the fifteenth floor, it was surrounded by blue skies and clear natural light. Classical music wafted through the air as the studio artists strove to create original, beautiful textile designs. Our creations had to be beautiful: ugly ones didn't sell. We relied on the salespeople to present our work to large manufacturers. There was no salary; we had to sell to survive. The greatest thing about designing textiles was that it didn't drain me. I could paint when I got home.

I styled a line of paisleys, geometrics, florals, and Art Deco roses that became so popular they were reprinted in a variety of colors on every type of fabric. My designs were the first to be printed on terry cloth. They made millions for the manufacturers, but artists were not unionized; we were paid 64 dollars per design, 25 dollars per coloring, and 35 dollars for a repeat. There was no royalty.

Studio 54

The *Village Voice* was the best cultural newspaper in New York City. In the late 1970s, the newspaper held a contest for its readers to vote for their favorite contemporary artists. Philip Pearlstein and I won. The prize? A free VIP entry to Steve Rubell's Studio 54, the hottest multimedia nightclub in the world, the place to see and be seen—and almost impossible to get into. Freewheeling drug use and open sexual activity took place in the club balcony and private basement rooms, but Phil and I knew nothing of this at the time. Paparazzi clamored outside the entrance hoping to get a shot of Andy Warhol, Ultra Violet, Edie Sedgwick, Mick and Bianca Jagger, or any other of the stars who made appearances.

Philip and I had been friends throughout our professional careers. He was barely five feet tall and very shy. His voice was almost inaudible, so soft one had to lean close to hear it, but Phil didn't like anyone to get close to him. I telephoned him.

"Hey Phil, we're gonna have some fun."

"I don't want to go. Anyhow I can't dance."

"Oh, come on, Phil. I'll teach you."

After much cajoling, he agreed, and we arranged to meet at the front entrance. Phil was already waiting in back of an enormous crowd of groupies and onlookers shoving and pressing to get in or at least to catch a glimpse of the stars. A huge bouncer with biceps the size of grapefruits guarded the door while another parted the mass of jammed-together bodies to make way for the celebrities. Phil and I looked absolutely unnoticeable and unimportant. We held up our passes and pushed our way to the front of the line.

"Let's go home," Phil pleaded. "This is crazy."

"No way. We're halfway there."

Now that I was out of the house, I was intent on having some fun. Phil, who was half the size of the grapefruit-biceps bouncer, looked up at him and handed him our passes. The bouncer looked down at us with a smirk. I quickly explained how we had won the *Village Voice* contest and that these were real passes. He moved aside, opened the sacred door, and let us through. Phil wore his Sunday best: a beige corduroy

jacket, plaid shirt, and tie. I wore my tight jeans, black turtleneck top, and high-heeled patent leather shoes.

Studio 54's dance floor was three stories high. The bar area wrapped around the sides of the room, almost like the Guggenheim Museum's walkway. The place was dense with celebrities and so noisy it was hard to hear yourself talk. The beat of the pounding bass was so intense that it shook your heart and vibrated your body.

I saw a slightly less crowded spot and yelled in Phil's ear, "Let's go over there."

We circled the bar and spotted Andy Warhol backed against a wall, surrounded by a crowd of admirers. Andy had been Phil's roommate at Carnegie Tech, and we stopped to chat. Andy's white wig turned purple, red, yellow, and blue as the moving colored lights shifted.

Even in the dimly lit room, nothing escaped Andy's eyes. He immediately noticed my ring and lifted my hand to his face to get a closer look.

"Oh, how pretty," he said. "And it has a big A on it!"

It was a 1940s US Air Force insignia ring, with an Art Deco letter A inlaid in the center of a black and orange enamel circle.

"Hmmm . . . my initial," Andy murmured, fingering it. "Where did you get it?" he asked in his childlike voice.

"The Seventy-Seventh Street flea market. Do you like the Art Deco style?"

"I love it! Can I have it?"

He twiddled with my fingers gingerly, shifting his eyes between the ring and me. I was tempted to give it to him, but I had just gotten it and I liked it.

"It's my initial, too, Andy," I said. "Sorry, maybe later."

Disappointed, he retreated and was whisked off to another part of the club by his entourage.

"Let's dance," I said to Phil, pulling him onto the dance floor.

Mobs of people dressed to shock were gyrating to the disco beat. Music blasted through the loudspeakers with such force it thumped in our chests. Everyone was a star and everyone was beautiful. Girls wrapped in short miniskirts with transparent tops so sheer you could see their gorgeous breasts were dancing with handsome men in tight pants that bulged around the crotch. Some dancers wore nothing but thin, filmy fabric stretched tight over their bodies. Drag queens batting false eyelashes were decked out in sequined gowns and outlandish wigs as they made orgiastic movements with their bodies.

Phil refused to budge.

"I don't dance."

"No one is remotely interested in us, Phil."

I put my arm around his shoulder and gently moved him. Phil shifted sideways, back and forth, like the pendulum on a grandfather clock. After a while, he allowed me to move him into a stiff two-step.

But then he pulled away and whispered, "Audrey, I'm dizzy."

I got swept up by the beat and danced wildly by myself. Phil stood there watching me.

The mirror ball above our heads spun around, casting spotted squares of swirling colored light around the room. It fell on our cheeks and into our eyes and covered our bodies like a net embracing us. Blinding white strobe lights flashed on and off, keeping the fast-paced rhythmic beat of the amplified disco music.

"I can't take it, we have to go," Phil said.

Arm in arm, we edged our way through the crowd, out the door, and into the street, where we took a deep breath of fresh air. The silence felt good. Phil and I lived within blocks of each other and shared a cab back to the Upper West Side, where we retreated to our respective studios. But first I had to check on the kids.

Realists lived more stable lives than the Abstract Expressionists. We raised families and didn't drink excessively or take drugs; the nature of our work wouldn't permit it. If our hands shook or our brains were not clear, we couldn't paint. We needed precise control and rational thought in order to paint. I tiptoed into the bedroom, kissed Bob on the cheek, took off my party clothes, and went to the studio to work.

Chapter 4

Family
Stories

My Panties or My Art

From the age of five on, I was called "bad." Except for being labeled "bad," my hyperactive nature didn't bother me at all. I liked the excess energy and not needing much sleep gave me more time to make things and draw. I woke up every morning hours before school and wove patterned bead necklaces on my small wooden loom. I made rings, belts, bracelets, and lanyards, crocheted hats and scarves, and drew pictures on the walls of my bedroom as well as any piece of paper I could get my hands on. I was excited and happy until teachers began to scowl at me because I couldn't sit quietly with my hands clasped like the other children. I jumped, squirmed, fidgeted, talked, ran around, and learned differently. As a result, I was constantly reprimanded.

Teachers demanded that I control my body's physiology, but as hard as I tried, I couldn't. As punishment, I was yanked out of class and made to sit in the hallway alone. But one day, a miracle was handed to me in the form of an art assignment. We were to make a diorama, which is nothing more than a shoebox filled with paper cutouts. The minute I began to work on it, my synapses calmed and my world changed.

The teacher said we needed a theme. The boys chose sports idols like Babe Ruth and Joe DiMaggio. I chose Esther Williams, the Olympic

swimmer and star of Hollywood water ballet extravaganzas. Even at the age of five I was looking for a role model, and it certainly wasn't the overweight matriarchs of Washington Heights. None of them worked and none of them exercised; it wasn't in style for women then. Charles Atlas's ads for his muscle-building gyms showed men with ripped abdominals and bulging biceps. I liked those strong, sexy bodies, but gyms were strictly for men. I was an athlete; I wanted a strong body. Esther Williams was perfect.

The first time I saw her was in the children's section of the Loews 175th Street movie theater. She stood at the edge of a fifty-foot diving board. Her body was arched, taut as a steel guitar string, and her arms were stretched high above her head. She was shrink-wrapped in a bathing suit so tight that every muscle rippled. The cameraman zoomed in on her perfectly formed half-grapefruit breasts. Nothing flopping around or hanging down there—just sheer perfection.

Silhouetted against a Technicolor-blue sky, she flew into the air like a magnificent bird, performing jackknifes, somersaults, twists, and backflips. Her sleek body sliced through the water and disappeared beneath the surface without a splash. I held my breath until I saw her shoot up like a geyser and smile at me, her dazzling white teeth sparkling like little stars. Her oiled muscles glistened with beads of water that never moved—nor did the purple orchid tucked behind her ear.

She was a goddess, an icon of the water, a female Poseidon who would come to life years later in the *Civitas* statues I created for the gateway to Rock Hill, South Carolina. She was beautiful; she was strong; she was my hero.

The diorama needed more than one solitary figure, so I cut out two Hawaiian hula dancers and three coconut palm trees, gluing them down with sticky white jar paste. My mother's blue-tinted makeup mirror became the ocean, and a cup of sand scooped from the park sandbox became the beach. As I sited each figure in space, the diorama came alive with the look of a miniature stage set. This was my first work of art; I had entered the zone, the artist's path to the sublime, and it was magical. I had wanted to create something super-real, and here it was!

The process of creating transported me out of the profane world into the ethereal world of art. I had feelings unlike any I had ever known. I lost track of time and even forgot that I was in school; everything around me dissolved as I merged with the work. Worries about my family, my hyperactive behavior, my poor grades, and being "bad" disappeared.

My reflexes were calmed, my ragged synapses smoothed, and I could concentrate. Something inside me changed. I entered a timeless space where everything made sense and life became a wonder. Art does that. It can save your life.

It didn't take long for me to become the class artist. Turkeys, pumpkins, Christmas trees, candy canes, American flags, Valentine hearts: I drew them all. The teacher assigned these projects to keep me from fidgeting, talking, giggling, and disrupting the class. I made an illustrated calendar for the class, and the memory of that calendar returned years later to become a symbolic element in my painting of Marilyn Monroe.

Art was my friend. My sketchbook was my ever-present companion. I was no longer alone. I belonged to a subgroup of humans called artists. I didn't know any of them, but I knew I belonged. I could put

a pencil on paper and create an image that looked real, and that act of drawing thrilled me. I was determined to understand the process. I tried to deconstruct the thinking behind the creative act.

Exactly how did an image get onto the paper? First my eyes had to focus on an object. Then my brain had to analyze it and break it down into something two-dimensional, an encrypted message that could be sent along the length of my arm into my pencil, where it would mark the paper with lines, tonal shadows, and highlights. Then, like magic, an image would appear.

I thought artists were gods who could create and capture life. That's what I wanted to do, and that's how it all began. A giant "A" had been imprinted early on: "A" for artist, "A" for Audrey. Like Hester Prynne in *The Scarlet Letter*, I had been branded. For her it was a sin. For me it was redemption.

School let out at three o'clock, and mothers waited outside chatting. P.S. 173 is a five-story Georgian brick building that takes up a whole block from 173rd to 174th Street on Fort Washington Avenue. Because it is so close to the Hudson River, sudden gusts of wind could literally pick up a child and blow her down the street. I was blown close to a car once. Luckily, the driver stopped short before he hit me.

I tumbled out of the double doors along with my classmates, clutching my precious Esther Williams diorama tightly under my arm. I searched the crowd for my mother, who was invariably late. I stood there and watched the loving exchanges between mothers and their children—the kisses, the touch of the hands—and felt pangs of jealousy. Those feelings were reawakened years later at the High School of Music & Art when I saw a postcard of a Mary Cassatt painting tacked up on a bulletin board. Cassatt had brilliantly captured the loving touch of a mother toward her child, and I instantly responded. Had she herself been deprived? (Ironically, Cassatt never married or had children.)

My mother was into high-stakes gambling and couldn't wrench herself away from ongoing poker games. These games could go on for days. There were times she didn't come home at all. Because gambling was illegal then, games were held in private gambling dens and could go on well into the night. The address was kept secret for fear of police raids. We never knew where she was or when she would come home. She was arrested and jailed several times.

She participated in all-nighters that lasted for several days in a row. Gamblers were served food, liquor, and strong black coffee to keep their

adrenaline pumping, and when they got heavy-lidded and bleary-eyed, they could catch a few winks on a sofa or easy chair before resuming play.

I observed my friends being warmly greeted and led home to afternoon snacks of milk and cookies. One by one they left, and I remained on the street, smiling to cover up my embarrassment and anxiety. I craned my neck in all directions, hoping to catch a glimpse of her.

A storm was flaring up, and strong westerly winds were gathering strength as they rolled in from New Jersey. Autumn leaves swirled in corners like miniature tornadoes, making crisp, crackling sounds as they rustled against the red brick building. I became mesmerized by the spiraling leaves and for a few moments forgot about the storm. Suddenly, the sky darkened. Claps of thunder boomed, bringing with them low-lying clouds that cast foreboding shadows on the people below. Raindrops were coming along with the wind, and I began to worry about my diorama. I wrapped my arms around the box, hoping to shield it from the rain. By now the school gates were locked shut. I had no place to go.

The few mothers left said their goodbyes, took hold of their children, and hurried home before the storm hit. The bristling, turbulent winds picked up speed and swirled around me making loud whistling noises. The atmospheric pressure plummeted and turned the sky into a grayish yellow.

I heard a snap. It was the elastic on my panties. I felt them sliding down my legs. I grabbed one side while holding onto the diorama with my other hand. I peered into the box; Esther Williams was wobbling and the dancers were shaking frantically when another blast of wind snatched Esther away. I gasped in horror as she sailed through the air, wafted around in circles, and landed in a puddle of dirty street water. Esther floated for a few seconds until a raindrop hit her belly. Then she curled up and sank.

"She drowned," I moaned.

I held tight to my drooping panties, afraid of having my naked bottom and pubis exposed on Fort Washington Avenue, but I would not let go of the diorama.

Should I drop my panties and save my diorama or let go of my diorama and hold up my panties? The conundrum repeated itself over and over.

My panties or my art? My panties or my art?

I looked up and saw my mother hurrying toward me, her hat cocked to one side, out of breath and conjuring up a newly invented excuse.

By then the box was crushed, most of the cutouts had blown away, and my panties hung limply around one thigh. I doubt that she noticed my bedraggled condition or sensed my distraught feelings. She was in her own world, the world of the compulsive gambler, and I was already in mine, the world of art.

Still, there was a great lesson to be learned from this childhood trauma. It was in effect a morality tale whose point held true for the rest of my life: "I never dropped my panties for my art!"

Death and Poker

The February air was crisp and breezy. It was 1985, and I was still sitting on the bench, deep in my subconscious, when the memory of my father's death hit me. It happened on September 17, 1957.

One week before that fateful day, my father had invited me to lunch. This had never happened before. The family went out together for Chinese food on Sundays or to Al's Italian Diner for special occasions, but no one ever had lunch alone with my father. We agreed on a small Italian restaurant near his factory.

Thirty-Ninth Street between Eighth and Ninth Avenues was a hub of excitement. You could almost get run over by the wooden pushcart trolleys filled to the brim with dresses, jackets, and suits that were wheeled along the bustling streets by deliverymen who zigzagged between cars, trucks, and pedestrians. The streets were alive with the jangling sounds of hangers bouncing against the metal pushcart railings. I knew my way around, having visited the factory since childhood. As a young girl, I worked alongside the finishers sewing buttons, hooks, and snaps onto dresses.

The minute you opened the gray metal factory door you were struck by the steady buzzing *zzzz* sounds of the sewing machines as the operators pushed down pedals to stich dresses together. Around the perimeter of the factory was an impressive bank of huge industrial windows. Lining the center were several rows of sewing machines, button-finishing tables, and a thirty-foot-long wooden table for cutting dress patterns. The pressers worked toward the back in their muscle-man undershirts, overheated and dripping wet from the bursts of hot steam hissing into the air from their ironing boards.

My father was a contractor who produced dresses for a fashion designer. He demanded meticulous craftsmanship from his workers, who both loved and feared him. Seams had to match, stitches had to be straight, patterns aligned, and buttons fastened properly. Each garment had to be perfect before it left his shop. I had the same meticulous sense of perfection with my Photorealist paintings. I felt a surge of pride when I walked past Peck & Peck, a boutique department store on Fifty-Seventh Street and Fifth Avenue, and saw his dresses displayed on mannequins in the windows.

I arrived at Tony's Italian restaurant exactly on time and saw my father sitting at a bright sunny table in the window. White dishes, cloth napkins, two sparkling wine glasses, and a basket of crusty garlic bread drizzled with olive oil glistened in the sun. I kissed my father on the cheek and sat down just as the owner arrived wearing an apron tied around his protruding belly.

"How are you, Mr. Flack?" asked Tony.

I was surprised and impressed that he knew my father—impressed by how far my father had come. Morris Flack had emigrated from Europe, a platinum blond, blue-eyed, fifteen-year-old Polish Jewish boy, ruddy-cheeked and athletic but alone and poor.

The owner glanced at me quizzically, wondering if I was Mr. Flack's young chippie.

"This is my daughter," my dad said with pride.

"Ah, then let me bring you some special treats."

He returned with a dish of caponata toast and a plate of mozzarella and tomatoes garnished with a sprig of basil. I was seeing a more sophisticated side of my father I had never before imagined. He ordered for us.

"We'll have a large platter of baked ziti parmesan, two Caesar salads, and a carafe of white wine."

We sipped wine and were enjoying our lunch together. My father rested his fork and, with a serious expression, asked about my life as an artist. All he knew about art was what he gleaned from Hollywood movies like *Lust for Life*, where Kirk Douglas played Vincent van Gogh, who sliced off part of his ear.

"How do artists live? What work do they do? Are you a bohemian?"

But over and above it all, he wanted to declare his love for me. I was his legacy.

"You are the most like me. I love your mother, but I know her limitations, and Milton takes after her. I love him, too, but he is weak; they

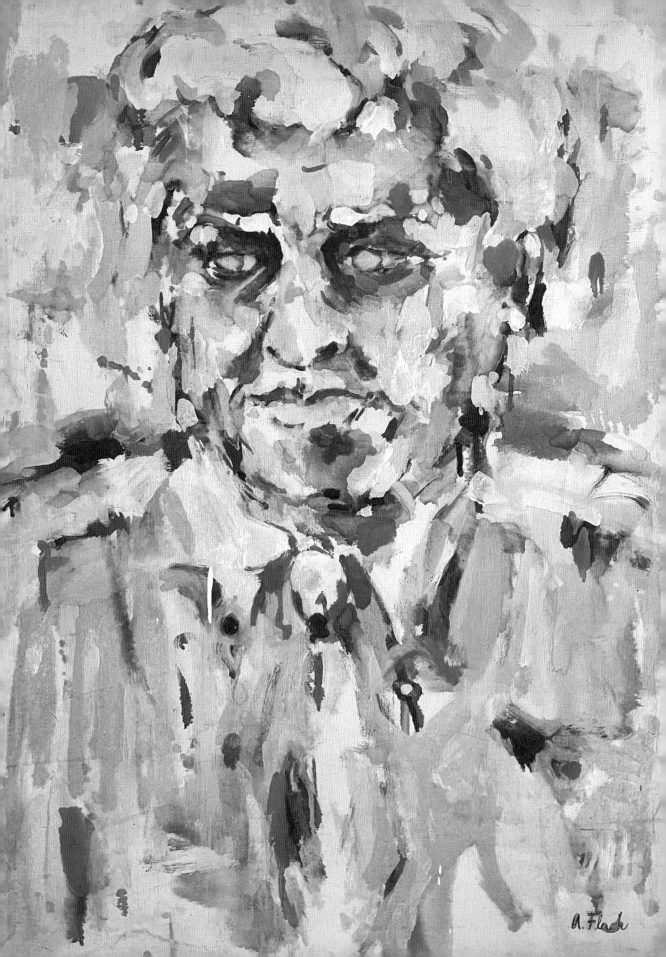

A. Flack

both can't control their gambling. You are what I am leaving in this world. Take good care of yourself, keep clean, and dress well."

I knew I disappointed him with my paint-stained jeans and raggy tops. My outfits were far from the high couture dresses he so carefully crafted.

"I'll try, Dad," I said, deeply moved by his declaration of love. He was right: I did take after him. I had his mood swings, his daring, but I also had his ability to think, analyze, and persevere. Milt took after my mother's joke-telling, carousing, gambling side of the family.

My father wanted to see me again. We scheduled a date to meet at the same place and time the following week. We kissed goodbye, Dad went back to his factory, and I went to my drafting table at the Jack Prince studio. The following week, I completely forgot and stood him up. I don't know why. Our lunch together had been wonderful and meaningful. It had to be a subconscious blunder.

Did I think I wasn't important or enough? Was I overwhelmed by his proclamation of me as his successor?

He was a man who expressed himself through action, not words, and now something had changed. He wanted to talk. He telephoned the next day.

"Where were you? I waited for you."

"I'm so sorry, Dad, I forgot. I'm really sorry. Let's reschedule for next week. I promise I'll be there." And I would have, had he not died the next day.

I left the design studio and came home to find a note taped to the door of my apartment: "Call the factory!"

My heart pounded as I heard the news from a distraught worker.

"Your father is dead."

He was fifty-nine years old, standing next to his rolltop desk and talking on the office phone when he jackknifed to the concrete floor, the telephone still gripped in his hand. He died instantly, but the telephone was still alive. A voice could be heard on the other end frantically repeating, "Hello, Dad, Dad, are you there? Hello, hello?"

It was my brother, who had undoubtedly been asking for a loan to repay yet another gambling debt. Milt's gambling had always enraged my father; he yelled, swore, and lectured but never failed to bail his son out, particularly when there was a threat from the Mafia.

Fig. 25 Lion Head—Portrait of Morris Flack, 1952. Oil on canvas, 36 × 28 in. Photo courtesy of Audrey Flack.

A lion of a man, Dad raged at the gods one too many times and blew up his heart. I can only imagine my brother's guilt, for in spite of Dad's violent temper, we both loved him.

Milton was somewhere in Atlanta, address unknown, and my mother was in a secret gambling den, no one knew where. Someone had to identify the body. I took a cab to the city morgue that rainy evening, despairing and alone. A morgue attendant ushered me into a dimly lit room, where I saw my dad lying on a cold steel slab, face up, with a hanging light spotlighting his rigid body.

I felt faint. I had to lean against the steel slab to steady myself. I felt a surge of love; I wanted to hug him, put my arms around him, and press my cheek to his.

"Please identify this man."

"He's my father, Morris Flack."

I lifted his hand, held it close to my chest, and stayed by his side, not wanting to leave him alone.

"You have to go now, ma'am."

He ushered me out and handed me a brown paper bag with my father's wallet, pants, shirt, and belt. I held it close to my heart and sobbed. I didn't go back to my Chelsea apartment. Instead, I took the train to Washington Heights. I wanted to give my mother the news in person. I needed to be with her and share my grief, but she wasn't home, so I slumped into the green velour sofa in the living room and waited.

Hours went by, and I fell asleep sitting up. At three-thirty in the morning I was awakened by the sound of the key turning in the lock. My mother tiptoed in, hoping not to wake my father and cause yet another fight. Her face was flushed, her eyes wide and darting like an animal on high alert. So consumed by the thrill of gambling and pumped up with adrenaline and cortisol, she didn't even ask why I was there.

"Audrey, you won't believe this, I had the luckiest night of my life! Winning hands were dealt to me one after another. Two pair, three of a kind, a straight to the ace. Can you imagine?"

Short of breath from her rush, she continued.

I got four spades and then a fifth for the flush, all dealt to me in five cards. Amazing! I got a full house, aces over eights. I couldn't believe it. I kept winning. Chips were piling up in front of me. I was on a rush, winning one hand after another! I thought it couldn't get any better, but it did. I got a royal flush, ten, jack, queen, king, and ace

of hearts, the highest hand you can get. Do you know what those odds are, Audrey? Over a million to one! Remember what I taught you, cards are mischievous; when they don't go, lay low. But when they keep coming in, you have to go with it. You can't leave a run of cards like that.

But then she noticed that my father wasn't there.

"Where's Dad?"

"He's dead," I said bitterly.

She dropped to the sofa and said, "Why was I dealt the best hands of my life while my husband was dying? Why did God punish me?"

It was the only time I heard her express feelings of remorse and allude to her addiction. It was left to me to make the funeral arrangements and select my father's coffin. I chose a plain raw pine box with a Star of David on the lid.

Milton borrowed money from me to fly to the funeral. We were entitled to a portion of my father's will, but we agreed to sign everything over to my mother, who was now a widow. When it was time to leave, Milton took me aside and asked for carfare home.

We all worried about her, but Mom bounced back quickly and was better than ever. Within a month, she got a job in the computer department of the Book of the Month Club, and after work, she used her mathematical skills to play the stock market with tips she got from her friends in the park. She did well, supporting herself and remaining an independent woman.

I, on the other hand, had lost my source of love. I grieved and barely left my small bedroom for one whole year. Worst of all, I wasn't painting. Pat, my roommate, couldn't stand living with her inconsolably depressed friend any longer.

"Get up and get out!" she demanded, hands on her hips.

Pat was formidable when she was angry. Thoroughly reprimanded, I forced myself out of bed and accepted a date with a tall German entrepreneur named Werner. He was an attractive man with long blond hair slicked back off his forehead. We went to a small restaurant in the neighborhood, where I ordered pasta and a glass of red wine.

"A toast," Werner said, holding up his glass. I held up mine and noticed the glass trembling in my hand. I had always been steady-handed and sure-footed, but I couldn't control this shaking. I watched the tremor increase with the detachment of someone who wasn't there.

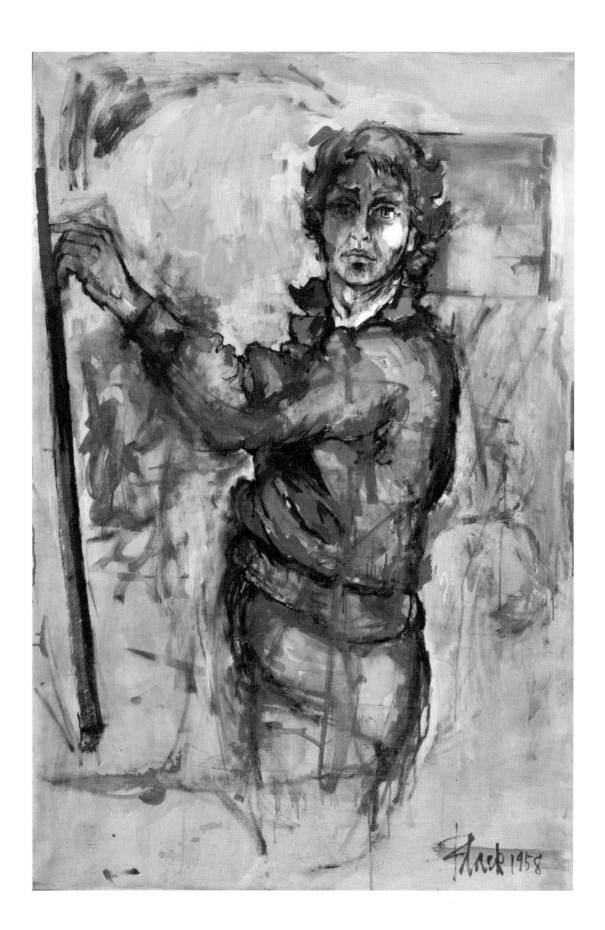

"Put the glass down slowly," Werner said gently. "I better take you home."

But Pat was right: going out, even briefly, broke the ice. After a year of grieving, I was strong enough to stand in front of the full-length mirror, take a good look at myself, and paint all of the feelings registered in my heart and on my face, the sorrow, the memories, and the love. I was his daughter. I was an artist. I would go on. I called my new painting *The Memory*.

When it was finished I signed my name in the lower right-hand corner as usual, only this time, to my surprise, it wasn't my signature. I had signed it in my father's handwriting.

Hitler and My Brother Milton

Sitting on the Broadway bench, my thoughts wandered back to my early days in high school and my brother, Milton.

No longer a misfit but an artist, I felt alive and happy. My elation continued until one striking event occurred, an event so strange it remains hard to believe to this day. In 1945, World War II ended, Jackson Pollock and Lee Krasner were married, and I entered the High School of Music & Art. But just a few years before Music & Art, life was not so pleasant. From 1942 to 1945 World War II raged. I lived with a nagging worry about Milton, who had been shipped overseas. He sent letters, but they were censored with solid bars of black ink stamping out sentences. Reading between the lines, we could tell that Milt was in active combat and in serious danger.

Many of the German Jewish refugees who managed to escape Nazi Germany immigrated to Washington Heights. Horror stories of relatives who had been starved, tortured, and murdered in concentration camps ran rampant in every butcher shop, grocery store, and bakery in the neighborhood.

Deep down, we were all frightened. Food and fuel were rationed and nightly blackouts darkened the city, but essentially, life went on as usual. Small cotton flags with a solitary blue star in the middle were hung in

Fig. 26 Self-Portrait (The Memory), 1958. Oil on canvas, 50 × 34 in. Photo courtesy of Audrey Flack.

almost every window. They signified that your son or relative was fighting in the war. A gold star meant that the person had died. Our satin flag was proudly displayed in my parents' bedroom window facing Fort Washington Avenue.

Milt left for college when he was sixteen. He was a philosophy student, president of his class, and headed for law school when the war broke out. Milt was told he could remain in school if he joined ROTC (the Reserve Officers' Training Corps). Within months, he was promoted. I remember the two rectangular gold bars he wore proudly on each shoulder. But the government reneged; they needed bodies, foot soldiers to fight on the front lines. He was yanked out of college and, after a few weeks of basic training, sent to fight in the Battle of the Bulge, where huge casualties were expected. These young men were nothing but sacrificial objects, dispensable human targets.

Milton, the sensitive philosopher-poet teenager who, in his youth, refused to fight on the streets as my father wanted him to, was forced to kill or be killed. This was war at its most primitive: bayonets, rifles, hand grenades, knives, heads blown off, necks slit, and guts ripped open. War turned my brother into a killer. His khaki shirt bore the insignia of the Blackhawk Division as he marched with hundreds of other infantrymen, advancing toward the enemy.

The fighting was a tragic, preordained massacre, an epic bloodbath. Milt's battalion got wiped out. By the end of the war, millions of soldiers had been slaughtered. Milt stepped over the bodies of his fellow soldiers as they dropped all around him. He took cover behind trees, hid in the forest, and killed German soldiers—boys his age—in a rage of retaliation.

On May 7, 1945, Germany surrendered in the small town of Flensburg, so far north of Berlin it might as well have been in Denmark. Three months later, on August 6, 1945, a US B-29 bomber dropped an atomic bomb on Hiroshima, and suddenly, Japan surrendered. The war was over. There was dancing in the streets, strangers hugged each other, and music filled the air.

Tall and slender with refined features, Milton attracted both men and women. A cross between Montgomery Clift, Alan Ladd, and Frank Sinatra, he radiated a sexuality that women could not resist. But when he returned from the war, he weighed ninety-five pounds and had haunted eyes, sunken cheeks, and a bad case of malaria. (After Germany, he had been sent to the Philippines.) He was debilitated by PTSD, post-traumatic stress disorder. It would stay with him for the rest of his

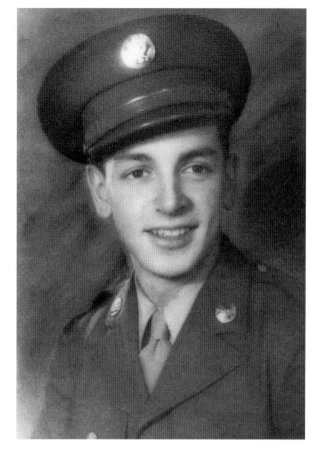

Fig. 27 Milton Flack in Army uniform. Photo courtesy of Audrey Flack.

life. He kept a pistol next to his bed and was ready to shoot when someone entered his room, but at least he was alive and in one piece.

Our family threw a homecoming party for him. Mom arranged platters of corned beef, pastrami, sliced tongue, potato salad, coleslaw pickles, potato chips, mustard, and Jewish rye bread. Everyone helped themselves to the cases of Schlitz beer and Dr. Brown's cream soda stacked on the kitchen table.

People danced the Lindy Hop and foxtrot to the big-band music of Glenn Miller. "Tangerine" and "Amapola," by the Dorsey Brothers with Helen O'Connell, came over the wooden Emerson radio in the living room. I played the upright piano as people gathered around and sang war songs like "The White Cliffs of Dover," "I Left My Heart at the Stage Door Canteen," and "Right in the Führer's Face," an anti-Hitler song containing spitting and farting noises by Spike Jones. The door was open. Neighbors and friends wandered in and out. All of Milt's girlfriends showed up to celebrate the end of the war and the beginning of a new life.

When the last guest left, Milt looked tired. He carried his overstuffed duffel bag into the bedroom we had shared as children. I followed close behind and sat on my bed. Milt set the duffel bag on his bed, reached inside, and threw something at me.

"Catch," he said, as an olive-green hand grenade went hurling through the air.

Luckily, I was able to catch it before it struck me in the belly.

"Now hold that handle down. It's live, I pulled out the pin. It'll explode, blow your hand off if you let go."

I clenched the grenade, terrified. "Aw, Milt, really?"

"Yeah, really!"

I gripped that handle as tight as I could until my hand ached, until I finally realized he had duped me again, the same as he had all my life. He could always fool me, convince me, charm me, enrage me. He was my big brother; I worshiped him and I wanted him to like me, but he was an erratic, irascible star who only occasionally would shine his light on me. His sights were high . . . millions of dollars, vast areas of land, foreign countries, the world. There were no boundaries to his imagination and his ability to transform his ideas into persuasive words.

One by one he removed his treasured memorabilia. The first to emerge was an ominous-looking German helmet, probably yanked from the head of a soldier he had killed. I picked it up and saw beautifully rendered red and black eagle imprints on either side. Their wings were outstretched and their fierce talons gripped hanging swastikas. I marveled at the precision and delicacy of the artwork and wondered why the Germans would go to such great lengths to put such refined art on an object that could easily get dented or destroyed.

The duffel bag toppled over and two more hand grenades rolled out. Milt reached inside and pulled out a long-barreled Luger pistol that, despite its mission to kill, was an elegant and beautifully designed object. He unfolded his handkerchief and gently, almost lovingly, polished it.

A minute or two passed and Milt resumed unpacking. This time he inched out a large black object I recognized to be a photograph album. He didn't open it, just set it aside and rested for a minute. The next object looked perfectly innocent; it was a small, nondescript black portfolio, one that any art student would use to transport their work. But it held the most shocking contents of all: *Hitler's watercolors*!

He put the portfolio aside and removed the last two items, a small wooden jewelry box and a strange-looking book. I have never seen any

book like it before or since, nor do I want to. It was bound in smooth white leather. The words *MEIN KAMPF* were printed in bright orange German Fraktur, with each letter outlined in what looked like eighteen-carat gold leaf. The letters were raised a quarter-inch high and were heavily burnished. The book gave off a strangely hallowed, almost sacred aura. I'm sure it was something Hitler intended. But to me, its presence was formidable. Was I holding Hitler's personal copy of *Mein Kampf*?

A hideous thought crossed my mind. The infamous Ilse Koch had made lampshades out of the skins of Jewish Holocaust victims.

Did she use them for books?

Was I touching a Jewish person's skin?

I thought about throwing it down the dumbwaiter, where we tossed garbage to be incinerated, but I couldn't bring myself to do it. So I put it on the shelf with its face to the wall.

Except for a few pieces of clothing, the duffel bag was now empty. We both fell silent. Milt seemed in a trancelike state as he recounted a story behind his stolen treasures—hot items, filled with so much shame, that any Jew would be loath to touch, let alone keep. Items the government would have confiscated, items our parents would recoil from. I listened, enthralled.

"I was one of the first foot soldiers to enter the 'Eagle's Nest,'" he said softly.

"What's that?" I asked, wide-eyed and rapt.

Milt continued his story.

The Eagle's Nest was the name given to Hitler's summer home, a picturesque Bavarian castle perched on top of a mountain peak near Berchtesgaden. The Nazis were losing ground, and Hitler had to evacuate in a hurry. We broke down the door and stormed in. The place was empty. No German soldiers, no servants, not even a dog. Everything was there for the taking and everyone was running around letting off steam, smashing dishes, stuffing their pockets with loot, raiding the pantry closets stocked with the finest wines, champagnes and liquor, along with canned meats, hams, and wheels of cheese, ripping up pillows until feathers floated through the air like snowflakes. But I knew that the good stuff had to be hidden. I went off by myself and searched the rooms. I tapped on the walls, doors, and floors, testing for secret hiding places with no luck until

Fig. 28 Hitler, 1963–64. Oil on canvas, 28 × 28 in. Photo courtesy of Audrey Flack.

I noticed a slight difference in one of the windowsills. I felt around and suddenly the whole panel popped up. It was a trap door, and deep inside was a metal-lined, insulated well.

Milt, it seemed, had been able to fathom Hitler's mind. Not only had Milt studied Nietzsche, but he also knew gambling scams and the methods "mechanics" (gambling cheats) used. According to my brother, he wielded that information like a divining rod to lead him to his astonishing discovery.

Milt leaned back against the headboard and took a long, slow drag on his Lucky Strike. After a few puffs, he sat up and opened the small wooden box to reveal an elaborately carved gold and ruby necklace resting on red velvet lining. Its ornate baroque design, embedded with faceted rubies, sparkled in the late afternoon sun. I was bedazzled.

"Come here, sis," Milt said, as he undid the clasp and placed it around my neck. Suddenly, I felt it come alive with the aura of the woman who had worn it. I laughed and twirled around and around, hearing the

echoes of Strauss waltzes and the rustle of full-skirted ball gowns. Only later did I imagine that it could have belonged to Hitler's girlfriend, Eva Braun. Could it have been stolen from the smashed window of a Jewish jewelry store on Kristallnacht? A horrible thought—but the necklace was a gift from my big brother, who had always mercilessly teased and been mean to me. Maybe this meant that he liked me, maybe even loved me, so I didn't dwell on its origin. I went to bed that night with my brain processing all of the new images I saw.

First thing in the morning I flipped through the Hitler watercolors, impressed with his technique in spite of the loathing I felt for him.

But then Milt left as suddenly as he had come. He returned to college to study law, but he was so riddled with PTSD that he quit school and spent the next few years gambling, drinking, and womanizing. The house became quiet. I had the bedroom to myself again, with one significant addition. I seemed to have become the private custodian of Hitler's personal memorabilia. At first it was spooky having these objects around, but I gradually got used to them. I cleared the bookshelf opposite my bed and arranged the disreputable objects as if they were props for a still life painting. After a while they became part of my everyday life.

The room wasn't the same after that. Nor was I. These foreign objects called to me. I picked them up, examined them, and wondered about them. I mentioned them to no one; they were mine, my secret. Somewhere I must have sensed the enormity of the shame they bore. Had Hitler touched them?

In the future I would incorporate guns and bullets into my work. My colossal head of Daphne wears bullets on her diadem to signify the triumph of nature over war. In *Amor Vincit Omnia* (love conquers all), I hold a gun to my head. Sophia, the écorché, catches a bullet in her side. And, most recently, the Luger appeared in my *Self Portrait as Saint Teresa*, but it shoots paint, not bullets.

There was no further mention of Milt's war booty from him or my parents, who deliberately seemed to take no notice of the objects. I would come home from school after having studied Picasso, George Braque, and the Cubists and sort through Hitler's academic watercolors. I loved Picasso, the Cubists, and John Marin's watercolors, but I was equally compelled by the Hitler watercolors.

The contemporary art world I grew up in dismissed all realism, particularly nineteenth-century academic artists like Gérôme and Bouguereau.

These artists had been famous and successful in their lifetimes but were now relegated to the basement storage rooms of museums. Their work disappeared from view; Modernism prevailed. I was interested in learning more about this mysteriously banished period of art, and Hitler's work intrigued me.

Fascinated with architecture, Hitler painted small watercolors and drawings of churches, street scenes, and historic facades. He wanted desperately to become an artist and left for Vienna at the age of eighteen to take the entrance exam for the prestigious Vienna School of Fine Arts, but became bitter and despondent after he was rejected. Would the course of history have changed had he been accepted and spent time with other art students studying the principles of art? We know that Hitler became the sickest monster of all time, but it makes me wonder how many monsters are walking around that could have been decent people had they been able to express themselves artistically.

Forced to rely on the talents of others to realize his dreams, Hitler used the architect Albert Speer to design buildings for the Third Reich; Leni Riefenstahl, the actress and filmmaker, to create *Triumph of the Will*; and Arno Breker, the academic marble sculptor, to create prototypical Aryan bodies. He looted, stole, confiscated the art of others, and became an epic murderer.

In school I imitated Picasso, Braque, and Juan Gris. I even forged a few Picassos. Modernism offered a new thought process, new ways of seeing and creating. I loved Cézanne, Cassatt, the Fauves, and the Impressionists, but at the same time I continued to study the nineteenth-century academic style that Hitler's watercolors offered.

I remember advertisements that the Museum of Modern Art placed in the *New York Times* showing a Picasso or a Stuart Davis opposite a highly realistic Bouguereau. The headline read, "WHICH IS THE REAL WORK OF ART?"

If you were sophisticated and "in the know," you selected the Picasso. If you were an uninformed, lower-class dolt, you liked the academic work of artists like Bouguereau. Still, in the three years leading to my sixteenth birthday, I looked at Hitler's *verboten* watercolors every day.

In the evenings I would take the photo album to bed with me and study the black and white snapshots, some probably taken by Eva Braun herself. There were pictures of Hitler playing with blond German children, Hitler petting his German shepherd, Hitler walking in his garden, Hitler picking flowers, Hitler sitting with Eva Braun, with his friends, with

generals. They were attached to the black construction paper by four corner slots. I slipped them out of their holders and saw German calligraphic script on the back with names of the people in the photographs: Hermann Göring, Joseph Goebbels, Rudolf Hess, and Albert Speer.

I lay on my side and studied their faces. How could the nice-looking people surrounding him partake in such depravity? How could this fiendish criminal orchestrate the murder of millions of innocent people and yet draw so well? I'm Jewish, and had my parents not immigrated to the United States from Eastern Europe, they would certainly have perished in Hitler's "Final Solution."

A few years later, Milt showed up with a small black suitcase. Happy to greet him, I lifted it up and was surprised at how light it was. Why would he bring an almost empty suitcase just for a toothbrush and clean underwear? Two days later I discovered that he had packed the photo album, the portfolio of Hitler's watercolors, the *Mein Kampf* book, the Luger, the helmet, and all but one of the grenades into the suitcase and abruptly left. At the time, I guessed he just wanted his possessions. Perhaps they were a comforting presence, a perverse reminder of having conquered death and evil.

By that point, Milt was a big-time gambler in Las Vegas and in international backgammon tournaments. Millionaires flew him around in their private jets. He could afford a Maserati when he was flush from a big haul, but on other occasions he had to unload his belongings, drastically underpriced, for quick cash to pay off a serious gambling debt. Serious means Mafia-style: fingers broken, kneecaps smashed, or maybe even worse.

Months passed. I was watching the evening news when something flashed across the screen. It was Hitler's photograph album! Milt's photograph album.

The newscaster announced that it had just been sold for a large sum of money. I had never thought of the album's material worth. It was ours, Milton's and mine. It was our secret, my secret, and now it was not only public, it was gone! Shocked, I rushed to the telephone and called Milt.

"Did you see the news? Was that our album?"

"Yeah, I think so," was the dejected reply. "I had to sell it to pay off a bad debt."

"Oh, Milton," I sighed.

He was upset with himself, but not for long; the inveterate gambler knows his possessions are here today and gone tomorrow. I hung up

the phone and went to look for the beautiful ruby necklace. It was missing. I had been so careful with it, always checking the clasp whenever I wore it, always putting it back in its box. I searched everywhere, emptied every drawer, went through every closet, but it was gone. It took a while for me to realize that my brother had stolen it from me. The treasures were gone, all of them returned to the universe. I had only the memory of them to use in my work.

I heard stories about other photograph albums that had been brought back by soldiers like my brother. And perhaps the Hitler watercolors were only reproductions. Then again, they looked real to me. It doesn't really matter. They served a purpose: they opened a hidden world of art and expanded my vision.

It was getting cold. The sun was going down, but memories of my brother were still alive in my brain when suddenly, I felt something pounding on my knee. I looked down and saw the little fists of a distressed toddler having a meltdown in the middle of the center island. She banged on my leg, stomped her feet, and screamed. The green light flashed, and I watched her mother grab the child's hand and rush across the street. I closed my eyes again, hoping to return to memories of my brother, but the child's cries had awakened memories of my daughter Melissa's anguished screams.

Marriage and Melissa

Silent nods were the closest thing to being welcomed at the Broadway Mall. Names were never used. My usual spot was taken by a wild-eyed, bearded man, so I chose a spot in the warm sunshine as far away as I could get from him. Memories washed over me on that bench like waves, relentless. Emotions, like an undertow, carried me into the depths of my mind. My thoughts slid back to 1958.

I was curled up in bed feeling morose and despondent. The image of my father's dead body lying face up on a steel slab in the morgue appeared on the ceiling above me. I felt angry, angry at everything, the trees, the

furniture in my room, even my coffee cup. These objects were still here and my father no longer existed.

I was staring at my self-portrait when the phone rang. It was an old friend with an extra ticket for a Leonid Hambro piano recital at the Ninety-Second Street Y. (Oddly enough, it was Leonid Hambro who performed at Ossorio's party the night of Jackson's fatal crash.)

"Why not," I thought.

It didn't take long for the rhapsodic sounds of Chopin études to lift my spirits. During intermission, I recognized a familiar face in the seat in front of me; it was Frank Levy, a music student from Music & Art. I tapped him on the shoulder. "Hi. We went to high school together."

"Uh, um, yes," he stammered, looking awkward.

Frank stood up and introduced me to the stiff-looking gray-haired gentleman he was with.

"This is Dr. Hammerschlag, my uncle." Dr. Hammerschlag extended his hand, clicked his heels, and performed an elegant European bow.

Frank looked handsome in his white shirt and black suit. He was tall and well built, with smooth, beautiful skin, but he was slightly nerdy-looking because of his black-rimmed glasses with thick, Coke-bottle lenses. But when he removed those glasses, I saw the face of the emperor Constantine, whose colossal marble head looks down on viewers in the Greek and Roman wing at the Met.

Frank was the star cellist in Music & Art's revered string quartet. I remember him looking rather distracted as he lugged his brown cello case through the halls. I loved the cello's mellifluous tones. I loved chamber music, and so when Frank, who was now a professional cellist and composer, invited me to his home for an evening of chamber music, I immediately accepted.

Saturday night arrived and I took the train to the Upper West Side. Frank lived in a brownstone on a quiet, tree-lined street. Two steps down, a metal gate: I rang the bell. Frank ushered me into the garden. He had set out an unusual assortment of hors d'oeuvres: duck liver pâté, oysters, anchovy paste, exotic cheeses, and European-style delicatessen meats, topped off by a French baguette and a bottle of chilled wine.

The musicians arrived, munched on the delicacies, and tuned up. They played several late Beethoven string quartets and ended with the Mozart G minor quintet, one of his most profound works and the only music that offered me solace when my father died. I was moved and enraptured.

On our next date, Frank said he would make dinner for me. I arrived to find his small apartment full of the aroma of coq au vin. He lifted the Creuset pot cover and there it was, simmering in rich brown gravy dotted with fresh herbs. This was a sublime gourmet dish unheard of in my mother's hamburger-and-boiled-potato home cuisine.

When we finished dinner, I sighed and asked if he would play the cello for me. Frank smiled, got out his bow, propped his instrument in the center of his oriental carpet, and performed Bach's cello suites.

Sitting this close, listening to the rich, resonant sounds flowing through his flame-back cello, thrilled me. I watched his long fingers move quickly up and down the ebony fingerboard, pressing the strings for each sonorous note. His hand trembled a vibrato for the sweetest soul-awakening sounds. I loved how the expression on his face changed as he interpreted and reflected the meaning of the music. The heavens opened up. I saw the clear blue sky through the open dome of the Pantheon; I saw galaxies, oceans, rainforests. I was falling in love.

Frank's family was filled with famous scholars, philosophers, and influential bankers. He was related to Josef Breuer, a Viennese psychiatrist and colleague of Sigmund Freud. His uncle, Dr. Ernst Hammerschlag, had been Freud's personal doctor and was now the chief psychiatrist at Lenox Hill Hospital. Frank's grandfather had been Freud's Hebrew teacher. Frank's mother was Anna Freud's close friend. She had posed for Oskar Kokoschka and traveled throughout Europe with Alma Mahler. Arthur Altschul, the famous financier and art collector, and Herbert Lehman, the governor of New York, were close relatives. But Frank was on a lower rung of the family tree, the branch that bore intellectuals, artists, and musicians. A branch with less social standing and little money.

Frank wanted me to meet his Aunt Lotte, a professional violist. The only problem was that Lotte was locked up in St. Vincent's mental ward at the time, having been institutionalized for severe catatonic depression.

"Hello, Aunt Lotte," I said, but her head was hanging down to her stomach and she could not speak. I should have known then that there was something strange in this family.

Frank's father, another Ernst, was a genius, a wunderkind, a child prodigy who, like Mozart, performed all over Switzerland at the age of four. He was now a composer, pianist, and professor at MIT. He was a cult figure in the music world, famous for his pianistic interpretations of Beethoven's sonata cycle.

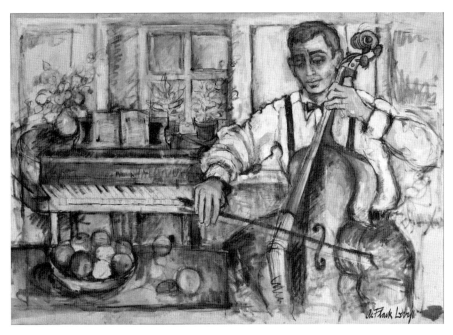

Fig. 29 *Frank with Cello and Bowl of Fruit*, 1958–59. Oil on canvas, 42 × 60 in. Photo courtesy of Audrey Flack.

This was a brilliant, intellectual family filled with geniuses but also filled with eccentrics, a family different from any I had ever known. Certainly nothing like any family in Washington Heights. The important thing for me was that they accepted me as an artist, something I had never experienced.

Frank said he was wearing Sigmund Freud's overcoat and button-fly trousers when he arrived for our next date. The coat, an oversized double-breasted herringbone tweed with padded shoulders, had taken on an ivory-yellow pall over the years. It looked like Vitamin Flintheart's overcoat in the *Dick Tracy* comic strip. Since no one else in the family would wear the depressing hand-me-downs, they were given to Frank, who was so absent-minded he didn't seem to notice the grungy look or the musty odor that emanated from them. It was as if the disturbed energy from Freud's patients had seeped into the fabric. After we married I stuffed Freud's clothes into the garbage can, but I regret not having kept the overcoat. It was a museum piece.

Frank spoke softly, with a slight stammer. He was filled with information, a true intellectual, and I was charmed.

"Yes, I will marry you," I said, after two months of courtship, without thinking twice.

The tall and elegant Else, my future mother-in-law, presented me with an amazing wedding gift. She selected twelve of my watercolors and had them matted by a professional framer. This would have been considered a total waste of money in my family.

The time came to meet Frank's father, Ernst, who was giving a solo performance the following Sunday at MIT's Killian Hall in Cambridge. It was perfect: Frank would introduce me; we would all have lunch and get to know one another; and if there was time, we could have dinner after the concert. Then Frank and I would fly back to New York that evening.

I wanted to impress my future father-in-law and decided not to wear jeans. Instead, I slipped into a tight-fitting black skirt and black turtle-neck sweater. I bought a new pair of green fishnet stockings and black high-heeled shoes just for this special occasion. Frank booked a much-too-early flight that forced us to fill the time until we could visit the great Ernst Levy. It was a chilly Sunday in November, too cold to sit on a park bench, and most of the stores were closed for the day. We took refuge in a small coffee shop, but wobbling around the cobblestone streets in high-heeled shoes took its toll. The backs of my heels began to blister from the fishnet stockings rubbing against the shoe leather.

At 1:30, the designated time, we arrived at his father's house and rang the bell. I hid a little in back of Frank until a sturdy, middle-aged blonde woman wearing a dirndl skirt and print blouse partially opened the door. She was his father's fourth wife, cook, housekeeper, maid, former student, and worshiper.

"Umm, I'm Ernst's son," Frank stammered. "Remember me?"

"Ah, oui, oui, wait here," she said in a thick French-Swiss accent. She gently closed the door and went back into the house.

We dutifully waited outside for quite a few minutes until we heard her returning footsteps. She peeked her head out and said, "Ernst must rest before his performance this evening, he needs quiet. He will see you tonight after the concert."

She abruptly closed the door on us and I stood there astonished. How could he shut out his own son? But Frank didn't seem upset; he was used to such treatment.

After several more hours of walking with my spike heels gyrating over the cobblestones, my blisters broke. I stuffed Kleenex in my shoes to sop up the blood and was angry with myself, but feeling even sorrier for Frank. I should have realized then that he would be unable to take care of me; after all, I was his fiancée. He couldn't judge a situation properly

or prepare for the inevitable. Without full awareness, the stage had been set. I was being baptized, dipped in a cauldron of boiling water.

Just before we were married, I took my mother to meet Frank. He was performing with The Little Orchestra Society conducted by Thomas Scherman at Carnegie Hall. Mom and I climbed the steps to the balcony and took our seats. One by one, the musicians arrived, carrying their instruments. All of them were dressed in black tuxedos, white dress shirts, black bow ties, and black shoes and socks. All but one.

"Look!" my mother exclaimed. "There is a musician wearing one black sock and one white one. What's wrong with him?"

"Oh, that's Frank," I said, trying to make light of his eccentricity. My mother didn't miss a trick. She looked miserable all during the concert. She knew something was off that I had not fully realized.

Despite her obvious discomfort, Frank and I got married. It happened fast. Too fast. My mother gave a party to introduce the families to each other. She served her usual: cold cuts, potato salad, Dr. Brown's cream soda, and Schnapps. Her brothers Sam and Max were busy telling their gambling stories while Uncle Harry waved his star sapphire pinky ring, puffed on his Cuban cigar, and slapped Uncle Ernst on the back.

"How are ya, doc?"

Uncle Ernst looked at him with the disdain of an intellectual elitist. The families were total opposites. I had been impressed with the intellectuality, style, and aristocratic background of Frank's European family. Compared to my rambunctious, joke-telling, crazy, compulsive gambling brood, they looked great. But as I look back at it now, we were the healthy set, the fun-loving set, and in our own way just as intelligent.

Frank and I found a great loft in a commercial building in Chelsea with enough room for a large studio. Five flights up, no elevator, but I gave it no thought; I was young and filled with energy. I could do it all. I started painting immediately. I was working toward my first solo exhibition at the Roko Gallery. Michael Freilich, the owner, had seen my work in various group shows around the city and asked me to exhibit in his new space on Seventy-Second Street and Madison Avenue, on the second floor of a beautiful nineteenth-century building decorated with ornate stone carvings (now the home of a Ralph Lauren boutique). This was an important show, and I wanted my work to look great. But within three months I became pregnant. It was unexpected and unplanned. I wasn't ready.

I continued painting throughout my pregnancy and completed all the works for the exhibition before my first child was born, including an ambitious six-by-eight-foot painting called *Dance of Death*. It was based on Hans Holbein's woodcut; I showed Adam and Eve standing naked in a grassy field under a clear blue sky, ready to face life together. But lurking far to the left was a trickster, a sinister skeleton squeezing the bellows of his bagpipes with bony fingers, while dancing to the call of death on his rickety legs. Death appears even at the start of life, even at the beginning of time. I selected a quote from the medieval English priest John Ball to accompany the painting: "When Adam delved and Eve span, Who was then the gentleman?" Was it a premonition of the way I would soon feel?

The show looked terrific. I even sold something. Frank's relatives, Governor Herbert Lehman and his wife, Edith, dragged themselves up the steep and narrow flight of stairs to see the exhibit. I was touched by their efforts and hoped they might buy a painting or at least a drawing, but they didn't. It was just a polite visit: something the high-ranking nobility did to show support for the lower echelon of intellectuals, musicians, and artists that flowered on the family tree.

On March 2, 1959, at 10:35 in the evening, I gave birth to a seven-and-a-half-pound baby girl with huge blue-green eyes and chestnut hair. Her beauty was extraordinary, and she had an ethereal, otherworldly glow. I was thrilled with her; I loved her, cuddled her, breastfed her, but after a day or two her responses seemed a bit odd. I couldn't quite put my finger on it. I asked the attending pediatrician, "Doctor, do you think my baby can hear?"

He looked down at my sleeping child and slammed his open palms against the plastic bassinet. The baby startled, her tiny arms jerked out to the side, and she began to scream.

"She can hear," he said. "Don't be so nervous." He turned his back on me and walked out.

My child cried for nearly the rest of the day. Frank and I took a taxi home from New York Hospital and I carried her up the five flights of steps, kissing and hugging her all the way. We named her Melissa, the Greek word for honeybee. She cried an awful lot—more than most babies, it seemed to me. With the arrival of our new baby, Frank became increasingly short-tempered and demanding. He wanted all my attention; if I put him off for even a minute, he got angry. I thought I could handle him, but it wasn't easy. I was beginning to have a hard time.

One evening we were having a small argument over dishes or something unimportant when, out of nowhere, he shoved me against a wall with such force that two of my ribs cracked. I stood there paralyzed with shock and disbelief. Where was the mild-mannered, soft-spoken intellectual I had married? *Just who was this man?*

You can't do anything about broken ribs. They just hurt when you breathe or laugh. Frank went to bed that night acting as if nothing had happened. I stayed as far away as I could, warily watching the sleeping man lying next to me, trying to process what had taken place. I asked him about his outburst the next morning, but Frank laughed and said I was making too much of things.

"Nothing happened," he insisted.

His denial seemed so authentic that I wondered if *I* was overreacting. Maybe it *was* just a moment of uncontrolled passion. Our life resumed normally for a while with no further incidents. However, as the weeks and months went by, Frank continued to change. He became more short-tempered and distant. He stayed away from home and didn't help at all. Eventually he morphed into a typical abuser. He would cry after an outrageous act and then be solicitous. He did not beat me, as happened to Farrah Fawcett's character in *The Burning Bed*. I would never

Fig. 30 Dance of Death, 1959. Oil on canvas, 6 × 8 ft. Photo courtesy of Audrey Flack.

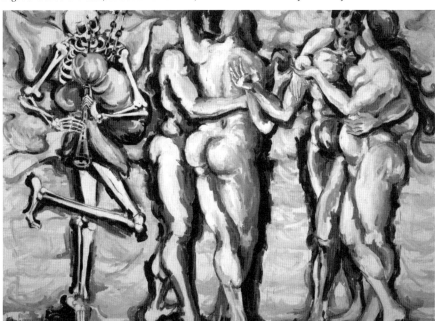

allow that. But once, I had to hold up his cello and threaten to smash it to ward him off. Frank had an impulse disorder, and it was hard to tell when it would erupt.

I thought about Lee Krasner and how she had put up with Jackson; Frank's outbursts were similar to his. They were sudden, unexpected, irrational, and frightening—only Frank's didn't come from alcohol. Probably Jackson's didn't either, but alcohol fueled them. Lee could have left her marriage. She didn't have a child to protect and care for, but she got caught in a trap, thinking that she could help Jackson. Believing, too, that the abuse she took was worth the price of being in the presence of his genius. Lee persisted until she got fame, money, power, a Park Avenue lifestyle, and recognition for her own art. Lee was the only one of the Ab Ex women who achieved that status in her lifetime.

My marriage had the perfect ingredients to keep me trapped. I became more and more isolated, living in a commercial area with no support from neighbors, friends, or family and with no money. As much as I wanted to, I couldn't get out. It wasn't until years later that I came to realize I was not alone, that many women from all walks of life find themselves in these situations. But at the time I was terribly alone.

I felt the pain of Melissa's cries and took her for long walks along bustling Twenty-Third Street, hoping it would calm her. Occasionally she nodded off. The rest of the time she screamed. I found that when I picked up speed she calmed down, so I walked faster and faster. Sometimes I reached a slow trot. I picked her up, put her down, fed her, patted her back—nothing helped. Melissa cried endlessly. I called the doctor.

"Don't worry so much. It's just colic."

The loft was over eighty feet long and thirty-five feet wide, with highly glossed wooden floors that the landlord had just scraped and polyurethaned. I decided to set up my studio in the front, facing Twenty-Third Street, a noisy crosstown thoroughfare with cars and trucks honking their horns and revving their engines all day long.

One great compensation for the noise was a bank of oversized windows that ran straight across the front of the building. They let in a stream of blazing light that projected itself deep into the space. I set up my easel right next to those great windows and began to paint. I could work and keep an eye on Melissa at the same time. I set the bedrooms up at the back end of the loft, where it was quieter. I hoped it would help Melissa sleep, but still my poor child cried incessantly. I didn't leave

Melissa for a second until she was three months old, but her uncontrol-lable screams were shredding my nerves.

Frank had long since developed an antipathy toward Missy that later turned to pure anger and eventually total rejection. The only way I could paint was while holding her. I cradled her in one hand, painted with the other. *Melissa and Me* was painted in 1959. My head is partially severed. I have no eyes. At the time, I saw myself only as a vehicle for her existence.

I don't think I had a day off or a night out for a solid year. Melissa continued with her maddening cries. Something was taking over her brain and her body, but I didn't know what it was, or how I could help her. The nagging fear that somehow it was my fault haunted me. When I think now about those early visits to pediatricians, my blood boils. How could those highly educated men dismiss my astute and accurate eyewitness reports so easily? How could they reduce me to nothing but a nervous mother?

I simply refused to accept the idea that caring for my child meant putting my work on the back burner. Making art was my only solace;

Fig. 31 Melissa and Me, 1959. Oil on canvas, 19 × 26 in. Photo courtesy of Audrey Flack.

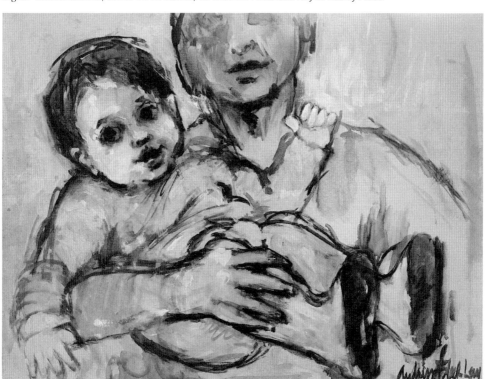

I needed it to survive, particularly now, when I was so isolated. There wasn't enough money to hire babysitters, I couldn't get out to exhibitions or openings, and I had no friends nearby. I relied more and more on the Old Masters. Rembrandt was always there when I needed him, and his late self-portraits never ceased to comfort me.

As the months passed, terrible, fearsome thoughts of death, accidents, and suicide flashed through my mind. Life and art were engaged in a fierce battle, threatening to rip me apart. I wasn't sure how much longer I could hold on.

Streets of New Haven

In spite of the lack of sleep and the hard times, I continued to paint and exhibit whenever I could. My best time was two or three in the morning, when the city was quiet, the traffic on Twenty-Third Street subsided, and Melissa dozed off. For those couple of hours, I was filled with the miracle of art and my spirit revived.

When Melissa was five months old, Frank got a summer job performing in a string quartet at Yale. The university offered us a modest apartment in a row of attached houses close to campus. Our loft in Chelsea was in a noisy commercial building, but this was a residential neighborhood with people living right next door to us. I was afraid Melissa's cries would wake the entire neighborhood.

Movement remained the only thing that could still her cries, so every morning, sometimes as early as four or five o'clock, I would bundle her up and push the carriage around the empty streets of New Haven. Sometimes I ran. Fast movement, constant motion, tossing her up in the air, pushing her high on the swings—anything excessive, anything that other children might find frightening, calmed her, relieved her. She even smiled.

I was familiar with the backstreets of New Haven, having attended Yale seven years earlier. I was a student then, free, happy, in charge of my life. Now I was skittish and anxious, pushing a screaming infant along deserted streets at four in the morning. I was in an open-air prison, my freedom gone, the joy of life buried beneath anxiety and sheer physical exhaustion. One hot summer afternoon, I pushed the carriage up to the corner of Chapel and High Streets and found myself in front of the Yale School of Art. A flood of memories came crashing over me. I wanted to bolt up those steps, the same ones I had dragged my paintings up to

show Josef Albers in 1951. But now, instead of canvases, I was gripping the handle of a baby carriage with an inconsolable, screaming infant inside.

If Josef Albers could see me now.

It took Melissa's stomach-curdling shriek to jolt me out of my altered state. I looked down at her, terribly worried, and made an appointment with a pediatrician the very next day.

The doctor performed the usual examination of height, weight, and length.

"She's fine," he said, irritated.

"Yes, doctor, but she looks right through me with a strange stare, as if I weren't there. Her pupils look dilated, like someone on drugs, and she doesn't stop crying."

"You worry too much."

I now rage at these self-important physicians who dismiss young mothers with an arrogant wave of the hand and a dismissive comment. Thousands of women in every country on earth still suffer this sort of treatment. The knowledge I gained over the years showed I was right: Melissa was in a world of abnormal pain and confusion, and no doctor would recognize her symptoms.

When Frank's performance schedule came to an end, we packed our belongings, folded up the baby carriage, and returned to New York. Melissa's crying had begun to subside, but her strange responses intensified. At times she didn't seem to feel pain, and at other times she did. She was hypermanic or lethargic. Her hearing would shut off and turn on, off and on.

Melissa couldn't speak, point, write, or use sign language. She could only look into your eyes and hope you could read her thoughts. She could not tell me if she had a toothache or a stomachache or if she were hungry, thirsty, or tired—and no one knew why. My child was trapped inside a body that was unable to communicate. She was suffering, and I felt every bit of it along with her. It seemed as if she had little will to live on this earthly plane. Was she an angel, an angel of terror and glory? I knew I would have to give her the will to live, protect and nourish her until she got there on her own. I was in a race against time, dealing with life and death every minute of every day.

My beautiful child's body, soul, and mind were being devoured by a mysterious neurological demon, and she fought it by kicking and screaming. I had to stop whatever was ravaging her before it was too late.

Frank was becoming more and more distant, staying out late, retreating to the bedroom and closing the door, leaving Melissa—now two years old—and her problems to me. He wanted nothing to do with her.

Amid all the turmoil, I had another child and protected her from the moment I knew I was pregnant. I ate carefully and handled Frank with care, too, keeping him at a safe distance.

Hannah Marie was born on February 28, 1961, weighing eight pounds, eleven ounces, and I knew from the moment I saw her that she was a healthy baby. She loved to eat, digested well, slept well, and rarely cried. She, too, was a blessing.

The Back Room and Painting Melissa

My struggles to help Melissa continued. The social worker who had initially evaluated her at the Child Development Center recommended she see a psychiatrist. We visited with a renowned Park Avenue physician. His brutal diagnosis delivered a shock to my heart.

"Send her away," he said. "She is incurable; she will never be normal. She is mentally ill, possibly schizophrenic. Save your own life."

Was he right, in spite of his cruel demeanor? How could he foretell that some of my friends with autistic children would die an early death? Did he care about me?

But that was nothing compared to the stockpile of problems dealt out daily. Windows had to be locked to prevent her from climbing out, even in the sweltering summer, when we had no air conditioning. Missy turned on the stove burners and threw knives, forks, and scissors on the kitchen floor. She seemed to take particular pleasure in shaking a knife in front of her face, sticking the point in her mouth, and running full speed ahead. Shiny reflections on the metal must have caught her eye and excited her senses.

I taped the silverware drawer closed, Melissa-proofed the entire house, and never left her alone. I even took her to the bathroom with me. I thought of tying her to a bed or a chair, but I just couldn't do it. Melissa threw dishes, cups, food, books, and Hannah's toys; nothing was safe. She turned chairs upside down. Towels got tossed into the bathtub along with soap, plastic cups, toothpaste, and shampoo bottles. She wanted closet doors to be open and turned the television on in every room. She hurled pillows onto the floor and tore the sheets off of beds. At first, I thought she was being perverse, but she needed things that way.

Maybe she saw the world upside down. I wondered if her retinas couldn't reverse object vision as normal eyes do. Was she trying to right things by turning them upside down because objects looked as if they were flying off tables? Was she living a real-life horror movie where poltergeists performed tricks on her? Or was she furious at being locked up in a body with an intelligent mind that was mute and unable to communicate her thoughts or feelings?

Ironically, she got into trouble when she tried to be independent, like getting a snack from the refrigerator. Her poor motor coordination made pouring a glass of milk an unattainable feat. She reached for the container, but the ketchup bottle was in the way. It fell off the rack, smashed to the floor, and broke into two large chunks of jagged glass. Globs of ketchup splattered all over Missy's pajamas and bare feet, but she hardly noticed. She was intent on getting the milk. But the milk container slipped from her small fingers and spilled over the red ketchup. I grabbed a roll of paper towels and was on my hands and knees sopping up the mess, picking up the glass, when Melissa bit into a slice of American cheese with the plastic wrap still on. I pried her mouth open and she bit me hard.

After that, I tied a rope around the refrigerator. Hannah later told me she thought everyone lived with a rope around the refrigerator. I had to protect Hannah, and she needed to sleep, so I moved Melissa into the small maid's room off the kitchen. It was far away from my bedroom, but I had no alternative. I read to her, sang songs to her, and tucked her in.

"Night-night. Now go to sleep."

I tiptoed to my bedroom, where I fell down, exhausted. But a moment later, I opened my eyes and there she was, staring at me. I put her back to bed, but again and again she appeared. I was forced to lock her in. I stood outside her door and listened until all was quiet. Sure she was sleeping, I collapsed in bed.

I woke up early and immediately went to check on Missy. I gently unlocked the door, peeked in, and gasped. Melissa was standing there stark naked, staring at me wide-eyed. The room was totally demolished. Every drawer was pulled out and turned upside down. Clothes, sheets, pillowcases, and blankets were strewn everywhere. The cot-sized bed was still in place but the mattress was standing upright against the wall.

Missy was a little thing; I couldn't imagine where she'd summoned the strength. She must have been in a wild rage, agitated enough to lift things ten times her weight. But that was the least of it.

Melissa had smeared her bowel movements everywhere. There was a brown streak running around the entire room, including all over the radiator cover, where she had pressed it into the pegboard holes. The steam heat intensified the overwhelming stench of shit.

"Oh my God, Melissa," I sighed. Dying internally but with a smile on my face, I managed to get Hannah off to nursery school and proceeded to wash the walls down with Clorox. I picked the dried feces out of the radiator cover with an old toothbrush and spent the rest of the day scrubbing, scraping, mopping, and disinfecting. Missy watched silently as I looked down at my rough, worn hands with brown shit under my fingernails and thought bitterly of my mother's words: "Audrey has golden hands; she can do anything with them."

After this catastrophic episode, it was easier for me to stay awake all night and track her wanderings than to go through that trauma again. Missy offered me a lesson I still am trying to decipher. Only now do I realize the extent of the frustration and anger she felt. Dark gray circles appeared under my eyes. I lost weight. Gaunt and frazzled, I developed a listless walk for the next few years.

Sometime after the back-room incident, Melissa caved in. She looked bewildered, as if she had fallen into a black hole. Her wide-open eyes had the look of aftershock, as if she had seen something terrifying. Those eyes looked right through me, as if my body had dematerialized.

Her hollowed yet magnificent face haunted me. I had to paint it, to capture Melissa's special look, the look that I would later learn was synonymous with autism. I wanted to make that autistic look visible, pick up the mysterious pieces, and put them onto canvas. I was ingesting, restructuring, solidifying the moment when the demons finally took over my child's brain. I called the painting *Melissa*.

When Hannah was eight months old we moved again, this time to a larger apartment on 104th Street and Broadway, directly over a dry-cleaning store. It was rent-controlled and we could afford it.

Missy and Hannah shared a bedroom, Frank and I had a bedroom, and I set up my studio in the dining room, which faced the back alley. The room was a dungeon that had never seen the light. Because it was an easy target for robberies, prison-style bars ran the length of the apartment's windows. But it was big and it had a door I could close for privacy. I installed a bank of floodlights across the ceiling, set up my easel, and started to work.

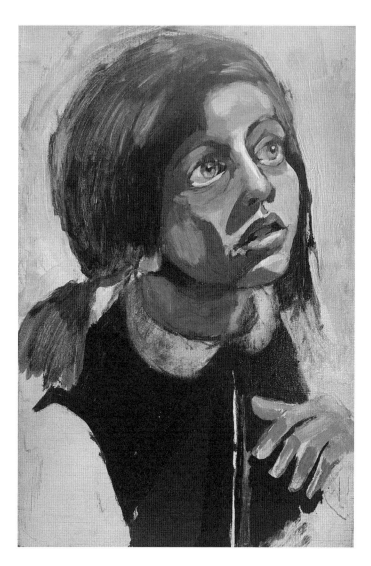

Fig. 32 *Melissa*, 1964. Oil on canvas, 15 × 10 in. Photo courtesy of Audrey Flack.

Interestingly enough, one of the largest paintings I ever made was created in that back room. *Four Horsemen of the Apocalypse* was so big that I had to lie on my stomach to paint the lower half of the canvas, because there wasn't enough ceiling height to lift it to eye level. The canvas was close to ten feet long, and when it was finished, I had to cut the wooden stretchers in half to get it out of the room. The need to paint overrode my physical fatigue. Once I held that paintbrush in my hand . . . I could continue with my life.

Four Horsemen of the Apocalypse is from the New Testament's book of Revelation. The Horsemen are a terrifying group of marauders mounted on angry horses, killing everyone in sight. They are destroyers bringing

war, famine, and death to the world, but when I grappled with them on the canvas, they brought me life. I was studying Delacroix's and Géricault's battle scenes. The difference between my work and theirs was that the naked, beaten bodies that lay trampled at the bottom of my painting were all male; there was not a woman in sight. I was reversing the male-female roles without realizing it. I'd had enough of being trampled and beaten. In art I could do something about it.

The more impossible life became, the more I needed to paint. My studio in the back-alley room was dark and depressing. I had long thought that the living room, with its four large French windows facing Broadway, would make a great studio, and the time had come.

Knowing my husband would object, I waited until his afternoon performance at Radio City and called my friend Anita, who lived in the building, to help me. Together we dragged my easel and work tables into the spacious light-filled living room and pulled the sofa and chairs into the dungeon.

I felt a charge of excitement, knowing this move would bring me new life. The need to paint overrode my physical fatigue. I drove myself beyond normal limits. At those times, I seemed to feel adrenaline squirt through my veins, giving me a jolt of energy. Once I held that paintbrush in my hand, my brain lit up with colors, forms, spatial concepts, and iconographic ideas.

The Drawing Group

By 1962 I was the frantic, worried mother of an uncontrollable three-year-old child. The diagnosis was a condition labeled PDDNOS: Pervasive Developmental Disorder, not otherwise specified (autism was not yet recognized). I also had a one-year-old baby with eczema. No more lace panties for me—just foul-smelling wet diapers I washed by hand in the toilet bowl. Disposables were not yet on the market. As I bent over the smelly toilet bowl, I thought of Marcel Duchamp's pristine urinal, sparkly clean so the art world could call it an art object. No woman flushing shit from a loaded diaper and scrubbing out the stains for reuse would consider the toilet bowl an art object.

Melissa had an extreme sleep disorder. She didn't sleep for four years. Oh, maybe she dozed occasionally for an hour or so, but essentially, she was awake and active twenty-four hours a day. Nobody believed me. I know it's hard to fathom; it doesn't seem possible for a human being to

exist without sleep, but I was not dealing with a normally functioning brain. Maybe her brain was so charged that she couldn't turn it off, or perhaps being awake calmed her in some way, but I, as Melissa's mother, continued to be blamed for this extreme insomnia. Either I was lying, exaggerating, or inventing the whole thing.

This meant that I did not sleep for four years. I took catnaps but always had one eye open, one ear listening, always in attendance. She wandered the house, and I had to protect her from herself. It got to the point where I didn't know if I ate or drank that day. It was only when I felt faint that I realized I had not eaten.

It wouldn't be until sixty years later, in 2022, that I would read an article by an organization of parents called NCSA (National Council on Severe Autism) and feel truly validated and corroborated in the nightmare that I lived through.

We were poor. Frank made a meager living playing the cello in string quartets and pick-up orchestras, and between sales from group shows and to friends, I was able to earn a few dollars. I traded a painting with Bev and Hy Dolinsky for a moss-green sofa. The velour was worn and faded, but it was plush and comfortable. I traded with David Bar-Illan, an Israeli concert pianist, for a portable dishwasher, and with another young couple for a washing machine and dryer. I also traded with my obstetrician, Dr. Buchman: a still life for delivering Melissa, a portrait of his son for Hannah.

The rest of the time I painted my life, my children, my husband, and myself, alternating between portraits and still lifes.

I could never get Missy or Hannah to sit still long enough, so I started taking pictures of them with my Kodak Brownie box camera. They were incredibly small, postage-stamp size, two- or three-inch black-and-white snapshots, but they gave me the gift of time—time to study expressions, analyze patterns of dark and light, isolate forms and study shadows. Some shadows were long, others compacted. There were large shadows of bodies cast on the ground and small shadows cast under eyes, noses, lips, creating abstract shapes and forms, creating space and depth. Best of all, I could work in the quiet of the night, when all was calm and I was alone in the studio. I was recording my life.

I entered competitions, exhibited wherever I could, and shared ideas with a few other realist painters. Phil Pearlstein lived a few blocks away, and so did Harold Bruder, Gabriel Laderman, Joyce and Max Kozloff, Alice Neel, John Koch, Raphael Soyer, and Sid Tillim—our drawing

group. Like me, they were also breaking away from the constraints of abstract painting, and we all loved to draw. Most of us had children, we all lived and worked in our apartments, none of us drank excessively, and there were no crazy parties or oversized lofts to impress collectors. When it was my turn to host, I fed the children, read them stories, and put them to bed early so I would have time to draw. Missy kept showing up in the middle of a pose with her pants hanging down, and I kept taking her to the bathroom and putting her back to bed until she would finally fall asleep.

One night when the model didn't show up, all heads turned toward me. Sidney Tillim (an artist, critic for *Art News*, and close associate of Hilton Kramer) put his hand on my knee and said, "Hey, Audrey, why don't you pose?"

I gave him my best dirty look and snapped, "Why don't you drop your pants and stand there with your penis hanging out?"

Sidney stood up, unbuckled his belt, unzipped his fly, and smiled his toothy grin. "Wanna see?"

"Sure," I said.

Caught at his own game, he sat back down, pulled off his shoes and socks, stuck out his bare feet, wiggled his toes, and said, "Here, draw these."

We all laughed, but I suddenly realized that although these men respected me, I was to them primarily a woman, then an artist.

The artists in our drawing group were producing a new kind of realism. We called it "New Realism." It was an important bridge between Abstract Expressionism and what was to come . . . Photorealism. We were bringing back figuration, looking directly at the object. The interchange between eye and subject was no longer cerebral, but direct and real.

When Grace Hartigan and Bill de Kooning referenced the figure, it was still mainly cerebral and based on Ab Ex thinking. I love some of those works, but they don't have the direct vision, persistence, clarity, and refinement that the New Realists brought with them.

The world was abstract. We were breaking the code, rejecting old-guard realism, and bringing vitality to figurative painting. But no galleries would show us.

That gave me an idea for an exhibition that I hoped would open up the abstraction-dominated art world to realism. I brought it to Robert Schoelkopf, who owned a gallery on Fifty-Seventh Street. He had been

Fig. 33 Wide-eyed Melissa, 1964. Photo courtesy of Audrey Flack.

studying art history at Yale at the same time I was there with Albers.
He visited my studio regularly. The names I handed him were Lennart
Anderson, Leland Bell, Harold Bruder, Paul Georges, Gabriel Lader-
man, Louisa Matthíasdóttir, Philip Pearlstein, Sidney Tillim, and myself.
Schoelkopf thought enough of the idea to put on the show.

In 1963, *Nine Realist Painters* opened at the Robert Schoelkopf Gal-
lery and traveled to the Boston University Art Gallery, accompanied by
an illustrated catalog. It was the first of its kind in over a decade. Many
of the artists were taken on by other galleries, several by Schoelkopf
himself, but I was not among them. Women with children were just not
taken seriously.

I was becoming more and more fascinated with the camera. Pho-
tography was a key to the visual process. It recorded three-dimensional
information and reconfigured it into a two-dimensional format. It was
exactly what I had been trying to accomplish since childhood. I took
black-and-white snapshots of my family and studied how the lens trans-
lated light and dark, shadow and highlight, clarity and the blurring of
vision.

Several of my artist friends objected to my use of photography. They
felt I was defiling art and stood their ground with what seemed like reli-
gious fervor. Would they have been less adamant had I been a man?

"Give up photographs or leave the group."

It wasn't widely known that artists throughout history had used the photograph. Vermeer could be found in his Amsterdam studio with a camera obscura; Bouguereau and other nineteenth-century academicians used a variety of photographic devices. Daguerre went deep into the forest, snapped pictures of trees, shrubs, and waterfalls, made platinum prints, and used them as references for his paintings. Degas, Cézanne, and Manet all used photographs.

I lost friends and it hurt, but no one was going to tell me what to do or how to paint. It seems hard to believe now that photography has become an established art form, but back then I was breaking the rules, and when you do that, you pay a price. Harold Bruder was also experimenting with photographs and remained my good friend. Phil Pearlstein didn't seem to care that much either way.

I was merely following the natural course of art. Human beings need to see images of themselves, whether drawn on cave walls, painted, carved, or photographed. Modernism, with its doctrine of total abstraction, severed that connection, and representation was removed from sight. Even at the Metropolitan Museum of Art, Roman portrait busts were considered decadent and remanded to the basement simply because they portrayed the personality and individualism of the sitter. Greek classicism was more acceptable because of its underlying abstract, geometric forms.

Trying to paint with no money and no help took its toll. No school would accept Missy, because she wasn't toilet-trained. I spent most of my days squatting on the bathroom floor trying to teach her, but nothing worked. I tried to decipher her odd movements and strange verbalizations. But the mystery of autism remained unfathomable, its symptoms almost infinite. In the summer of 1963, I managed to scrape up enough money to rent an old shack on Neck Path in East Hampton for the month of August. I had rented there earlier, when Jackson Pollock, Bill de Kooning, and the whole Abstract Expressionist crowd came out. In those days, East Hampton was cheap and affordable. You could always find groups of artists lying on blankets with picnic baskets and bottles of wine, sunning themselves on "Artists' Beach," otherwise known as Georgica Beach. But I couldn't hang out with them, because without money for babysitters, I had no chance.

Fig. 34 Triple Self-Portrait, 1958. Oil on canvas, 42 × 40 in. Photo courtesy of Audrey Flack.

I was beginning to feel like one of those Spanish Dolorosas, the ones with a slew of daggers piercing their solid-gold hearts, except my heart was not gold. It was flesh and it hurt.

Jackson and Missy

Frightened, frustrated, and desperate to help my child, I dragged her to more doctors and was given a series of contradictory diagnoses. The devastating thread that linked all these opinions together was the implication that I was responsible for her abnormal behavior.

I knew that there was an intelligent brain locked up inside her head, so I went to the library and pulled out books on childhood mental disorders. I found nothing that even vaguely resembled my daughter's condition.

Autism was an unknown entity until 1943, when Leo Kanner, a doctor at Johns Hopkins University, isolated a small group of children who could not be categorized. Kanner noticed that while their behavior lagged behind the norm, these beautiful and strange children did not appear to be developmentally disabled in the classical sense. A great many remained mute, unable to express themselves or make their needs known. They didn't play with other children but remained isolated, sitting in corners rocking, spinning tops, or mechanically stacking objects. I was excited about finding the similarities between these children and Melissa. As painful as it was, at least I had a diagnosis. It seemed Missy was autistic.

Some autistic people have extraordinary skills, such as memorizing a telephone book with just a glance. One teenager made a mural-sized drawing of the entire city of Tokyo after taking a twenty-minute helicopter ride. Each building, window, and street was exactly placed and numbered. The term *idiot savant* was eventually changed to *autistic savant*, and in 1997 the movie *Rain Man*, starring Dustin Hoffman, exposed the syndrome to the public. But only a rare few are truly savants. The overwhelming majority of people with autism are far from glamorous.

My eyesight changed because of my special-needs child. I saw things I didn't want to see. It was as if shards of glass and detritus flew into my eyes and embedded themselves into my sclera. They pierced my iris and shot deep into my retina; they formed prisms and fractured the light. It hurt to see so much, but at the same time, it expanded my vision.

I began to visualize Melissa's brain looking like a complex computer, but certain wires were tangled into a jumble of knots. Amid this intricacy, there were sections so smooth that messages skidded over them.

Is that why she couldn't speak? Could her brain ever get untangled?

I thought of Jackson and felt a connection between him and Melissa. Her hold on life was as tenuous as his. Neither of them was grounded. Jackson wandered into outer space when he painted: floors, walls, and ceilings dissolved. I always pictured him floating in a white spacesuit, his hands extended, connecting ropes of stars and galaxies, and Melissa's perception of space was similar. There were no boundaries, no borders. She could float out of a window or in front of a car—ready to take off with no earthly connection. I feared for her life, knowing her fragile hold could be easily broken.

Was she a living Pollock, tied up in lacy, tangled threads and unfathomable vast spaces? She spun around and wandered, aimlessly drifting everywhere, nowhere, no goal in sight, blindly unaware of the world around her. She could be lost or not; no matter to her. You have to belong somewhere to be lost, but Melissa didn't belong anywhere. She could walk off the edge of the world. Who was she? Did she know she was a baby, that she had a foot, a hand, a mouth, that they were attached to her body? How could she move them? Somehow she did, and she ate and cried, and cried, and cried, and I wondered why, why, why?

Refrigerator Mothers

In the early sixties, Bruno Bettelheim's name kept popping up in the medical literature on autism. He claimed great cures and declared himself the sole savior of these tortured, misunderstood children, and he was praised as a hero. His book *The Empty Fortress* compared the homes of autistic children to Nazi concentration camps. He lectured throughout the country, speaking before psychiatric organizations, hospitals, and universities, and he even appeared on national television. At each event, he insisted that abnormal maternal behavior was the principal problem, that we rarely cuddled our children, that we were removed and uncaring. Autism was the result of bad mothering. No blame was ever placed on the fathers.

He said that being brought up by women like us was like being reared in a refrigerator that never defrosted. The worst blow of all: he said our *breast milk was black and poisonous*. By removing these children from

their homes and severing all ties, he was liberating them from destructive mothers who wished to annihilate them.

Over and over again he reiterated that because of extreme frustration in the mother-infant relationship, our children had developed the symptoms of autism. The mental health profession accepted his theories; mothers were a major "pathogenic" factor in contributing to the disorder. Bettelheim cursed us with the name "refrigerator mothers."

The label stuck. The fact that Melissa's checkups and blood tests were normal only reinforced Bettelheim's theory. I was the bad mother who had caused Melissa's condition.

Bettelheim created the Orthogenic School for "mentally disturbed" children on the campus of the University of Chicago. It was an impressive-looking building with a statue of a full-breasted, naked woman lying at the front entrance. The poor creature was on her back, fully exposed. The children going in and out were encouraged to kick, beat, and stomp on the reclining, helpless mother figure.

Moreover, Bettelheim had masks made with stiff, unexpressive faces. He called them stone masks. They, too, represented the mother, and children were encouraged to scratch, slap, and step on them.

He was a guest on the *Dick Cavett Show* and bragged about his theories to a vast television audience. A reviewer in the *New York Times* on March 10, 1967, called his book "inspiring." It wouldn't be until years later that Bruno Bettelheim was exposed as a fraud. He had invented his qualifications and degrees in psychology and psychiatry.

Way back then, in an odd way, I almost welcomed the blame. If I was the cause of Melissa's condition, then a change in my behavior could also cure her, and I wanted desperately to cure her. But I did not know what behavioral changes to make; I was already dedicating my life to this child and I wasn't cold or unfeeling. Just the opposite: I felt every ounce of her pain. I still do.

Considering that there was no other help available, and taking into account Dr. Bettelheim's glowing reputation, I sent for the literature and school application. I found that once a child was admitted, the mother was not allowed to see or speak to her child for one year. I could never hand Melissa over to a stranger and not see her for a year. And I didn't have the means to pay the tuition, even if I'd wanted to. As far as I could tell, only well-to-do families could afford tuition.

Families were destroyed by Bettelheim's accusations. Husbands held their wives accountable. Some became abusive; others up and left.

Wives stayed behind and became depressed or dependent on pills given to them because they were "neurotic." Husbands who remained in their marriages stayed late at their jobs and avoided coming home, and who could blame them? Wives were left alone to care for noncommunicative, uncontrollable children. Eighty percent of the marriages ended in divorce.

In 1964 I learned that Lenox Hill Hospital was about to institute a special program to study autistic children. It was based on Bettelheim's refrigerator mother doctrine as well as Freudian psychogenic theories, but I didn't care; it was the only help available, a straw held out to a drowning woman, and I grabbed it. The hospital would evaluate each mother and child separately to determine which ones fit their research.

I was subjected to a series of interviews with Mrs. Janus, the social worker, before Melissa could be accepted for treatment. She sat behind her desk with a cold, superior attitude and responded to every question I asked as if I was a "schizophrenogenic mother" (Bettleheim's term) and she was the analyst examining my mental state.

It was insufferable, but I suffered it. I said what Mrs. Janus wanted to hear in order to get Missy into the program. All the mothers did. I bit my lip until it bled, nodded my head like a bobbing doll, forced a smile and got Melissa in.

The teachers were instructed not to talk to the mothers because we were the cause of the children's problems. Melissa was four years old and still mute.

The process of getting her to the hospital was formidable. First there was the ordeal of getting her dressed. She fought, kicked, screamed, and bit. My arms were scarred with bite marks. Little did I know that Melissa's skin was so sensitive that the touch of clothing was painful.

We had to cross Broadway to get to the bus stop. I couldn't afford a babysitter, so I brought little Hannah along. Melissa refused to walk; I dragged her. Everyone looked. Heads turned. The light turned green.

"Let's cross, children, come on."

The three of us made it halfway across when Melissa yanked free and lay down flat on her back in the middle of oncoming traffic.

"Get up, Missy. Please!" I begged.

I looked up—cars, trucks, and buses were headed toward us.

"Hannah, darling, hold on to Mommy's coat. Don't let go."

I held up my hand.

"Stop!" I shouted.

They honked and beeped but waited long enough for me to get Melissa up. I yanked so hard I was afraid I'd pull her arm out of its socket, but I got her up and carried her in my arms on the crosstown bus. Once on the bus, I prayed for a seat. As I was working my way down the aisle, Melissa snatched a wig from a woman's head.

Her incredible peripheral vision had kicked in and, once again, she performed a startling act while looking straight ahead. It happened so fast the woman was stunned, but then she spotted Melissa holding her mop of hair.

"Give it back now!" the bald woman yelled.

"I'm terribly sorry," I apologized, trying to pry the wig from Melissa's clenched grip. "Let go, Melissa, please."

Words did no good. I had to use force and un-pry each finger. The wig was a mess when I passed it down to the woman, who by this time was filled with rage. She pointed at me and yelled, "That mother should be put in jail!"

I wrapped my legs around Missy to prevent her from kicking and held her hands down so that no one else would lose hair or hat. Hannah sat by my side hugging a stuffed animal.

We disembarked at Park Avenue and Seventy-Ninth Street and began the three-block trek to the hospital.

"We're nearly there," I said cheerily, out of breath.

I looked down. Melissa's hat was half off and she was now walking without a shoe. Her foot was wet and caked with snow and slush. If I retraced my steps, she would miss her one hour of school, the only hour in town. Who knew when or where she kicked it off? It could be back on the bus for all I knew, or run over by a truck. I picked her up.

"Hannah, darling, can you walk one more block?"

"Yes," she nodded sweetly.

I was told to wait in the freezing hospital lobby until my name was called and spotted a couple of other bedraggled women like me—my sister refrigerator mothers. We didn't even have a waiting room, just a row of hard, orange plastic chairs in a section near the front entrance. Every time the automatic doors opened, our children tried to run out. Because frigid blasts of air blew in, we kept their snowsuits, hats, and gloves on, even though they constantly took them off. Most autistic children don't like to wear clothing; their skin is too sensitive.

Like madwomen, we chased our children around the lobby, putting shoes and hats back on, zipping up jackets, or just physically holding them down to keep them from knocking over potted plants, chairs, and lamps or running into the elevators.

We compared notes, talked about possible cures, and shared horror stories about the physical and mental abuse going on in state institutions. None of us had sufficient funds for private schools, and the thought of our children winding up in Pennhurst or Letchworth terrified us. Some of us started talking to ourselves. Most of us looked as though we were on the verge of a breakdown—and many of us were.

The mothers' observations and opinions were dismissed as neurotic and therefore invalid, so in spite of the fact that we knew far more than any doctor about our children's condition, we learned to keep silent. We tolerated mental and verbal abuse in order to keep our children in the pitifully inadequate program.

The one-hour program was really for the benefit of the hospital's psychiatric research department. Our children were specimens, and so were the mothers. After Melissa was accepted, I was instructed to bring her to a separate hospital entrance on Lexington Avenue in a room a few steps down from the street. I was to ring the bell and wait. I followed the instructions. A door opened: the teacher took Melissa's little hand and, without a glance or nod of recognition to me, closed the door in my face. I was never let in or spoken to.

After a year of such studied and cruel indifference, the door once again slammed shut and I found myself in a drenching rainstorm on Lexington Avenue. Tears poured down my cheeks and mingled with the rivulets of rain. I stood there sopping wet, with nowhere to go, and not caring. Death was my only consoling thought.

A police car inched by and the driver noticed me, a solitary figure standing frozen in the pouring rain, without an umbrella, while everyone else scattered for cover. The policeman yelled from his window, "Are you all right, lady?"

His voice was enough to pull me out of my stupor.

"Uh-huh," I murmured, and moved on.

I took refuge in a nearby coffee shop, where I waited until Missy's playgroup was over. The door opened once again, and Melissa was handed to me without a word.

One mother, Madeleine, was lucky: her husband, Arvell Shaw, was supportive. At least 6'5" and powerfully built, Arvell had been approached by several football teams to be a linebacker, but he was a gentle soul and a great musician. Madeleine was a stunning, six-foot-tall woman with flaming auburn hair, ivory skin, and a strong French accent. Their daughter Victoria's skin was the color of light caramel, a perfect blend of her parents, and just as big as both of them.

Arvell was Louis Armstrong's bass player, and Louis was Victoria's godfather. Victoria had the amazing ability to hum any song the first time she heard it, but she couldn't speak a word. The experts decided to stop Victoria's singing, thinking it would encourage her to talk, but the end result was that she stopped singing and never spoke.

Arvell's jazz trio played at small supper clubs around the city, and occasionally Madeleine and I went to the dark, sophisticated bars of the Carlyle and Embers. We wore dresses and high-heeled shoes and sipped martinis, like ordinary New Yorkers with ordinary problems. I'd softly call out songs like "Embraceable You" and Arvell would wink at me and play them. It was a dream that lasted only for an hour or two, but it was a wonderful reminder that life was out there.

Arvell was one of the few husbands who remained by his family's side. Although he was going blind, he continued to give benefit performances for autistic children long after Madeleine died of heart failure in her mid-forties. He called me to share the terribly sad news. He said, "Her heart couldn't take it. The strain and worry about Victoria killed her."

When Arvell died, he was the last shred of contact I had with my early life as a "refrigerator mother." I miss him terribly.

I was in my late thirties when several of my refrigerator mother friends began to get sick, and two of them died. I wondered why I was still alive. Was it because the Old Masters were there for me? Rubens, Tintoretto, Crivelli, Cézanne, and Rembrandt took the place of friends and family. I could rely on them. Rembrandt's self-portraits pulled me through when I felt despondent. His paintings gave me solace. His last self-portrait was so brutal that I couldn't believe it was the same person. From a corpulent, well-fed Dutchman he had dwindled into a shriveled, hunched, doddering fool, weakened by life to the point of bathos. He has a strange, disturbing smile, almost a laugh, almost the cackle of a gibbering idiot. Was he presenting us with the ultimate irony, getting the last laugh at life before dying?

That's me, Rembrandt, that's me, I thought.

I functioned automatically. I shopped, cooked, cleaned, and worked without stopping. I seemed to be able to exist with almost no sleep. Melissa was still mute, and I tried Applied Behavior Modification (ABA) and anything else I heard about, as long as it didn't harm her. But everything proved to have very little effect in helping Melissa communicate.

Hannah's asthma worsened. I was worried sick about her. It was two in the morning, and I was holding Hannah's hand, watching her gasp for breath, and I knew this had to stop. Melissa's needs could no longer jeopardize the health and well-being of little Hannah. I was forced to make a devastating decision: COMMIT MELISSA.

One of the mothers suggested the Camphill School in Exton, Pennsylvania. It was based on Rudolf Steiner's theosophical philosophies, and it was reasonably priced. The school was in Amish country: a large, white, rambling farmhouse in the middle of a vast field of uncut grass. Its mission was to help special-needs children. When I visited I found everyone to be kind, and the food was healthy and ample. This was the place: Missy would be well cared for, I could bring Hannah back to health, and I could get some time to paint. But I needed money for tuition.

I wrote up a proposal to teach a drawing class at the Riverside Museum on 103rd Street and Riverside Drive, two blocks from my apartment. If the babysitter got into trouble I could get home within minutes. Oriole Farb, the director, accepted my proposal on the condition that I get enough students to register. I designed a small poster and tacked it up on lampposts and storefront windows.

Twenty-five students signed up, and it was a go. My mother-in-law, Else, watched the children. I set up easels, hired models, gave individual instruction and demonstration lectures, and taught my first drawing class. At times, I brought a small canvas and painted the model while the students sketched. The greatest thing about it was getting out of the house and interacting with adults. I felt alive; I was a person, a teacher, an artist. It reminded me of the Grand Chaumière, the atelier I attended during my glorious days in Paris after Ruth Kligman had sold my painting to Marcel Marceau. The class was a success.

But I also knew I had to leave Frank to make a decent life for the children and myself. I needed money for rent and food. I had none. I began to hide small bits of my salary, five or ten dollars under a green sweater in the closet, in containers in the kitchen, wherever I thought Frank would not look. But he sensed my resolve and tried to control me with threats.

He stalked me, followed me around the house, and snapped pictures of me in the kitchen or in the bathroom. When I was brushing my teeth or washing my face, I would turn around and there he was, with the camera clicking again and again as the flash went on and off.

It was time to get out. I became hyper alert, defending and protecting my children as best I could until I could make my move. Hannah's childhood asthma wasn't getting better. I wanted a divorce, but it would take time to get one.

I was teaching my drawing class when Oriole Farb called me into her office and offered me a commission to paint a portrait of her family. Of course I accepted, and within days she handed me an advance payment. I now had money for Missy's tuition. The time had come for her departure. Choking down tears, I packed her clothes, toothbrush, and favorite toys, helped her into the car, and drove three hours up the turnpike to Exton, Pennsylvania. I tried to explain what was going on to Missy, but I don't know if she understood, or maybe she understood too much: she threw up. We were given a tour of the premises and introduced to her teacher Hedda, who would be her main support.

Missy looked bewildered. Her eyes opened wide, her pupils dilated; she stared right through everyone and even refused the juice and cookies. Hedda tried to comfort me, but I was deeply concerned about Melissa and shaken by my decision to leave her. I tried to say goodbye, hug her, and kiss her, but Melissa wouldn't look at me.

"Please look at me, Missy. Mommy loves you. I'll be back soon. You'll be fine."

I wrenched myself away and drove off without looking back.

Without Camphill, I might have gone under, and who knows what would have happened to Hannah? With Missy away, I was able to work on the commission. I arrived at Oriole's apartment carrying a tripod, cameras, and rolls of film and carefully posed the family, considering height, position, and character traits. I had them stand in a frontal pose, like Grant Wood's *American Gothic*, shot over one hundred photographs and slides with all sorts of bracketing and lighting changes, and took my leave.

Back in my studio, I stretched a linen canvas and started to sketch the figures in charcoal. It was ten o'clock at night and the drawing was almost finished when I got an idea that blew my mind open. If I was going to paint over my drawing, why not eliminate it altogether? I could project the image and paint directly onto the canvas. Even though it

Fig. 35 Self-Portrait in Tank Top, 1956–57. Oil on canvas, 70 × 48 in. Photo courtesy of Audrey Flack.

was close to midnight, I called a photographer friend who lived in the neighborhood.

"I'm sorry, I know it's late, but can I borrow your projector?"

Jerry understood the art imperative and within minutes he knocked on the door and handed me his Kodak Carousel. I dropped my slides into the slots, switched on the projector light, and my world of art instantly changed.

Incredibly, the scale and accuracy of my drawing matched the projected image to within a fraction of an inch. I was pleased with the exactness of my vision, and from that time on, I eliminated the time-consuming, tedious preparatory drawing and worked directly from

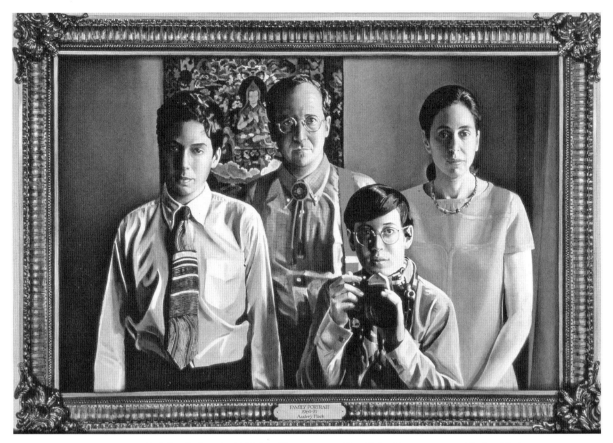

Fig. 36 Farb Family Portrait, 1969–70. Oil on canvas, 40 × 60 in. Photo courtesy of Audrey Flack.

projections. To my knowledge, *Farb Family Portrait* is the first contemporary painting ever made from a slide projection.

During that year, Hannah and I spent wonderful times together. Hannah painted at her small easel, and I was right next to her at my big one. I played Mozart string quartets, Beethoven piano concertos, Diana Ross and the Supremes, Josh White, Bob Dylan, and Joan Baez. I took her for Suzuki violin lessons and tied a big pink bow in her hair when she performed on her tiny quarter-sized violin with her class. We even stopped off for ice cream or a snack on the way home.

As the months passed, I missed Melissa terribly, despite the chaos and confusion she created. I also realized that she wasn't making much progress and needed more of a program than the one Camphill offered. I brought her home.

We drifted until I heard about a Manhattan school for autistic children in a church on Twelfth Street and Fifth Avenue. I took Missy for

an interview, and thank God, she was accepted. A school bus for special-needs children picked her up in the morning and brought her back at one o'clock in the afternoon. Having Missy at school for even such a short amount of time allowed me to search for another teaching job. I heard about an opening at the Pratt Institute, but I needed a recommendation and called my old classmate and friend Milton Glaser. I asked him to write a few sentences on my behalf. He replied . . . "What can I say? I'll tell them you're a nice girl."

It was a devastating blow. Milton and I had been classmates at Cooper Union. We had painted next to each other and sung folk songs together; he had dated my roommate Pat and hung out in our living room. He was a graphics major and had already started Pushpin Studios. Milt asked me to be part of the group, but I was a painter, not a graphic artist, and I politely declined. Years later Milt became famous for (among many other things) co-founding *New York* magazine and designing the I ♥ NY logo.

In those days graphic art was considered a commercial tool, and even though Milton became rich, powerful, and famous, he wanted acknowledgment for his painting as well as his graphic design. At the same time, I was broke but exhibiting and gaining recognition in the fine arts world. His competitive feelings must have simmered for years, because he refused to write a recommendation for his down-and-out

Fig. 37 Audrey Flack painting with Hannah in studio. Photo courtesy of Audrey Flack.

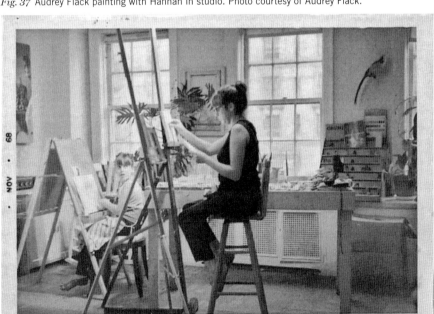

classmate. It took me years to forgive him. We became cordial again when we both received honorary awards and were elected to the board of our alma mater, Cooper Union. I was the only woman trustee and had to fight hard to have my voice heard. Our friendship became strained once more when Cooper Union threatened to close the Art School as a result of financial difficulties. Milton and I fought over the matter, and it was due in part to my protest and intervention that the Art School remained open.

Luckily, another job opportunity arrived when Sid Tillim got sick and asked me to take over his drawing class at Pratt. I grabbed the chance and went to work the very next day. All my pent-up energy went into teaching that class. My sense of humor returned, and I even cracked a few jokes. I wore tight jeans and strode around the classroom imparting knowledge, excitement, and humor. The students loved it and so did I.

Howard Conant, the chair of New York University's art department, heard about that class and offered me a job teaching anatomy and drawing. I now had two jobs teaching what I loved. I asked if, by any chance, they had a skeleton. The custodian vaguely remembered one being stored in a basement locker years ago and handed me a loop of keys. I wandered the bowels of NYU's basement until I spotted a beat-up, rusty locker tilted sideways in a corner and pushed a key into the padlock. Miraculously, it opened. There she was, smiling at me with all but one of her teeth, a beautiful but slightly abused specimen.

I called her "The Bride of Frankenstein" because she was put together with parts from more than one dead body. I cleaned her bones, realigned her misdirected fingers, wheeled her up to my sixth-floor classroom, and proceeded to teach the first art anatomy class at NYU in fifty years.

It took an hour by subway to get to my morning class at Pratt. At twelve-thirty I hopped the subway back to Manhattan to teach life drawing at NYU. I gobbled a muffin and slurped coffee on the subway ride back to Pratt and taught two-dimensional design, lettering, and anatomy. At the end of the day I boarded the train back to the Upper West Side, happy to get a seat. I relieved the babysitter, cleaned up Melissa's mess, attended to Hannah, cooked supper, and fed the children. I was exhausted and exhilarated at the same time. For those few hours I escaped the bondage of autism and entered the outside world.

It was great spending time with the artists Romare Bearden and Rudolf Baranik, who taught in adjoining rooms. We shared ideas during our lunch breaks. Teaching jobs were scarce, particularly for women.

Fig. 38 Audrey Flack (next to skeleton, with right arm akimbo) teaching anatomy at New York University. Photo courtesy of Audrey Flack.

The students responded to my teaching and my classes were filled to capacity, but I was given the worst time slots and the lowest salary. At the end of the year I asked about better hours and a possible raise. The answer was, "Be glad you have the job. You're married."

I recognized the attitude and immediately shut up. I needed the work.

Sometimes Frank would arrive home in time to wolf down a brief dinner between performances. Spotlighted in the center of the Radio City stage, he played "Kol Nidre," the most haunting, poignant song of the Jewish High Holy Days. That remained the height of his musical achievement. There were four to five shows daily, and he was rarely home, staying downtown and eating out.

The school bus picked Melissa up every morning at eight o'clock. When it didn't show up, I'd buckle up both children, drive to Missy's Twelfth Street school, double-park, and coax Missy up the stairs while carrying Hannah. I'd drive to Pratt with Hannah buckled in beside me.

Prepared with cookies and snacks, I gave her colored pencils and paper and began to teach. Hannah sketched the model along with the class. Everyone loved her.

When I got more classes to teach, I found a mature, capable woman to babysit, certain that she could handle the children until I got home. One Friday afternoon around six o'clock, after teaching all day, I was walking from the Ninety-Sixth Street subway stop to 104th. I picked up a few groceries for dinner and was feeling good about the day until I rounded the corner and saw red-and-blue strobe lights flashing in front of my building. A flurry of people surrounded a policeman holding a little girl's hand. It was Hannah! I rushed toward them.

"Hannah, are you all right?"

She nodded yes.

"Where is Melissa?"

"Upstairs, Mommy."

"What happened?"

Hannah looked down. The policeman answered.

"A man found your daughter a mile away, sitting alone on a swing in Riverside Park."

Thank God he wasn't a pervert. It was wintertime; the sun set early, and the park was dark, deserted, and cold. He reported the missing toddler to the police. I had taught my precocious Hannah her address and street number, and the police took her home in their car. She had been missing for three hours.

I carried Hannah upstairs and asked the worried babysitter what had happened. She explained that she'd been running after Melissa and when she turned around, Hannah was gone. She couldn't handle both children at once; no one could. I cut my schedule after that and came home before play school ended. I hated to give up those classes. I needed the work and the money so I could get the kids and myself out of the hell we were in. I was crawling out of the bottom when the Riverside Museum requested my work for a forthcoming exhibit called *Paintings from the Photo*. It was 1969 and, notably, the first exhibition of Photo-realism anywhere.

Freedom

I was thrilled to have my work in an actual museum, even though it was on 103rd and Riverside Drive. I didn't realize it then, but I was the

only woman in the exhibition. My excitement skyrocketed higher still when one week later I got a surprise call from Jim Monte, curator of contemporary art at the Whitney, who said, "Audrey, I've got good news. You're going to be in the Whitney's *22 Realists* exhibition. You're the only woman in the show; it will open this coming year."

I had never heard those words before . . . "the only woman." And when *Arts Magazine* published a photograph of all the Photorealists on their cover, I saw myself for the first time as the only woman in a group of male artists including Chuck Close, Robert Bechtle, Richard Estes, and a dozen other artists.

I came home from the Riverside Museum *Paintings from the Photo* opening in time to hear the phone ring. It came out of nowhere, a call from someone I hadn't seen for many years: my first boyfriend, Bob. The boy I had my first dance with, the boy I'd shared my dreams with.

"Hello, this is Bob Marcus. Remember me?"

"Of course I do! How are you?"

"I'm fine. I saw your name in the *New York Times* announcing the exhibition at the Whitney Museum and I thought it would be nice to catch up. Would you like to have dinner some evening?"

I felt a flush of comfort just hearing his calm, assuring voice.

"I'd love to," I said. "But I'll have to get a babysitter, and there are time constraints. I have to be home before ten o'clock." That was when Frank's last Rockettes performance ended at Radio City.

"Like Cinderella?" he asked.

". . . Yes, I guess so."

Fig. 39 Group photograph of the Photorealists, 1970s. Audrey Flack is in the second row, between Richard Estes and Charlie Bell. Photo courtesy of Louis K. Meisel Gallery.

Fig. 40 Young Bob Marcus. Photo courtesy of Audrey Flack.

We arranged to meet at Orsini's, an upscale restaurant on Fifty-Sixth Street. Bob was waiting at the entrance when I arrived. He hadn't changed much: tall, slender, a little less hair, the same serious face. We shook hands. Bob remembered my favorite wine and ordered a bottle of Pouilly-Fuissé. We clinked glasses and smiled at each other. I was delighted to find Dover sole on the menu. Bob seemed amused as he watched me close my eyes and relish every morsel of the delicately flavored fish. It was the first relaxed meal I'd had in years. Still, I looked tired and strained.

I told him I was married with two children. He said he was living in Westchester with a wife and three children. He had recently left his job to venture out on his own, dealing in commodities. As we caught up on our lives, I mentioned Melissa's difficulties.

"If I could only find a school for her, I could get a substantial job. There is no babysitter on earth that can handle her long enough for me to go to work."

And out of a deep well of kindness, Bob threw a lifeline to his drowning friend—no strings attached. He lent me five thousand dollars, enough to start Missy in a sleepaway school in Connecticut. Bob was far from rich; he was just starting out, but he possessed a compassionate generosity of spirit that has been with him all his life.

"I'll pay it all back. I promise."

"Whenever," he said quietly.

The school was in Cheshire, Connecticut, and had more of an educational program. I went through the interviews and painful feelings of separation all over again. It was the second time I was sending my child away, and there was no getting over it.

With Melissa away, I was able to resume teaching, get some sleep, and pay more attention to Hannah. Even though I worried continually about Melissa, keeping her at school was the only means I had to save Hannah and myself.

Bob was brought up by a stoic British mother who rarely showed emotion. She was skinny and wore tight dresses with lace collars. Her household was neat and orderly, and so was her cooking. She made square hamburgers, so uniform they looked measured with a ruler. What a contrast to my mother's plop-and-fry jobs!

Bob's house was always quiet, controlled, and empty; it felt like a mausoleum compared to my katzenjammer three-ring circus. Bob had the reserve of a true Brit, which made it all the more surprising when he spoke to me about his troubled marriage.

"You must try to make your marriage work. That's what I'm doing."

I was conflicted. I knew I had to leave, and yet I would fall for Frank's apologies and try again. In those days, divorce was something you simply didn't *do*, and I was still obeying the rules.

Bob and I hugged goodbye and didn't see each other for a long while. Frank and I went to a Viennese Freudian marriage counselor, a friend of Uncle Ernst who liked Frank a little too much. She sided with him, falling for his innocent act, and I didn't have a chance. Frank became more demanding and even less involved with the children. And he frightened me with his sudden outbursts, which had become more frequent. I lay in bed next to him and waited for him to fall asleep. Only then did I feel safe enough to close my eyes.

We were having an argument in the car, which was double-parked on Broadway. Frank was agitated; I was fed up and scared.

"I'm not driving with you!" I shouted.

"Yes, you are." He held the door closed.

I pushed it open and walked to the trunk to get my sketchbooks. Suddenly, the engine revved, and Frank backed the car up. With hyper reflexes, I was able to jump onto the sidewalk with barely an inch to spare before I got hit. Frank drove away with a screech.

My God, was he trying to kill me? Maybe he didn't see me. I was in denial. I stopped to catch my breath when a woman walked up to me and said, "I saw what that man tried to do to you. If you need a witness, here is my card."

"Thank you, but that's not necessary," I stupidly said.

But it was the corroboration I needed, and it registered. She was a Good Samaritan, a woman who had probably been in a similar situation herself. I will always appreciate her offer of support.

I became more detached, more determined to leave, and Frank sensed it. He threatened to kill me if I left him. He said he would take Hannah and put Melissa in a state institution where she would die.

It is hard to fathom a mind that has broken from reality, a mind so twisted and desperate that it no longer adheres to civilized behavior, a person who follows his own rules and uses force to get his way. And it was hard to believe what was happening to me.

Was Frank a borderline personality, shifting back and forth between reality and psychosis?

Such people can be seductive, brilliant, and charming; sometimes they resemble geniuses. I couldn't let him harm Missy and steal Hannah, but I had to survive until I could get us out. It happened quietly and suddenly, one month after the car incident, while I was teaching at NYU. The thought of returning home made me shudder—I had reached my limit and could no longer live in fear. I had to get out; my marriage was over. The revulsion and pain that had been building for years now turned into action. I asked my teaching assistant to take over the class and called the only lawyer I knew, a young man I had dated years ago.

"I need your help. I'm afraid of my husband. I can't go home anymore. What should I do?"

"Do you have a place to go?"

"I could stay with my brother in Atlanta."

"Then change the locks and leave town immediately. Call me when you get back."

I searched the Yellow Pages telephone directory, found a locksmith, and told him to meet me at my apartment at exactly two-thirty, a time when I knew Frank would be performing.

"You must be there on time, not one minute late, and you must be finished before the hour is up!"

"Okay, lady. What's the hurry?"

"Just be there!"

I was afraid for my life. I couldn't have Frank walking in on us. Unconcerned—or maybe he was used to this kind of urgency—the locksmith agreed. I went home, and with adrenaline pumping and a racing heart, I packed two valises, one for me and a little one for Hannah. I made sure to take her ragged security blanket and favorite stuffed animal. I watched nervously as the locksmith turned the last screw into the symbolic end of my marriage. I paid him, locked the door with my new key, and ran down Broadway to Hannah's school. Her teacher looked up in surprise when I walked into the classroom.

"I need to get Hannah a little early," I explained. I grabbed her little hand and said, "Wave goodbye, Hannah. We're going on a little trip. We'll be back soon."

I hailed a taxi.

"LaGuardia Airport, please," I said, "and make it fast. We have to catch a plane."

We just made it. Once on board, I buckled our seatbelts and heaved a sigh of relief. We could live with my brother, Milt, until things subsided, until I could get my bearings. I looked at Hannah sitting beside me. She was mumbling something.

"What are you saying, Han?"

"I wrote a poem."

"Let me hear it."

I waited patiently until she responded softly: "That was the day that lightning struck. We took a taxi, we passed a truck."

Hannah and I stayed with my brother for two weeks. She slept in a room with his children, and I slept on the couch. It was the first time I'd felt safe in years. My brother told jokes, like our mother. He had a million of them stored in his brain, one for every occasion. I began to smile.

"Did you hear the one about the talking dog? Or the one about the farting Honda salesman with the toothache? Did you hear the one about the dumb blonde on the airplane?"

Only when I doubled over laughing did he stop. He crooned tunes with his resonant Frank Sinatra voice while I accompanied him at the piano. We had breakfast, lunch, and dinner together. Hannah played happily with her cousins. Her asthma seemed to be easing when it was time to return to New York. Hannah had to get back to school, and I needed to get back to work.

We returned to a quiet apartment. Frank was gone. Missy was at away at school. The chaos was over. It was a great relief, but Hannah and I rattled around, confused and disoriented. Living with disturbance and destruction was what we had become accustomed to. We had been home for two days when I heard crashing sounds at the door. It was Frank, trying to break in. I picked up the phone to call the police but decided to try his mother first. The last thing I wanted was another scene. Else lived a few blocks away and quickly came to her son's rescue, as she had always done. She was able to persuade him to leave quietly. I had let myself be convinced by his pleas and promises so many times before, but no more. No more stories, no more explanations, no more threats, tears, or bargaining. I was getting a divorce.

I bought a gray-striped suit and white silk blouse to fly to Mexico, alone, to get the divorce. For some reason I wanted to look proper. This was a solemn occasion—not that anyone noticed. I made arrangements for Hannah to stay with my friend Anita, who had a child the same age and lived in the building. I boarded the plane with other individuals in the same boat. It was a quiet trip.

I stayed overnight in a decrepit hotel in Tijuana, stood before a Mexican judge who spoke no English, handed him my papers, and got a divorce. I agreed to fifteen dollars a week for child support for both children: it was hardly enough to buy a pair of shoes. I received nothing else, no alimony, no health benefits, nothing. I was alone, I was free, and I was euphoric.

We were divorced in 1969. Three months later, Frank remarried and subsequently divorced within a year. It wasn't until 1970, when Melissa was ten and a half years old, that she was officially diagnosed with autism by Dr. Mary Coleman, director of the Children's Brain Research Institute in Washington, DC. Dr. Coleman was tall and slender and wore a full-length white doctor's coat. She took Melissa's hands and smiled down at her. Missy looked into her eyes and spurted a barrage of sounds. She didn't stop for another ten minutes, louder and increasingly emphatic.

Her questioning sounds were intense and heartbreaking. Missy desperately wanted to talk.

"Yes, Missy, I know," Dr. Coleman said. "You have many questions."

"Mummummmm?" Missy continued.

"I am going to try to help you," Dr. Coleman replied.

She turned to me and said, "Be careful what you say in front of Melissa. She's smart. She understands everything."

Dr. Coleman ordered brain scans and blood tests, but the results were normal. We worked with Dr. Coleman for many years and explored new scientific theories. But nothing helped Melissa.

The Hero

In the interim, Bob's marriage continued to deteriorate. He went to the famous Ackerman Institute for marriage counseling and saw Nathan Ackerman himself, who after several sessions said, "Get out, you're dying!"

Within months, Bob rented the second floor of an East Side brownstone and we began seeing each other more frequently. He stopped by my noisy Broadway apartment after work, and we went out to neighborhood restaurants for dinner. We watched TV, played games, and laughed over his silly yet clever quips. When it got late, Bob slept over. We made sure to put Hannah to bed first so she wouldn't know. Bob got up before dawn and tiptoed out the door between five-thirty and six o'clock in the morning, but I think she knew anyway.

At last, life had changed for the better. This entire period was one of exploration and joy. I became wrapped up in photography and sorted through objects in flea markets, gathering props for future work. My paintings changed, my colors brightened, and death took second place as my subject matter. I painted Michelangelo's statue of David, the young hero, the slayer of Goliath. That painting was about Bob; he was my David, my prince, my hero. I was in love.

It took Hannah and me a full year to adjust to "normal" life. With the chaotic energy gone, Hannah became physically healthier, and her asthma gradually subsided. The simple act of living, sleeping, eating, and working without fear and panic was a blessing. I was offered several teaching positions with better schedules and began to work full time. Still, I found it difficult to shake my depression over losing Melissa. Hannah and I were rattling around in an empty apartment without Melissa,

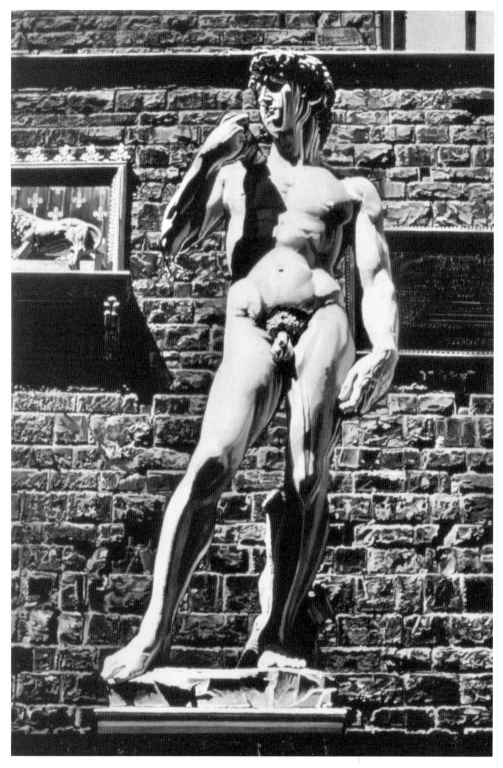

Fig. 41 *Michelangelo's David*, 1971. Oil on canvas, 66 × 46 in. Photo courtesy of Audrey Flack.

without Frank. But I loved my new light-filled studio. The window-sills were twice as wide as ordinary ones and gave me ample room to set up complex still life arrangements. Tulips, roses, red and pink geraniums, oranges, peaches, apples, vases, and vibrant drapery filled the room with bolts of colored energy as I played Schubert's "Trout" quintet, Mozart's G minor quintet, Diana Ross, and old-time banjo music. Glorious sounds filled the bright, airy room as Hannah and I listened and painted together.

It was a year that brought a whole new way of life. I bought a German Hasselblad with a set of exquisitely precise lenses and began shooting in a square 2 by 2 inch format, as opposed to the 35mm rectangular form of the Nike and Canon cameras. The proportions of my canvases changed, and I began to make square paintings. I studied aperture openings, time exposures, lighting systems, and filters. I turned the studio bathroom into a darkroom and printed my own Cibachrome color photographs.

I was making large and complex paintings that took months—even years—to complete. In between these enormous projects I decided to make a couple of smaller tour de force works as a relief. What could be better than luscious, creamy sweets to offset the soul-searching life-and-death *Vanitas* paintings I was creating? So I bought a scrumptious coconut lemon cake at Lichtman's bakery on Amsterdam Avenue. I found a heart-shaped Valentine's Day cake on Madison Avenue and laughed when I saw the word *Mother* written across the top in bright red icing. It was the pinnacle of saccharin-sweet irony for a mother you might love but also want to devour. I found a vintage crystal dish, perfect for a banana split sundae, and filled it with a sliced banana and three scoops of vanilla bean ice cream. I squirted swirls of whipped cream and drizzled strawberry preserves over the top. One solitary, glistening maraschino cherry crowned the mouth-watering creation. After the photo shoot, Hannah's friends hung around, waiting to lap up the collapsed whipped cream, melted ice cream, and sticky syrup. They licked up every last bit.

The early seventies brought with them the start of the feminist movement. Marcia Tucker, then curator at the Whitney Museum, invited a group of women to her loft in SoHo to form one of the first consciousness-raising groups. We met once a week and discussed hitherto unspoken issues, such as being financially independent of the men in our lives, our feelings about our bodies, and sexuality. At one meeting I said, "I just scheduled a one-man show."

I was shouted down.

Fig. 42 Banana Split Sundae, 1974. Oil over acrylic on canvas, 38 × 50⅛ in. Photo courtesy of Audrey Flack.

"You are referring to yourself as a man, Audrey. A male artist would never say he was having a one-woman show."

The very language we used was being questioned. From that time on I said "solo" show or "one-woman show."

Sylvia Stone arrived at one meeting with a black eye. She was married to the painter Al Held, who beat her, sometimes with a stick. We encouraged Sylvia to leave him, to expose his brutal behavior, but she refused because she didn't want to damage his career (not that it would have). Instead, she left the group and disappeared. We never saw her again.

The artists' wives in the group posed nude, primed canvases, sent out mailings, and assumed responsibility for financial matters that interfered with the purity of male artistic thought. One of them proudly told of setting a lunch tray with a fully cooked meal and a glass of red wine outside her husband's studio. As an afterthought, she mentioned leaving a pot of red geraniums to inspire him with a touch of color.

All this while, I was worrying about Missy at school, caring for Hannah, cooking, shopping, teaching, and competing in the male-dominated art world, never realizing how heavily tilted the scales were.

As I continued working, my paintings became sharper and clearer, my colors more vibrant, my forms more defined. If I painted an apple, it was the consummate apple, the archetype of all apples, brilliantly red and perfectly formed. A lime had to be acid green; a human body, flawless. Yet amid all this exactitude and perfection, I was dealing with an imperfect child.

Was I trying to heal my child through my work? Is that why everything had to be so perfect? Was I trying to restore harmony to a discordant life, mine as well as hers?

Bob and I grew closer by the day, and on June 7, 1970, we were married in a small, private ceremony at the home of Bob's best friend. I was thirty-nine years old, Bob was forty-one, Missy was ten, and Hannah, eight. Bob's children—his son Mitchell and his twin daughters, Aileen and Leslie—were only two or three years older. Everyone was there except Melissa, who was at school. Bob's children possess the same even-tempered good nature as their father, and though their parents' divorce was difficult for them, they handled it well. We became a family and remain so to this day.

Bob was kind and loving, and he stayed by Hannah's bedside when she had trouble breathing during an asthma attack. His calm, self-possessed nature provided much-needed relief and moral support. We needed him badly. He invented an "asthma symphony," which he conducted

Fig. 43 Leslie, Hannah, Mitch, Aileen. Photo courtesy of Audrey Flack.

by moving his arms up and down while making an odd assortment of grunting and wheezing noises. His performances usually took place at midnight. His audience was a rasping, gasping, terrified nine-year-old and a frantic mother. He made us laugh, lightening the atmosphere and allaying our fears. Hannah's asthma began to dissipate. Bob is an amazing person, a man with a true Buddha nature.

It was nine o'clock at night, three months after we were married, when I received a phone call from Frank. The telephone was on the night table next to the bed.

"Hello, Audrey?"

"Yes."

"Ask Bob if he wants to adopt the children."

He said it just like that, as casually as someone suggesting a restaurant for dinner. My knees buckled. I sank to the bed, unable to speak.

"Audrey, are you there?"

It took several minutes for me to respond; I needed time to process his unnatural request.

"Yes, Frank. I will discuss it with Bob and get back to you."

Why would someone give his children away? It couldn't have to do with money. I wasn't getting alimony, and he had long since stopped paying the fifteen dollars a week for child support. Years later Frank told me he did it to get back at me for leaving him. After the initial shock, I realized what a relief it would be. I was always worried about the children's safety when Frank took them. He was absent-minded, inconsistent, never on time, and a terrible driver. He had once attempted a U-turn in the middle of the George Washington Bridge.

Bob loved the girls and agreed immediately. I could see anyone wanting to adopt Hannah, but only a saint would adopt Melissa, with all the responsibility that came with her. I loved Bob even more. He lived up to the name my mother gave him: "Bobgodblesshim." One word, no hyphens.

We went through adoption proceedings. The judge asked the nine-year-old Hannah if she liked Bob. She said sweetly, "He is very nice to me. Mommy left my bike in the hallway at home and Bob brought it to Fire Island so I could ride with the other kids. I like him a lot."

Since there was no way of asking Melissa, we went through legal procedures that made Bob her legal guardian, along with me. The papers went through, and Hannah's and Melissa's last names were changed. Bob was now father to both of my girls.

Fig. 44 Bob Marcus and Audrey Flack, 1979. Photo courtesy of Audrey Flack.

It was a huge responsibility for such a young man to take on. He was only forty-one years old, with three children of his own to support and care for. He had a fledgling business to attend to, and yet he had the strength and courage to take on a child with autism and another with asthma. I am still awed by his power and kindness. Melissa had touched something deep inside him. He saw the purity of her soul and it awakened in him the deepest feelings of love, caring, and giving.

Mitchell, Aileen, Leslie, Melissa, and Hannah were now officially one family. As our life stabilized, Hannah literally began to breathe more easily, and her absences from school steadily diminished. Bob expanded his business and I proceeded to produce some of the best paintings of my life. The household came alive with friends, music, and creativity. I bought myself a coyote jacket and a pair of boots. I wore blue-tinted glasses that faded into rose; it was the new me . . . or maybe the old me. I was, as my father would have said, a "Flack" again.

Chapter 5

On Being an Artist

Jackie and Me

The painting block held me so tight that by March of 1985 I no longer even attempted to work. I was forced to accept my condition and hoped it would run its course. Every day, I returned to the Broadway Mall, my only source of contemplation and asylum. At least I was making progress; my memories were up to 1963, when Melissa was four years old, Hannah was two, and I was thirty-two and still married to Frank.

We were in the living room with the TV blasting when I heard the unthinkable: President John F. Kennedy had been assassinated. It happened in Dallas, on a beautiful day. But it simultaneously happened in our houses, on the streets, in bars, in front of all of us. The whole country was in shock, stunned, stupefied. The earth seemed to stop rotating on its axis. Wristwatches, wall clocks, and train schedules became irrelevant as people wept openly in the streets or privately in their homes. Everyone stopped working. Traffic came to a standstill as crowds were drawn together in bars or huddled before storefront television sets, transfixed by the unfolding drama that gripped the nation for weeks. As the story

was transmitted around the globe, millions of people shared a violent and traumatic tragedy, accessible as never before, one that was broadcasted repeatedly until our brains were permanently imprinted.

This was a world-changing moment. At that time there were only old-fashioned box TV sets—no cell phones, no Twitter accounts, no YouTube, no reality television. For the first time in history, people all over the world heard about a murder together in real time. The brutal reality that the president's brains had been blown out forced our neurons to accept the unthinkable. Perhaps this was another step in the history of evolution.

It was a time when art, technology, and political events converged and caused a historic shift in the collective unconscious. Scientific minds had invented the black-and-white camera and motion pictures decades before, and now there was color photography, Technicolor movies, and live television. And I was making use of it all. I used photographs and movie stills as references for my work, and my subjects were archetypal icons like Marilyn Monroe, Carroll Baker, Davey Moore, Sojourner Truth, President Franklin Delano Roosevelt, Stalin, and other political figures.

I made quick spot sketches from my TV screen. They were rapid ten-second, five-second, and sometimes only two-second drawings of people running, fighting, smiling, crying. Eventually, I became a serious photographer. I printed my own Cibachrome photos in my darkroom and used the photos along with projected slides as source material.

An event like JFK's assassination breaks open the edifice of your life, your daily rituals, and exposes a banal reality. Here was Jackie Kennedy with her two small children, facing her husband's death, and here I was, with two small children, no money, and no help. I could have handled it all if not for Melissa.

Missy's beauty was astonishing; many parents of autistic children comment on their child's amazing beauty. But she tried to walk out of windows and turned over tables and chairs. Every single thing had to be thrown on the floor. I did what I could to prevent disaster and keep us alive, but death seemed to be waiting around every corner. I was her only intercessor. It took close to ten years for the doctors to diagnose her, and our days and evenings were filled with sudden, unexpected trauma with no help, no solution, and no end in sight.

Missy would become agitated and destroy the house if I didn't keep her moving and outside. Each day, I bundled up my children

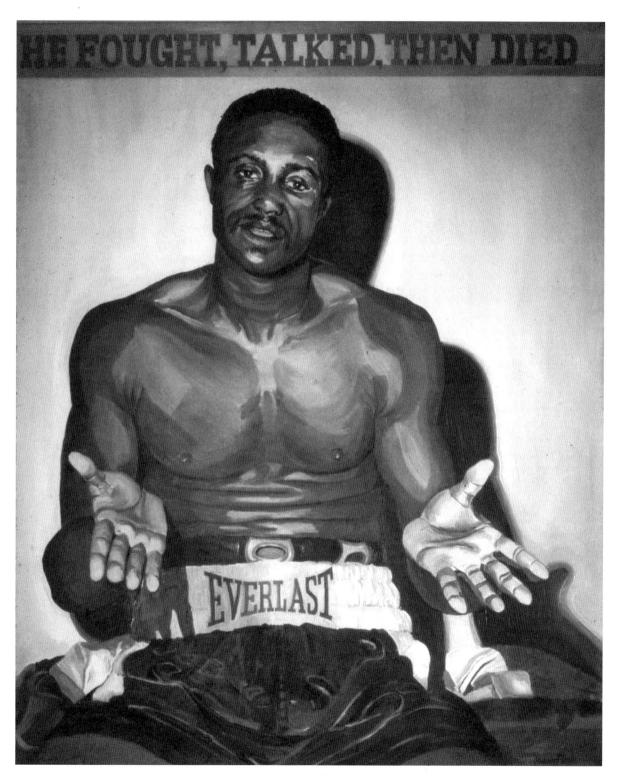

Fig. 45 Davey Moore, 1964. Oil on canvas, 36 × 30 in. Photo courtesy of Audrey Flack.

and wandered the streets of the Upper West Side. I looked haggard: stringy hair, sagging clothing, and dirty, food-stained sneakers. People shied away from us. Melissa made strange movements with her fingers and covered one eye with the back of her hand. I never could sit long enough to connect with other mothers in the playground. And they clearly didn't relish the thought of their "normal" children playing with Melissa.

So I took the children to places where outcasts went. Such outsiders were not shocked by Melissa, and I didn't feel judged by them. I pushed the stroller in and out of supermarkets, shoe stores, specialty shops, anyplace that would let us in, even when it rained, even in the freezing cold, when snow was on the ground. On a really bad weather day, I dressed the children in raincoats and galoshes and maneuvered the stroller through ice and slush to the five-and-ten-cent store on 110th Street. We could take refuge there and warm up without being asked to leave.

I showed Melissa what she liked best, hardware and pegboard. I kept Hannah busy with children's books and stuffed animals. I always put on a smile, afraid that if I showed my distress no one would play with Hannah, and she needed friends.

During Hannah's asthma attacks, she gasped for breath and her light green eyes widened with fear. I stayed up with her nights on end reading *The Snow Queen* and Robert Louis Stevenson's poems. I smiled and tried to look calm and unconcerned, but I was terrified, watching my sweet child struggle to breathe. A bad attack could last for three days and nights. Inhalers, throat sprays, antihistamine, antibiotics; I researched them all, choosing selectively, protecting her from overmedication. I sang nursery rhymes and silently prayed for her poor little lungs to clear and let in some air.

Cortisol is called "the stress hormone" because it is secreted during the body's flight-or-fight response. In soldiers, it surges to astounding levels during battle. My levels were off the charts. The only real question for me was whether or not to commit suicide. I thought about it every day. Ask any mother of an autistic child who doesn't have money, help, or schooling for her child: suicide may not be far from her thoughts, and even more so back in those days, when no help was available and a mother was blamed for her child's condition. There have been, and still continue to be, tragic murder-suicides in the autism community by parents (both fathers and mothers) who out of love, yes, love, snap and commit heinous acts.

I would never harm my children, but I did think seriously about suicide. I was able to resist for fear of what would happen to them without me. Someone would probably take Hannah, even with her asthma, but I knew that fragile Melissa would wind up in a state institution, where she would no doubt be abused and die. Death consumed my thoughts continually. Kennedy's assassination was a perfect subject for me.

I spent the week of the assassination binge-watching the unrelenting TV coverage. Between washing dishes and cleaning diapers, I caught glimpses of white horses pulling Kennedy's wooden casket draped in an American flag.

Jackie kept a steady pace behind the rolling wagon, her face covered with a long black veil. She held her children's hands as little John and Caroline walked on either side of her. Even at this moment of death, she was beautiful, her clothing fitted, her hair coiffed. The children wore matching light blue outfits. John was fitted in a suit with short pants, and Caroline wore a dress. I started to cry when three-year-old John stood in front of the casket and saluted his dead father. I was alone in my kitchen with food-stained clothes and uncombed hair, crying for myself, too. Jackie had two children, like me, but she had money and power; she could recover from this tragedy. Could I recover from mine?

The funeral ceremonies went on for days. The steady beat of drums set the pace for a black riderless horse; cannons fired heavy pounding booms; gentle prayers were recited; celestial choruses performed in perfect harmony; and kilted pipers squeezed their bags in melancholy drones of lamentation. The end of this weeklong drama showed a solitary trumpeter, silhouetted against the sky, sounding taps.

I couldn't get the image of Kennedy's brain matter out of my mind. I kept wondering what it must have looked like splattered against the black leather seat. Was it yellow or gray? What did his face look like? Were his eyes wide open in shock, or closed with the tranquility of death? I felt compelled to capture this moment. I had to paint it.

Elaine de Kooning had painted several portraits of Kennedy late in 1962, a year before he was murdered. Kennedy did not sit still; he was restless, and so was Elaine. She thought fast and worked fast. She arrived at the White House with her palette, canvases, paints, and brushes and swiftly executed study after study of him on the spot: Kennedy sitting at his desk, leaning against a wall, talking on the phone, or in repose, thinking. Her gestural, loose brushstrokes included touches of representational imagery, but Elaine was basically an abstract painter. I knew

those paintings well, and while she caught the essence of Kennedy, his face was always a blur. She never rendered a detailed study.

Kennedy couldn't pose for me. I couldn't even work from a death mask, as Daniel Chester French had for the Lincoln Memorial. Kennedy's skull had been shattered. The only way I could paint Kennedy was through photographs, which was perfect for the direction of my work.

I spent several weeks sorting through hundreds of books, magazines, and newspaper articles until the right one stared up at me. I didn't want to paint the actual assassination, no broken skull, blood, or brain. I decided to use suspended irony, to focus on a moment before the fatal shot, when everything was dazzling, happy, ordered, and strangely serene. I wanted to freeze that moment on canvas, to capture that incredible, electric second of transition before the world changed. Through art I could keep him alive, immortalize him. I didn't know it at the time, but in choosing to keep Kennedy alive, I was keeping myself alive.

When the children were asleep, I stretched a clean white primed canvas, got out my charcoal sticks, and began sketching. Charcoal is a pliable medium, easy to smear, erase with my fingers, and make corrections. My work jeans and shirt were covered with sooty black charcoal as I redrew, erased, and corrected each figure until they were in exactly the right place. When I was satisfied with the composition, I started to paint.

Handsome Jack Kennedy appeared calm sitting beside his beautiful, soft-spoken bride. They were the perfect couple riding through the streets of Dallas, flags waving, crowds cheering as they drove by in the presidential limousine. It was a bright, sunny day. The sky was an unusually clear cobalt blue. It felt preternatural.

I painted Jack with his thick auburn hair and winning smile, looking relaxed and innocently exposed in his white shirt, dark suit, and blue tie. The convertible's hood was down, and Jack's right arm rested on the car door. I painted the reflection of his hand on the metal edge, and then I noticed the cast shadow of a man on his suit jacket. I decided to include it; to me it foretold an ominous outside presence.

I painted the Air Force One captain and crew standing alongside the limo as it slowly passed by. All of them were smiling. I painted the Secret Service agent driving the car behind the limo. The Secret Service agent Clint Hill had leaped from the car to get to Jackie when she frantically climbed onto the trunk of the limo. Hill said Jackie was trying

to retrieve a portion of Kennedy's brain and bones, hoping the doctors could reconstruct his skull.

I painted Jackie waving to the crowd wearing white cotton gloves that looked cartoonish in the glaring sunlight. She looked stylish in her famous pink pillbox hat and matching Chanel suit. One dozen blood-red American Beauty roses lay across her lap. They were a perfect color to accentuate the scene and add a touch of irony.

I painted Governor John Connally in the front seat, peering suspiciously at the camera, looking worried and not at all relaxed. His ten-gallon Texas cowboy hat cast a dark shadow over his eyes. His left hand adjusted his tie but also covered his chest. His was a self-protective gesture, compared to Kennedy's open vulnerability. *Did Connally sense that something was about to happen?*

A curator at the hottest new gallery in town, the Fischbach Gallery, heard about my Kennedy painting and called to set up a studio visit. This was Aladar Marberger, who later became the gallery director. In a state of high excitement, bordering on elation, I gave him directions: "104th Street and Broadway, second floor, apartment 2B, right over the dry-cleaning store."

Although I had exhibited in group shows and had even had a couple of solo exhibitions, this would be by far the most important and prestigious venue yet. If the meeting went well, it could be a major break for me.

Women artists were having a hard enough time in those days, and to reveal that I had children meant certain doom. I had to have the children out of the house when Marberger came—Melissa was so out of control that there was no telling what she might do. I arranged for Clover, their beautiful Jamaican babysitter, to take the girls out. Like Carmen in Bizet's opera, Clover wore skintight dresses that reeked of sexuality. She perambulated up Broadway with a butt swagger that spun men's heads. And she was the only one besides my mother-in-law who could handle Melissa.

"If it's nice, go to the playground. If it rains, walk up to the five-and-dime store on 110th Street. Melissa likes hardware. Find a piece of pegboard for her to stare at and get a stuffed animal for Hannah. Whatever you do, don't come back before twelve o'clock."

I scurried through the apartment removing any signs of them, throwing toys, diapers, and baby utensils into drawers and cabinets. I kissed the children goodbye, waved to Clover, and locked the door behind them.

I rushed into the studio and began to pull paintings out of racks. The paint was still wet when I put *Kennedy Motorcade, November 22, 1963* on the easel. I got on a ladder and adjusted the overhead floodlights to focus on Kennedy without causing a glare. I stacked the rest of my work against the side walls in case he asked to see more.

The doorbell rang. Thank God he was on time. I ushered him in and offered to take his coat. He declined. I offered him coffee. He declined that too.

"I just want to look," he said.

I knew this was in case he disliked the work and wanted to make a fast getaway. I tried to act self-assured as I led him down the long narrow foyer to my studio, concerned because it was not an impressive loft.

I opened the door and switched on the lights. Kennedy brilliantly came to life. Marberger ignored the fold-up director's chair I had prepared for him and walked straight up to the easel. He got close and examined the canvas for a long time. I tried to catch an expression on his aloof, impervious face, but it remained expressionless. Only when he slid his long camel-hair overcoat off his shoulders and casually handed it to me did I know he was interested. He took a seat in the director's chair and said, "Let me see more."

I jumped up and one by one showed him the canvases leaning against the walls, keeping Kennedy on the easel. All the while I silently prayed that Clover would not show up with the children in the middle of his visit.

"I'm curating an exhibition. I'd like to take the *Kennedy Motorcade* and the rest of these," he said, pointing to several I had pulled from the racks.

He put on his coat, belted it, and left the studio with me beside him, elated. I was thrilled; this was an important exhibition in a major gallery. For the next few weeks I thought of nothing but how my work would look on the crisp, white walls of this high-end gallery. I could hardly wait for opening night.

The announcement came in the mail eight weeks later. The caption read, "SIX WOMEN ARTISTS."

My God, this was a women's show. I had no idea. I never thought of myself as a *woman* artist. It didn't occur to me; I was an artist like everyone else. I wanted to be a great artist, yet all the great artists I knew of were men. Women did cross-stitch embroidery, sewed quilts and dresses, and were considered inferior. The art world was filled with

insidious prejudices that had gone on for centuries, and I had internalized them.

Marilyn Fischbach was taking a big chance with this women's show; it was the first exhibition to feature women, exclusively, in a gallery owned by a powerful woman. I was not the wife or girlfriend of an Abstract Expressionist. I was an independent woman artist, a new breed, with no attempt to hide my gender. It felt great to see my name, Audrey Flack, in bold print.

On opening night, I got all spiffed up in my usual: a black turtleneck sweater, tight jeans, high-heeled boots, and gold hoop earrings. I had already put the children in their pajamas, brushed their teeth, and read them bedtime stories. As usual, Frank was playing in the orchestra pit of Radio City Music Hall, so I hired Clover to babysit. We spent a few minutes chatting while Hannah was busy with her blocks. Melissa was somewhere down the hall near the bathroom. I gave Clover last-minute instructions and slipped out the garbage collection door in the kitchen so the children wouldn't notice. I tiptoed down the back stairway with my umbrella and was about to exit the building when I heard Clover's frantic shout.

"Audrey, come back, quick! Hurry!"

I ran up the stairs two at a time, brushed past Clover, and breathlessly surveyed the situation. Hannah, my adorable honey-blonde two-year-old, was sitting on the floor playing with her picture books. She was dressed in her pink-and-white bunny pajamas with attached covers for her little feet. I looked down the long foyer and saw Melissa standing in front of the bathroom, her eyes wide open, looking startled.

"Missy, are you alright?"

She said nothing. At the age of four, beautiful Melissa still couldn't speak. Instead, she held her hand in front of her face and made peculiar, unnatural movements with her fingers. That didn't concern me, as I had seen this strange behavior before. I moved toward her and she flinched, as she always did; she flinched like a frightened bird when anyone came near her.

"It's okay, Missy."

I gently ran my fingers through her thick hair and lifted her bangs. There was no bump, no sign of blood. I felt her body, rolling up her blue flannel pajamas and running my fingers over her long legs. Everything seemed to be intact. Calmed, I finally heard the sound of rushing water. I ran into the bathroom and found water gushing ferociously

from the faucets. It had reached the brim of the sink and the drain was choking and gurgling like a person gasping for breath. A sleek sheet of glassy water spilled over the edge like a miniature Niagara Falls before it crashed onto the bathroom floor. For a split second the artist in me marveled at the flickering patterns of light and ever-changing watery forms, but then my gaze shifted to the floor of the small bathroom. The checkered tile was already covered with an inch of water. Toys were bobbing up and down—Hannah's plastic rattle, a soggy Raggedy Ann doll, a teddy bear, Scrabble tiles, a rubber duck, a Humpty Dumpty top, and bits of broken plastic from toys that had cracked on the way down.

I quickly turned off the faucets and concentrated on the toilet that was flushing and bubbling uncontrollably. I rolled up my sleeves, shoved my hand deep inside the toilet bowl, and fished out two of Hannah's diapers, a bunch of wooden blocks, and a wad of Play-Doh. The toilet still wouldn't stop flushing, so I got on my hands and knees and found the water valve. It was stuck; I had to use all my strength to turn it off completely. Then I salvaged whatever toys I could and picked through the broken ones, being careful not to get cut by sharp plastic shards.

"Oh, Hannah, here is your big red fish. Aren't we lucky it didn't break?"

I handed her the huge plastic carp that she took to bed with her every night and was grateful it survived. I spotted Hannah's security blanket lying in the corner. It was a wet, shrunken lump, shredded and full of holes from so many washes. She needed it, slept with it, sucked on it, carried it everywhere. Thank God it didn't get flushed down the toilet.

Clover watched as I threw a bunch of towels on the floor to soak up the water. I assured her that the worst was over and that she could manage the rest of the evening. I reapplied my lipstick and dashed out the door, hoping I would make it before the gallery closed.

I forgot my umbrella amid the chaos and was dripping wet when I arrived. It was seven o'clock by now; most of the Madison Avenue stores were closed, but the Fischbach Gallery lit up the avenue like a Hollywood stage set. It reminded me of *Nighthawks*, that magical Edward Hopper painting of a glass-fronted diner whose lights illuminated an otherwise dark street. Luckily, the place was still buzzing with excitement. The thick plate glass double doors transported everyone who walked through them into a rich Madison Avenue world that exhibited the latest in cutting-edge art. An air of glamour drifted through the gallery's

stark, white interior; it was the place for artists to show and hotshot art collectors and critics to be seen.

The moment I walked through those swinging glass doors I entered a dynamic, vibrant world. The gallery was packed with artists, critics, and collectors all milling around, sipping wine, busily discussing the paintings on the walls. This was my other life, my real world. I felt a surge of exuberant energy. I could stand tall. I could see clearly.

Marilyn Fischbach's spiked patent-leather pumps clicked with confidence as she strode toward me, extended her hand, and welcomed me with a smile. She was pretty, young, and sexy, with yellow hair, Windsor-blue eyes, and thick, mascara-coated eyelashes. She wore a black-and-white checkered Chanel suit with a tight short skirt that showed off her shapely legs. There was an air of excitement about her, enhanced by rumors of affairs she was having with the male artists she represented. Her gallery was known for serving the best hors d'oeuvres and wine at the openings, and artists came from all over the city to get their fill.

I loved talking to the other artists, exchanging ideas, feeling part of this world. I smiled, I laughed; nobody knew what I had just left or what I had to face when I returned home. Nobody knew that my kids were running in between my legs while I painted or that I was living from one calamity to the next.

I kept my children and Melissa's autism a secret from the art world. I also never spoke of my husband's total rejection of his own child and his increasingly abusive behavior. I never let them see the pain or the struggle I was dealing with. Having children was bad enough, but I thought that having a special-needs child would surely define me as nothing but a mother, a failure, a weak person, and that my work would be dismissed as "ladies' art." I couldn't let that happen. Art was my life long before I had children, and it would remain so forever.

Art was the thread, the glue, the sustaining force to which everything else adhered. When things got rough, art gave me the strength to go on. So I smiled, shook hands, felt bright and intellectually astute. I never lied—just glossed over sensitive issues and redirected the conversation. And the work spoke for itself.

Is the drive to create, even under the worst of circumstances, an act of defiance or the human spirit's stubborn will to survive?

I noticed a group clustered around my Kennedy painting. I walked over and heard them debating my use of photography. Although it's a common practice now, it was radical then. Not only had I used a

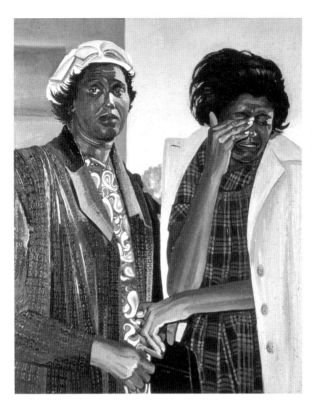

Fig. 46 Two Women Grieving over Kennedy, 1964. Oil on canvas, 36 × 28 in. Photo courtesy of Audrey Flack.

photographic reference but I used a color print, not a black-and-white image similar to a nineteenth-century Eadweard Muybridge photograph. Without intending to, I had created an aesthetic controversy.

While I had worked from small Kodak snapshots before the Kennedy assassination, this painting marked my total commitment to the study of photography and the start of Photorealist painting.

When I was sorting through pictures for the Kennedy painting, I came across a photograph of two Black women that affected me deeply. They were weeping, grieving, despairing. Holding hands, they were keeping vigil outside of the Dallas hospital where their president lay dying. Their anguish reminded me of the two Marys standing before the crucifixion in a Giotto Pietà. These women would be my next painting.

At eight o'clock, the lights flickered. The opening was over. The gallery was closing. A group of artists gathered.

"Hey Audrey, we're all going out for dinner. Why don't you join us?"

"I'm busy tonight, but thanks for the invite. Maybe next time."

I had to make a fast getaway, get home, pay Clover, and assess the damage. I could only hope that no calamity had occurred during my two-hour absence.

After the Fischbach exhibition, I started on a series of political paintings: *Teheran Conference, War Protest March, Truman's Teachers, Rockefeller,* and *Sisters of the Immaculate Conception Marching for Freedom.*

The exhibition was a sort of miracle, but there were also what I call "everyday miracles," like a kind person smiling and holding the door open for me while I pushed Hannah's stroller and dragged a howling Melissa into a supermarket, or getting a painting commission when I couldn't pay the rent. They came out of nowhere and seemed to show up just when I needed them.

In the meantime, I was always juggling, spinning plates in the air, never stopping, because even a moment's hesitation brought on a crash. If one of them fell, they all went down. I was a whirling dervish, a one-woman band, beating drums, banging cymbals, blowing horns, running to doctors for Hannah's asthma and to specialists who couldn't figure out what was wrong with Melissa. I was keeping them alive and entertained. There is a physical and psychological limit to excess and madness, but I could do it all because I was hyperactive and could function with minimal sleep, just like my father, who never got more than five hours a night. This restlessness that had plagued me and caused trouble throughout my school years now served me well.

Photorealism

By 1985, I was well into my second year of depression, sitting on the bench, sorting through bits and pieces of my disrupted life. Memories flitted across my mind helter-skelter, lacking any chronological order until I got to the year 1963, when the world of photography opened up for me, bringing with it new cameras, precision lenses, new 35 millimeter transparencies, newer 45 millimeter transparencies, and new ways to print with color, including Cibachrome and dye-transfer. Almost all of my photographs were used as bases for my Photorealist paintings. I was making a radical break from traditional painting, and the memories of these glorious days of Photorealism lifted my spirits.

Life had steadily improved from 1963, when I lived above a dry-cleaning store, to 1970, when Bob and I moved to a new apartment that faced the

Hudson River and bought a house in East Hampton with a studio that was so near the ocean, I could hear the roar of the crashing waves. The fresh ocean breezes infused the air with beads of moisture, and the negative ions invigorated me. To be surrounded by nature was healing, and I was producing one painting after another. I had reached a pinnacle. Every painting I produced came out well, and I felt that some were even great.

I bought new equipment, refined my darkroom, and continued my Cibachrome color printing. Unlike Abstract Expressionism, where feelings hit the canvas with immediacy, emotions were now tempered and controlled. There was no other way to do this exacting Photorealist work. The work was thrilling, and I was high for about ten solid years. Days ran into nights as my arm whipped the airbrush across the canvas like an athlete in her prime.

I took occasional breaks and met with Richard Estes, who lived in the same neighborhood. We became good friends. It was easy to make studio visits and exchange ideas. We were both exploring new territory, breaking new ground, and there was a lot to be shared in terms of painting techniques, lenses, projectors, and cameras.

Early on, I wanted to try an airbrush even though it was still considered an immoral instrument. "Let's give it a try, Richard," I said. "We can buy one together and see how we like it."

Sharing our new equipment would also mean sharing the burden of guilt. It took days to persuade him, after which I researched and bought a new shiny silver airbrush, a Swedish compressor, and all of the accessories and attachments needed to enhance our work. When Richard came to my studio to view the equipment, he backed up—and backed out.

Richard apologized and said that he would continue using photographs, just not an airbrush. Intrigued with the instrument, I proceeded to explore what was to become an essential part of my Photorealist technique. Chuck Close and I were the only two artists in the original group who used the airbrush.

The airbrush looked harmless enough, like a short silver cigar, but in reality, it was fast and dangerous. I could spray large areas with one sweep, but I could also make thin, exacting lines. I inserted the finest needle into the tip and exerted precise control as I created each delicate strand of Marilyn Monroe's hair for my *Vanitas* painting. Thin streams of paint miraculously appeared on the canvas.

Carlo Crivelli's *Pietà* at the Met, and the way he meticulously painted every strand of Mary Magdalene's hair, came to mind. A tour de force,

Fig. 47 Audrey Flack and Richard Estes. Photo courtesy of Audrey Flack.

but Crivelli's painting was small. Mine was huge. With an airbrush, I could now accomplish in weeks what would have taken years—though *Marilyn* did take a solid year to complete.

After a while, I mastered the hairless airbrush. I wielded it like a gun, and it was just as perilous. Without warning, it could splutter, blast, clog, and spit out blobs of paint. One stroke could create magic; another could destroy an entire area. It was electrifying!

In seconds I could cast a shadow that would have taken days using traditional glazes, but I had to be on full alert; a slip of the hand, a move of the airbrush in the wrong direction, could cause severe problems that were sometimes unalterable. But when it worked, when I moved my arm back and forth spraying particles of paint across the canvas, I entered another dimension. I thought Jackson Pollock must have felt the same way when he moved across the canvas strewing paint in rhythmic patterns.

In 1969 Ivan Karp, the director of the Leo Castelli Gallery on Seventy-Eighth Street off Madison Avenue, decided to go out on his own. With the foresight of a visionary, he moved downtown and opened OK Harris Gallery, one of the first galleries in SoHo. Ivan strutted around his gallery puffing a fat Cuban cigar, wearing a multicolored love bead necklace, and sporting a short ponytail. He was rough and gruff and talked fast, yet he remained accessible to artists and would look at their paintings right there in the gallery. That was the way he kept his finger on the pulse of the latest trends.

In the mid-sixties, he noticed a small group of radicalized artists who were using photographs as references for their paintings. A new movement was developing, and he quickly sensed its importance.

Ivan was invited to speak to the Alliance of Figurative Artists. The Alliance was run by a large number of disgruntled realist painters who felt that the art world was dominated by Ab Ex and had passed them by. They were impassioned and vocal about their anger. The meetings often turned vicious, with artists attacking each other as well as the speakers. They were traditionalists who resented Photorealism. I was subject to one such attack years later, when I was invited to speak. Milet Andrejević yelled out, "Your work is PHOTO FART ART," and everyone laughed. But Chuck Close got worse treatment. Unbelievably, the crowd threw a half-full beer can at him.

Ivan decided to try out his new ideas there. He gathered slides from all of us, and I watched as he put a box of my slides in his jacket pocket. I went to hear his presentation that evening. Even though the club members were violently opposed to the use of photography, they were impressed with this important art dealer and hoped he would exhibit their work.

Ivan stood at the podium, loaded the slides in the carousel projector, and started to describe the new movement. "Photorealist paintings," he said, "are distant, cool, and detached, just like the camera. These artists remove themselves and show no emotion in their work. Their paintings are brutal in depicting banal subject matter."

What he was describing didn't sound like my work or philosophy, but I waited, hoping he would expand his definition. The lights dimmed. Ivan pushed the button and on came the first slide. It was an ordinary car parked on a boring street in front of a dull suburban house. The next slide was of a street in Manhattan with a row of storefront windows. Cars and trucks that lined the streets were reflected in storefront windows, but there were no people to be seen. And from then on it was

slide after slide of cars, trailers, motorcycles, trucks, storefronts, empty streets, and deadpan portraits.

These were terrific paintings by Robert Bechtle, Richard Estes, Chuck Close, and others, all friends of mine, all Photorealists like me. I kept my eye on the screen, hoping to see my paintings, but my slides were never shown—not a single one.

With a cigar in one hand and the remote control in the other, Ivan was single-handedly isolating a movement that eliminated women. With each projection, I became more and more aware of the difference between "the men" and me. My colors were brighter, I used narrative and iconography, and my subject matter was humanist.

I again realized that I was the only woman artist in the ground-breaking group, as well as the only artist who came out of Abstract Expressionism, with the partial exception of Chuck. My work had an allover pattern similar to Jackson Pollock's, with edges that extended beyond the picture plane. It was different from the work of the other Photorealists, and it certainly did not fit into Ivan's male-oriented definition. I was both hurt and furious. I left the room while Ivan was bent over, packing up his slides.

Later that week I went to pick up my slides.

"Why didn't you show my paintings, Ivan?"

He pulled me into the back room, took the cigar out of his mouth, and said in his raspy voice, "Audrey, you don't fit in! Don't be a fool: paint cars and trucks and I'll make you rich and famous."

Ivan pulled no punches. Enraged to the point of being almost speechless, I gave him an angry stare and managed to spit out, "Never!"

I left knowing that my work would be excluded from national and international exhibitions. This would also affect what collectors would buy. It was a bitter realization. Once again history was repeating itself; women were being written out.

I had considered myself part of the group. We were all exploring new territory, sharing information about paint, photography, airbrushes, canvas primers, cameras, and projectors. We were all interested in light. They painted reflections on metal surfaces like those of cars and motorcycles; I painted reflections on silver teapots and gold bracelets. Instead of using the glass in car headlights, windshields, and storefront windows, I used the glass in mirrors, bottles, crystals, and prisms. Our emotional content differed as well. When Chuck Close painted a face, he was interested in mapping the facial terrain through mark-making. He had no

interest in portraying feeling or expression. When I painted a face, I wanted to capture the emotion, the human condition. When Bob Bechtle painted cars on empty streets in California, his attitude was basically deadpan. When he included people, they were expressionless. Richard Estes rarely put people into his panoramic street scenes, and when he did, they were accessories.

I think highly of these artists, and I was an integral part of the group. Yet clearly my work was being removed from exhibitions because of its content.

I have always believed that there should be no prejudice in terms of gender, race, color, or religion in the world of art. Art and artists are a universal continuum, defying time and space, an amalgam of the highest ideals. I couldn't accept Ivan's definition.

Despite this initial setback, I pushed on with my Photorealist work.

I was flipping through the mail when a small postcard fell to the floor. The postmark was from Spain. Marcia Tucker, chief curator at the Whitney, had sent it with a note scrawled across the bottom that said, "Thought of you when I saw this."

The picture knocked me over, simple as it was. It was just the image of a woman with intense dark eyes, long eyelashes, and a torrent of tears pouring down her cheeks. There was an eternal beauty about her. She had suffered, yet appeared serene. I felt a surge of empathy, sadness, even love for her. It was like coming across a long-lost friend. I read the title: "The Macarena Esperanza, Patron Saint of Seville."

It was a carved wooden statue of the Madonna. *I am not religious, not even Christian; why would I respond so strongly to a Catholic Madonna?*

I attributed my reaction to the greatness of the work and let the thought pass. Still, I knew that someday, I would have to travel to Seville and stand before her to see if she possessed the power that came through the postcard.

I booked a trip as soon as possible. It was early in May when Bob and I arrived in Seville. Bob wanted to unpack and rest a bit, but I couldn't wait. I set my valise on the folding stand, washed my face, slung my tripod across my shoulder, hung my cameras around my neck, and left in search of the Macarena. The desk clerk gave me directions.

The blazing Spanish sun beat down on me as I trudged my way to the church. It was a modest building, not at all impressive. Exhausted, I set my bags on a stone bench in the courtyard and rested for a few minutes before pushing open the heavy wooden door to the sanctuary.

Momentarily blinded by the contrast between the brilliant noonday sun and the pitch-black interior, I felt my way in the darkness, running my fingers against the cold, damp, stone walls until I reached the baptismal font. The rectory table was a few feet away; I leaned against it until my eyes adjusted to the darkness.

Suddenly before me appeared a statue so radiant, it transformed the gloomy church into a luminous heaven. The Macarena was enshrined in an elevated niche and presided over her domain like an enthroned queen, studded with jewels, lace, and a dazzling gold crown. Her white lace shawl was embedded with precious emeralds that emitted a shimmering green light. Rubies and sapphires sparkled in between pearls on her satin bodice. A red velvet Miss America–style ribbon cut diagonally across her tight-fitting dress. A black velvet cape with embroidered fourteen-carat gold swirls was draped around her shoulders, lending a mysterious air.

She knew the past and could foresee the future. Glistening teardrops flowed from her huge glass eyes. False eyelashes made them look even larger and more intense. Her cheeks were flushed with a faint touch of pink, while the rest of her smooth ivory skin glowed from within. Her rouged lips held words unspoken. Her furrowed brow anticipated the future. Serenity and pain, beauty and grace, emanated from the Macarena. It was hard to believe that she was only a carved piece of wood.

Solid gold spears shot out from the back of her head. It was a crown fit for the queen of heaven and took my breath away. She was spellbinding. I felt a rush, my heart quickened, my knees buckled; I wanted to kneel. Suddenly the resounding sounds of organ music descended from the balcony. I was transported deep into the sacred, no longer affected by profane time, struck by the miracle that only great art can deliver.

The smug art world had belittled this form of art. They called it kitsch; it was too sentimental, too glitzy, with too much color and too much emotion. But I knew that I was standing before a masterpiece. I had to find out more about the artist. His skill was incredible.

I set the tripod up and began taking pictures, moving from side to side, bobbing up and down like a boxer. I shot frontal, side, and three-quarter views. I shot from below, from above, changed lenses, zoomed in and out, and bracketed. All the while, two disgruntled parishioners shot disapproving stares at me. One of the men headed straight toward me, grabbed my tripod, and laid his heavy hand over the lens.

"Okay," I said. "I'm packing up."

I slung my camera bags over my shoulder and wandered down the side aisle hoping to find someone who knew more about the statue. A tray of flickering votive candles cast a gentle red glow in front of a private chapel. The gates were swung open, and in the dim light I could make out the figure of an old custodian, bent over, sweeping the floor.

"Por favor, señor," I said in my faltering Spanish. "Do you know by any chance the name of the artist who sculpted the Macarena?"

"Si, si. Ella se llama La Roldana."

I never expected such a reply, for most of these sculptors are anonymous. Not only that, but the custodian had used a feminine article.

"Una señora?" I queried, amazed.

"Si, porsupuesto la artista es una mujer. Ningun hombre puede expresar los sentimientos de una madre asia su hijo. Ningun hombre puede crear la belleza de una cara." (Yes, of course the artist is a woman. No man could express the feelings a mother has for her son. No man could create a face of such beauty.)

Here was an open acknowledgment of a feminine aesthetic. This custodian felt the work was superior because it was an interpretation of a woman, Mary, by another woman, Luisa Roldán.

There was a connection between Luisa Roldán and myself, which I didn't find out about until years later. I had seen her work without knowing it at the Hispanic Society on 155th Street, less than twenty blocks from my childhood home. When I was very young, I wandered its spooky halls, poking into shadowy corners where gilded saints peered out from their secluded niches holding symbols of their martyrdom.

Saint Lucy offered her eyes on a plate, Saint Agatha offered her breasts on a platter, and John the Baptist's head lay bleeding on a silver tray. I was morbidly fascinated. I found out thirty years later that a small ceramic figure group depicting a dying Mary surrounded by angels and putti was by Luisa Roldán herself.

I didn't care that Spanish Passion art was frowned upon in sophisticated circles, that it was to be ridiculed because of its extreme emotionality and lack of classical restraint. I didn't care that this art was dismissed as lower-class kitsch. I loved it. How remarkable that the essence of Luisa Roldán's work would remain with me until it was reawakened by a postcard some thirty years later.

I felt strongly that Roldán's work should be better known, so I wrote an article about her. It was first published in 1979 in *Helicon Nine,* a

Color Plate 11 Queen, 1976. Oil and acrylic on canvas, 80 × 80 in. Photo courtesy of Louis K. Meisel Gallery.

Color Plate 12 Macarena Esperanza, 1971. Oil on canvas, 66 × 46 in. Photo courtesy of Audrey Flack.

Color Plate 13 Macarena of Miracles, 1971. Oil on canvas, 66 × 46 in. Photo courtesy of Audrey Flack.

Color Plate 14 (opposite top) Jolie Madame, 1972. Oil on canvas, 71 × 96 in. Photo courtesy of Louis K. Meisel Gallery.

Color Plate 15 (opposite bottom) Chanel, 1974. Acrylic on canvas, 56 × 82 in. Photo courtesy of Louis K. Meisel Gallery.

Color Plate 16 *Leonardo's Lady*, 1975. Oil over acrylic on wet sanded canvas, 74 × 80 in. Photo courtesy of Audrey Flack.

Color Plate 17 *World War II* (*Vanitas*), 1976–77. Oil over acrylic on canvas, 96 × 96 in. Photo courtesy of Audrey Flack.

Color Plate 18 *Royal Flush*, 1977. Oil and acrylic on canvas, 70 × 96 in. Photo courtesy of Audrey Flack.

Color Plate 19 Marilyn (*Vanitas*), 1977. Oil over acrylic on canvas, 96 × 96 in. Photo courtesy of Louis K. Meisel Gallery.

Color Plate 20 Wheel of Fortune (*Vanitas*), 1978. Oil over acrylic on canvas, 96 × 96 in. Photo courtesy of Louis K. Meisel Gallery.

Color Plate 21 (opposite) Time to Save, 1979. Oil over acrylic on canvas, 80 × 64 in. Photo courtesy of Audrey Flack.

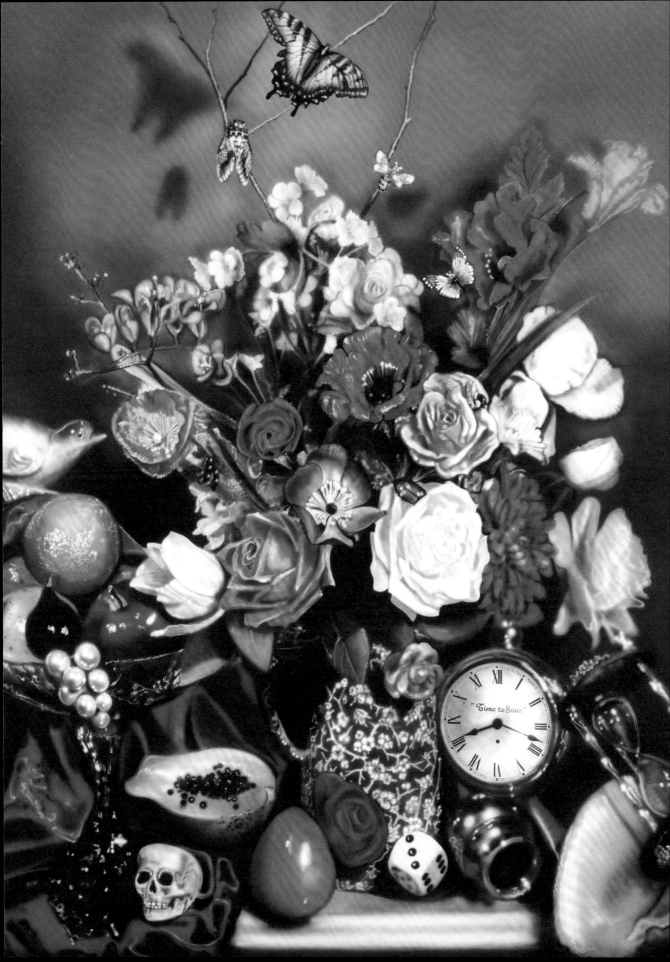

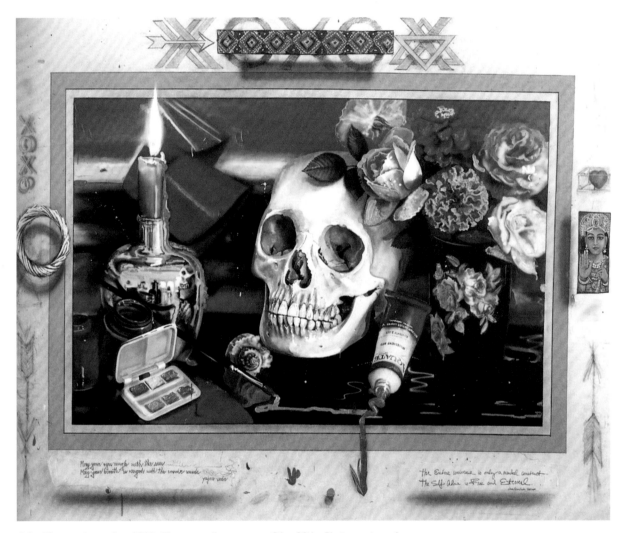

Color Plate 22 Invocation, 1982. Oil over acrylic on canvas, 64 × 80 in. Photo courtesy of
Louis K. Meisel Gallery.

literary feminist arts journal, and later reprinted in my book *On Paint-ing*. Thankfully, the Getty Museum had recently purchased one of her masterpieces, a life-sized polychromed statue of Saint Ginés de la Jara.

I flew to the Getty to see Roldán's statue of Saint Ginés. He was standing on a pedestal, commanding a small room with nothing else in it. His patinated pink skin radiated a luminosity so lifelike I thought he was about to speak to me. His outstretched arms and open mouth beck-oned me close. His brocaded robes were decorated with embedded gold leaf and incised with ornate designs using a technique called *estofado*. This dazzling, emotional realism was perfect for the Catholic Church, which sought to attract people and make Christianity more accessible. Although Roldán's work is revered in Seville, it took six hundred years for this great woman artist to be recognized on our shores.

When I returned, I stretched several canvases and started to paint the Macarena. I included all the kitsch elements: glass eyes, glass tears, false eyelashes, crown of gold, lavish drapes, emeralds, rubies, and pearls, everything people have worshiped and adored for centuries. People loved the Macarena for her soul but also for her splendor. I could not leave any of it out, even if it meant condemnation by the art world.

To his credit, Ivan Karp eventually recommended my work to French & Co., a prestigious gallery on Madison Avenue. Previously controlled by Clement Greenberg and his Color Field painters, the gallery was now interested in Photorealism and offered me a show. It was there in 1972 that I first exhibited the Macarena paintings. The show sold out. *Macarena Esperanza* and *Dolores of Cordoba* went into private collec-tions, *Macarena of Miracles* went to the Metropolitan Museum of Art, and *Lady Madonna* went to the Whitney.

Before *Macarena of Miracles* was acquired by the Met, it was exhib-ited in a Whitney Biennial in 1972. Critics thought I was poking fun. Postmodernist theories of irony and sarcasm were considered attributes to be admired. Critics assumed that I added the Macarena's tears as a note of sarcasm, or at least a feminist ploy, and they applauded it. When I asserted that I took this work seriously, that Roldán's Macarena was a masterpiece—that the tears were not my addition but part of the orig-inal statue—the critics reversed themselves. My work was now labeled kitsch and vulgar.

As time went on, I identified more and more with Roldán. We were women artists, mothers, and both of us struggled. The Macarena was crying for her suffering child. Luisa Roldán was doing the same thing,

begging for food to feed her children. In spite of her fame, she had to beg the king and court for money to support her family, appealing to Charles II's second wife, Maria Anna, for help. But it proved insufficient.

I'd had to feed my children spaghetti, count my pennies, and struggle as an artist to support my family. I, too, had been crying for my damaged child, and in need of money. Unconscious of these connections at the time, I would not permit myself to be in touch with the ghosts of my despair. I just painted weeping Madonnas and Dolorosas whose solid-gold hearts were pierced with bloody daggers, unaware that it was my own personal sorrow I was recording. No wonder Luisa Roldán was able to create such a profoundly moving face: the Macarena cried for her, too.

These Macarena paintings were the very same ones that were first accepted and then pulled out of a 1972 Documenta exhibition in Kassel, Germany, and replaced by the work of a Photorealist artist who painted cars. As upsetting as this was, it nevertheless rolled off my back. To tell the truth, after what I had been through over the years with Melissa, it was nothing.

In 1972, I began work on a six-by-eight-foot still life called *Jolie Madame*. It was huge, the largest still life I had ever done or seen. The size allowed me to analyze the minutiae of deconstructed light. Fascinated with the challenge of painting glass, I took a bottle of Jolie Madame perfume from my bureau and placed it in the center of the arrangement. It was half full, and the amber liquid sparkled with refracted light. Objects seen through the glass were distorted. I painted the gorgeous vermilion background with my regular brushes but used my airbrush to capture the light of the swirling perfume.

It was natural for me to use perfume bottles, rings, metallic teapots and bracelets, apples, and peaches—all part of my life, an extension of myself, just as cars, motorcycles, and trucks were for the men. I didn't think of *Jolie Madame* as a feminist statement. I was a painter using my own props.

Jolie Madame was exhibited at the New York Cultural Center in an exhibition called *Women Choose Women*. It was 1973 and the show was historic, the first time a large group of women were exhibited in a museum. The artists May Stevens and Sylvia Sleigh were forces in the women's movement and wanted a woman to hang the show. They nominated me, a vote was taken, and I was unanimously elected.

Sylvia was the wife of the critic Lawrence Alloway, who coined the term "Pop Art." Lawrence came for brunch after he completed his chapter

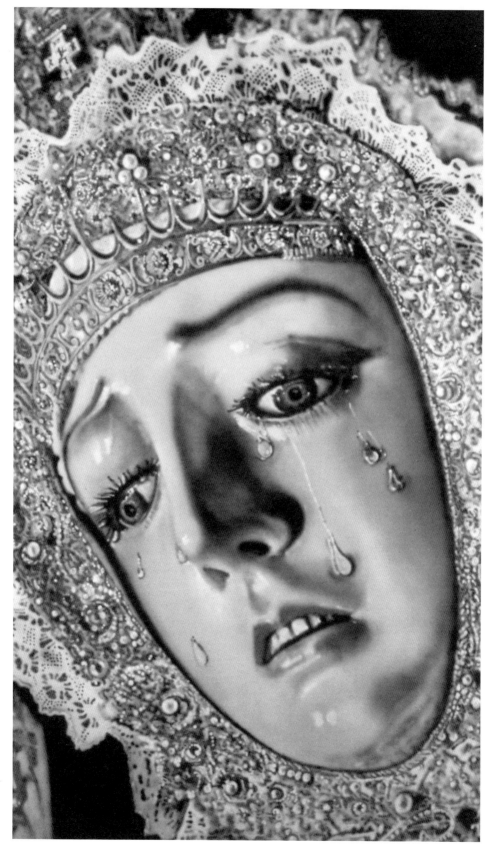

Fig. 48 Dolores of Cordoba, 1971. Oil on canvas, 70 × 50 in. Photo courtesy of Audrey Flack.

for my Abrams book. I set before him a platter of lox with freshly baked bagels and cream cheese from Zabar's. This was not as commonplace as it is today. Lawrence politely asked in his elegant British accent, "Audrey, which is the lox, and which is the bagel?"

"The salmon colored slices are lox, the bread with the hole is the bagel."

"Then I'll have a lock."

Lawrence was as stiff as any Brit could be, but he was a great critic and great supporter of women's art.

It was my responsibility to determine where each painting would hang and where sculpture would be placed. I wanted the show to look strong but soon realized that all of the works were small. Dwarfed by the scale of the museum, they looked inconsequential. Mario Amaya, the director of the museum, had set a size limit; there were to be no large works. It was clear to me that this women's show would be dismissed as "petite ladies' work" if those restrictions were held to. I met with Amaya the next morning and voiced my concerns. It took a lot of convincing, but he agreed that larger works could be hung, and I literally ran out of the room to telephone as many of the artists as I could get hold of—Alice Neel, Joan Mitchell, Perle Fine, Betty Parsons, and many others.

"Bring me your largest and most impressive works right now. There is no time left, the show opens in three days." At that moment I decided to show *Jolie Madame*.

The exhibit received wide critical attention and attracted huge crowds. The *New York Times* came out with a major article in its Sunday edition with praise for the power and importance of the exhibition. I eagerly read the review but was shocked when *Jolie Madame* was singled out for its subject matter and decadence. The critic called *Jolie Madame* "one of the most beautiful ugly paintings I have ever seen."

What was the critic talking about? The painting is beautiful! Decadent? The objects I depicted were priceless. How much is a rose, an apple? How does a gold bracelet compare to the value of a motorcycle or racing car? Had the critic never seen seventeenth- or eighteenth-century Dutch still life paintings? Those paintings contained similar subject matter and were my source of inspiration.

The worst part was that the review was written by Rosalyn Drexler, a woman, who insinuated that the opulence of the painting was feminine and therefore antifeminist. Only then did I realize that simply by

being a woman and selecting objects from my own life, I had created a work with a feminine sensibility. It was this sensibility that was being called ugly. The feminine aspects of *Jolie Madame* were shattering to an art world whose entire history was predicated on male vision, judged by male standards, evaluated by male critics, and written about by male art historians. For this female critic, ironically, my work was too feminine.

I was undeniably a woman and celebrating that point of view. Carl Jung refers to the anima and the animus, the male and female aspects of the self that reside within each of us. Their function is to balance, not extinguish, each other. Art that allows the transfer of these energies can reach everyone, and that's what I wanted to do.

In 1974, Tom Wolfe and I were part of a panel at the New School, discussing the state of contemporary realism, when an attractive young man in a blue denim shirt with red roses embroidered across the shoulders approached me. At his side was a woman who looked like Cleopatra, with long black hair and straight bangs. They were the gallery owners Louis and Susan Meisel.

"I came here especially to meet you," said Louis. "I live in the neighborhood—why don't you come over for coffee? There is something important I would like to discuss with you."

"Now?"

"Yes, we have an apartment in a townhouse just around the corner. Come on, follow me."

Meisel's gallery had a good reputation and I was curious to hear what he had to say, so I agreed. He led the way, the heels of his cowboy boots clicking on the pavement. Susan prepared a mouthwatering platter of Balducci's pastries with marzipan strawberries and steaming hot, freshly brewed coffee.

Meisel was handsome and sure of himself. His intense blue eyes reminded me of my father.

"I'm putting together a collection for Stuart Speiser, a prominent aviation attorney. I want to commission you to make a painting. The one requirement is that it has to have an airplane in it."

Having fought the subject matter battle for so long, I was not about to cave in now.

"Not interested," I said.

"But, Audrey, you can have total freedom. I like your style; I think your approach to Photorealism would be an important asset for the collection. All we need is something to do with aviation."

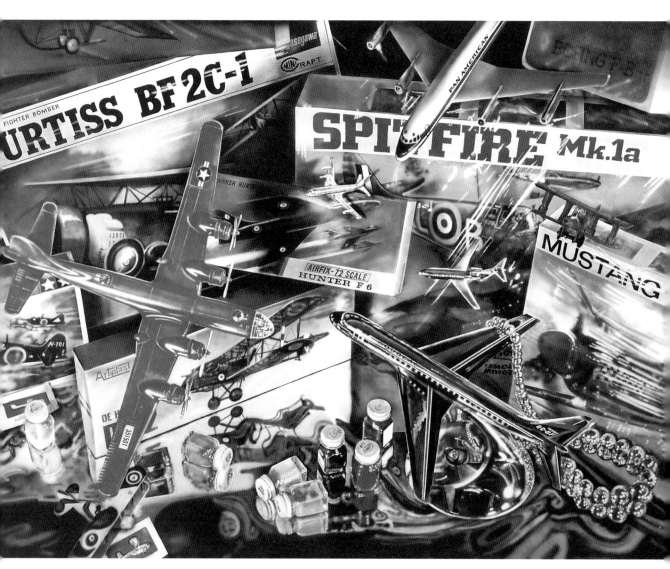

Fig. 49 Spitfire, 1973. Acrylic on canvas, 73 × 110½ in. Photo courtesy of Audrey Flack.

I liked Meisel's passion for art, and in spite of his macho manner, he had no problem dealing with women artists. He recognized good art no matter who created it. By the end of the evening, after two cups of coffee, a chocolate éclair, and a marzipan strawberry, I agreed, reasserting that I wanted total control over the painting. Meisel concurred.

The commission eventually took its place in the Stuart M. Speiser Collection, now a part of the Smithsonian Institution. Lou Meisel became my dealer in 1972.

It was because of *Jolie Madame* that I decided to paint *Chanel*, my first intentionally feminist painting.

If they want to see what feminist art is, I'll show them!

I rifled through lipsticks, rouge pots, compacts, face powders, and bottles of lotion, finding colors and objects that fit my concepts. I wanted items that could be reduced to perfectly geometric shapes. The apple became a sphere, the lipstick tube a cylinder, the rouge pot a circle, and the powder box a rectangle.

It was May of 1974, and the New York art world was buzzing with the excitement of auction week. Major collectors flew in from Europe and all parts of the country. Morton Neumann, the famed Pop Art collector, walked into the Meisel Gallery and was taken with *Chanel*. He told Meisel he wanted to meet me. The next afternoon I got the call.

"Hello, Audrey, this is Morton Neumann. I saw your painting at the Meisel Gallery. Why don't you come to Chicago and see my collection? There are artists you know in it."

That was just what I was afraid of. He collected every realist but me. My work was being left out of these male-oriented collections. Bob convinced me to accept.

Neumann's five-story townhouse looked exactly like all the other brownstones on the block. They lined up like a Giorgio de Chirico painting. We rang the bell and waited for Neumann to unlock the bolts and turn off the alarm system that protected his vast collection. The amount of art packed into that building was astounding.

Paintings were hung one on top of another from floor to ceiling. They hung in front of draperies and bookcases; even the windows were boarded over to provide more wall space. Surveillance cameras relentlessly blinked their red lights as they scanned every room.

Neumann had been friendly with Picasso in the early days and purchased works directly from him. Some of Picasso's masterpieces were bumping up against Mirós, as the collection continued chronologically.

I wanted to see everything, but Morton wanted to watch the tennis matches on his sputtering black-and-white TV set.

"Rose, you take Audrey around. Bob, you stay here with me and watch the games."

It was male bonding. I was a woman; I belonged with Rose. He would never do that to Robert Rauschenberg or one of his other male artists.

Rose Neumann was a small, white-haired woman who dutifully followed her husband's orders and led me up the stairs to the second floor, which housed their Abstract Expressionist collection: Pollock, de Kooning, Kline, Rothko, Gottlieb, and Guston. The paintings were so great that I forgot my annoyance over Neumann's prejudice toward women artists. On the way to the third floor, I noticed a small relief sculpture hanging on the swinging door to the kitchen. It was a Louise Nevelson.

"Rose," I blurted, "is this the only work you own by a woman artist?"

"Yes. Morton doesn't think women make a good investment."

I looked at the Color Field, Minimalist, and Pop Art collections that jammed the next two floors until we reached the top floor, where Morton kept the realist painters. There they were, every Photorealist but me. I was fuming but said nothing to this gentle old woman as we walked back down to join Bob and Morton watching the tennis matches. Bob took one look at me.

"Keep cool," he whispered.

We said our goodbyes, and I complained all the way back to New York. Two days later, Neumann called Meisel to ask if he had a *small* Flack for sale. Louis telephoned me with the news. I was happy about the request, but I knew what would happen.

"If Neumann gets a small Flack, he'll hang it on the kitchen door next to the Nevelson. I won't do it!"

Meisel backed me up, telling Neumann that if he was to have a Flack at all, it would have to be a major work and he would have to pay a substantial price. Neumann bought *Chanel* the following day. It is one of the only specifically feminist paintings I ever did. My other still life paintings contained lipsticks, jewelry, and perfume bottles, but only as part of the narrative. In *Chanel* they *were* the narrative. Neumann hung it prominently in the center of his library. After that, he purchased work by other women artists, but the battle was far from over.

I went on to paint *Queen*. The locket in the painting contains portraits of my mother and me. The eye shadow, the rouge pots, the perfectly

round apple, and the succulent orange slice are objects of pure geometry. Every element in the painting was designed to evoke female sexuality.

Queen reverses the hierarchy of the male over the female in gaming. The queen of hearts dominates the center; the king is absent. The chess queen takes a prominent position in the lower left-hand corner. While she is the most powerful and freely moving of all the chess pieces, the game only ends when the king, who is severely restricted (he can move only one square in any direction), is put into checkmate.

Why isn't the game over when the chess queen falls? Why is the king ranked higher—why not the queen? In card games, why is the sequence ten, jack, queen, king, ace? Why isn't it ten, jack, king, queen, and ace? In the best of circumstances, they should be equal.

I painted *Royal Flush* because poker has always played an important part in my life. Being dealt a royal flush is the closest thing to God a gambler knows. Ten, jack, queen, king, ace, in any suit, is the highest hand you can get and the fulfillment of a dream that, for the compulsive gambler, is never fulfilled. A royal flush symbolizes money, success, power, fame, and love. I wanted to illustrate the unattainable dream, particularly for my mother. I painted it in hearts to symbolize and offer a sense of unconditional love, something my mother always had difficulty with.

Anwar Sadat

By 1978 photorealism was going strong, and I was gaining recognition. My sense of despair had diminished, and at times I even felt elated. Life was good. I had just finished painting and was lying in bed watching television with Bob when the news came on. Anwar Sadat's face came floating across the screen. He was standing on the deck of his presidential yacht, looking imperial in his white pants, white jacket, and gold-braided epaulets. Sadat was on his way to conduct peace talks with Israel. I turned to Bob and said, "If that man creates peace in the Middle East, I will paint his portrait and give it to him."

Not knowing how or if this would ever happen, I lay there trying to sleep and mused about how I would mix his skin tone. I decided on yellow ochre and sienna, with touches of red ochre.

The telephone woke me at 9:30 the next morning. It was Walter Bernard, the art director of *Time* magazine, asking if I would paint Sadat

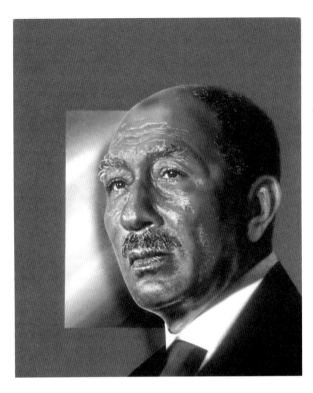

Fig. 50 Painting of Anwar Sadat by Audrey Flack for *Time* magazine cover (Man of the Year), January 2, 1978.

for the cover. Sadat was chosen to be their 1978 "Man of the Year." It was an astounding coincidence, or perhaps something predetermined by a karmic universe.

I had never met Walter and knew no one at *Time*. The magazine dealt mainly with illustrators and traditionally retained the commissioned artworks, but I was a painter, and this was a real portrait on canvas. We made a verbal agreement: I would be paid a nominal amount for the use of my work, but I would keep the painting. Down deep I hoped someday to give it to Sadat.

Anwar Sadat was in Cairo and couldn't pose for me, so I requested photographs. "Send as many as you can. Three-quarter, frontal, and profile views, black-and-white and color please."

I loved the shape of his head, his high cheekbones and taut skin pulled tight over his skull, almost mummylike. I made several compositional studies and came up with an idea for the sky that blended the colors of the Egyptian and Israeli flags. The symbolism was significant but subtle: only the very astute would notice. I wanted no political objections. The cover hit the newsstands all over the world, and one week later I began to get calls from *Time*.

"We want to buy the painting. How much?"

Fig. 51 Letter from Anwar Sadat to Audrey Flack, 1978. Photo courtesy of Audrey Flack.

بسم الله الرحمن الرحيم

The President
of the Arab Republic of Egypt

الرئيس

Cairo, April , 1978

Dear Mrs. Audrey Flack :

 Really I have been deeply impressed
by your kind words and the very expressive
Photo of mine which you have skilfully painted.

 The Photo reflects an artistic
mastery and talent .

 Please accept my cordial thanks and
congratulations for that wonderful piece of art,

Sincerely,

(Anwar El-Sadat)

"I told you, I don't want to sell it." But the calls kept coming in, and the phone kept ringing with messages that sounded more and more urgent. I suspected something was up, and I was right. I didn't know it, but Anwar Sadat had been calling from Cairo asking for the painting. He loved it. *Time* poured on the pressure and I succumbed, but with one stipulation.

"If you ever give my painting to Sadat, I want to be there."

I was naive enough not to get it in writing. Six months later, I was flipping through the magazine and stopped when I saw a photograph on the editorial page: several *Time* executives smiling, shaking hands with Sadat and handing him my painting. It was framed in mahogany and had a gold plaque on the bottom that read, "To Anwar Sadat from *Time*."

They were in Cairo, and Sadat looked happy; I was in New York and not so happy.

I felt tricked. I called Walter Bernard, who apologized. He was considerate enough to send word to Sadat. Two weeks later I received a letter from Anwar Sadat with a presidential envelope, presidential seal, and Egyptian stamps, mailed from Cairo and signed personally. Sadat expressed his "thanks and congratulations for that wonderful piece of art."

I have cherished that letter all these years and recently gave it to the Smithsonian's Archives of American Art. After Sadat was assassinated, I've been told that his widow, Jihan, took the painting. I hope to see it again someday.

Vanitas

I started on a new series of paintings called *Vanitas*, a word that comes from the book of Ecclesiastes. Written by a preacher said to be the son of King David of Jerusalem, Ecclesiastes proclaims that all the actions of man are inherently vain, futile, empty, meaningless, and temporary: "People . . . don't know when their time will come. Like fish tragically caught in a net or like birds trapped in a snare, so are human beings caught in a time of tragedy that suddenly falls to them" (Ecclesiastes 9:12 [CEB]).

According to Ecclesiastes, there is no escaping tragedy or death, but we can live our lives to the fullest by remembering that we too shall die. When you look at your face with its ruddy complexion, pink cheeks, and full head of hair, remember that beneath the flesh lies a bald skull ready to be exposed at any moment. That was the theme of my *Vanitas* trilogy—*Wheel of Fortune*, *Marilyn*, and *World War II*—the largest and most complex of all my works.

I spent months collecting props: skulls, timepieces, insects, patterned drapery, vases, flowers, lipsticks, and burning candles. I arranged them into complex still life compositions and then photographed the arrangements, shooting roll after roll of film under hot floodlights in preparation for the *Vanitas* paintings. This was my life I was photographing, my story I was telling. A single painting might take an entire year, even two.

Wheel of Fortune is about what fate delivered to me: Melissa, the child who nearly killed me and became an angel that changed me. There is a picture of her in the upper left-hand corner. You can see me holding a tripod in the gazing ball on the right. The frame of the painting has a quote from the poem "Invictus," by William Ernest Henley:

> It matters not how strait the gate,
> How charged with punishments the scroll,
> I am the master of my fate:
> I am the captain of my soul.

The *Marilyn Vanitas* is about her unrelenting need for love. Marilyn needed it, I need it . . . we all need it. (*Marilyn* turned out to be the most sought-after painting I ever made, winding up on the cover of a couple of art history books.)

World War II is about Walpurgisnacht, about the nature of humanity, about evil, purity, and survival.

The three most major works of my life were now complete and exhibited together at the Meisel Gallery in 1978.

In spite of the critical attacks on my subject matter, there was great public response to my work. Busloads of visitors, tour groups, and college classes poured into the gallery. At times, there were so many people that Meisel had to put up ropes to protect the paintings. Abrams was about to publish a monograph on my work, my shows were selling out, and there was a waiting list for future paintings.

Photorealism was now being exhibited both nationally and internationally, with extensive coverage in newspapers and art magazines all over the world. I had exhibitions in Paris, London, Madrid, Brussels, Japan, and Australia, and I lectured all over the United States, Europe, and Asia. The movement was on its way into the history books, but I remained the only woman in the groundbreaking group who was using humanist imagery.

The most exciting event was when Mary Cassatt and I became among the first women to be included in H. W. Janson's monumental textbook, *The History of Art*. Anthony Janson, the art historian and son of the original author, had succeeded in breaking through centuries of prejudice.

But at first my reaction to success was strange. I felt detached, apart from it, as if it were next to me, not within me. When the Museum of Modern Art purchased my painting *Leonardo's Lady*, I was struck with a migraine headache so severe that it lasted for three days.

Was the promise of acceptance and recognition overwhelming? Perhaps it was the review Hilton Kramer wrote about *Leonardo's Lady* in the *New York Times*. While he complimented MoMA for "waking up enough" to purchase my painting, he also referred to me as the Barbra Streisand of the art world. Streisand was being criticized at the time for being a temperamental and difficult diva.

I got a phone call the next morning from Patricia Hills, curator at the Whitney Museum, who pointed out that Kramer's comment was not only anti-female but also antisemitic. "He didn't call you the Grace Kelly

Fig. 52 Photograph taken for the cover of the October 1980 issue of *ARTnews*: "Where Are the Great Men Artists?" (Audrey Flack is in the back row, second from left.) Photo: Neal Slavin.

of the art world, nor would he compare any male artists, like Rauschenberg, to a Hollywood movie actor."

In those days women who stood up for themselves were considered aggressive and contentious.

Still, I was driven, elated. I couldn't stop painting. I painted day and night. I was on a roll, a rush. I hit it with every painting. I was in a continuous state of heightened alert. I would stand before the canvas in the darkened studio, mesmerized by the projected image as the gelatinous slide illuminated the entire studio with rainbows of colored light.

Each painting was a step forward. I developed new theories of color and light, delved into new concepts of space, devised new subject matter. I took my own photographs, worked in my own darkroom, and projected my own images, staking claim to unexplored territory.

I was in the zone, creating my best work, one painting after another. You know when it's happening: every artist does, and don't let anyone tell you different. Michelangelo knew he had created a masterpiece when he chiseled David and painted the Sistine Chapel. Bernini knew it when he stood back and looked at *The Ecstasy of Saint Teresa* and *Apollo and Daphne*. Caravaggio, Crivelli, Luisa Roldán, Van Gogh, Picasso, and Pollock—they all knew.

It's like having an unending series of orgasms: divine but exhausting. There comes a moment when it takes over. You are no longer in control of what's happening to you. You're hitting home runs with the bases loaded over and over again. The tennis ball is making that ping in the exact center of the racket. You never make a mistake. All your serves are aces.

In music it feels like all the instruments and voices in a great cantata intersect, sync, and vibrate in sublime harmonic resonance. In art, it's as if all the colors, shapes, forms, and iconographical concepts converge.

At these moments, something akin to an atomic explosion takes place. A new energy is formed, and that spark of life sets off vibrations that never stop resonating. When we stand before great art, we feel those vibrations even if the work was created hundreds of years ago. These

Fig. 53 Ecstasy of Saint Teresa, 2013. Graphite and color pencil on paper, 29 × 22 in. Photo courtesy of Audrey Flack.

exquisite particles of energy enter our bodies through our retinas and restore internal order. This is how art can heal.

My days as a paint-slinging, dripping, smearing Abstract Expressionist were long gone. Photorealism called for precision, planning, meticulous control, and discipline. I was consumed and worked in a charged and altered state all through the seventies, until I completed *World War II*. It was in 1978 that I began to get premonitions of death. I knew I was wound too tight: my brain was too wired and it had lasted too long.

Can you die from too much of a good thing, from a never-ending orgasm?

The other Photorealists began to show signs of physical problems. One started drinking heavily, two had strokes, and Chuck Close became paralyzed. Seeing what was happening to my artist friends was troublesome and must have played a part in what was to happen to me, but there were other forces at work that I was not yet aware of. On the surface it looked as if I had an ideal existence.

World War II

The idea had been brewing for years. Now, at age forty-six, I wanted to do something for my people, for my brother. Picasso painted *Guernica* and everyone thinks it's about World War II, but it is really about the Spanish Civil War. He painted it for *his* people. In 1977 I felt it was time to tell the story, to paint an allegory of war.

I read everything I could get my hands on about Hitler, Speer, Göring, Heinrich Himmler, Goebbels, the whole entourage, and then I came across a book called *The Survivor* by Terrence Des Pres. It told of acts of kindness and caring that took place among the prisoners in concentration camps and showed that even under the most depraved circumstances, humanity could prevail. I was deeply moved and gathered my forces together in the hope that I had enough energy to paint good and evil, beauty and horror, deprivation and abundance, to electrify the painting with shocking contradictions and still create beauty.

An idea can germinate in my head for a year or two before I start actual work, but *World War II* took longer. All during that time, I searched for props, collecting old photographs, mirrors, vases, Holocaust literature, and symbolic objects that would help the narrative. I never knew where an object or an idea would pop up—in a subway, a garbage can, a flea market, a newsstand . . . anywhere.

A photograph had seared its way into my brain when I was younger. It was a black-and-white magazine photo taken by Margaret Bourke-White at Buchenwald in April 1945, moments before American soldiers liberated the heinous concentration camp. It showed a group of emaciated victims staring silently at the camera from behind a barbed-wire fence. This was the moment they had been praying for, the moment of liberation when their suffering would cease, yet they could show no affect. They were stunned beyond expression; only their hollow cheeks and sunken eyes revealed their ordeal. I saw misery that went beyond human endurance—yet they had endured. Their souls had been murdered, but they were still alive.

I chose not to paint scenes of senseless murder. Too much blood had been shed already, and I did not want to get the attention of or titillate the audience that way. But at the same time, I wanted to shake the viewer into consciousness.

Here were starved, brutalized men. What better contrast than to show them next to sickeningly sweet pastries resting on a silver platter? Opulence and deprivation. Were we not all eating at that time? Are we not all eating now while people are starving elsewhere? This is part of the *vanitas* of life.

I found a gold-rimmed porcelain demitasse cup encased in silver, a string of pearls, and a hand-blown indigo blue goblet, a Viennese heirloom I inherited from my ex-mother-in-law. Its silver cover would reflect the faces of the prisoners . . . a perfect cup of sorrows. A Mexican silver candlestick with a hand-tooled design, a half-rotted pear, a pocket watch, a sheet of cello music left over from my ex-husband's music library, part of a keychain with a Star of David, and a clear red rose with a slight bluish tint: each of these was carefully positioned.

The pastries were an important symbolic element. I walked to Lichtman's bakery on the corner of Eighty-Sixth Street and Amsterdam Avenue, the last of the old-style European Jewish bakeries. I peered into the glass counter, scanning every petit four they had on display: chocolate, vanilla, strawberry, all exquisitely styled and decorated with edible marzipan cherries, leaves, and flowers.

I asked the saleswoman if she could have the baker enlarge a cherry, repair a leaf, smooth a chocolate glaze—these delectables had to be perfect. She parted the curtains and walked into a large back room where the baking took place. Moments later, a gentle-looking man wearing a white apron emerged and asked in a Hungarian accent, "Can I help you?"

It was Mr. Lichtman himself. I smiled and explained that I needed his petit fours for my new painting.

"What kind of painting needs such special pastries?" he asked.

I explained that I was painting prisoners behind bars in a concentration camp and that his pastries would be a vital symbolic element.

Mr. Lichtman looked up at me with an intense stare and slowly rolled up his sleeve, revealing a series of tattooed numbers on his forearm. A chill of prickly goose bumps ran up my arms. We exchanged a long look of understanding. He brought out a new tray of freshly baked petit fours, and together we selected the ones with the most perfect icing and glazed cherries. I promised him a reproduction of the painting.

In *Polish Jews*, a book of photographs by Roman Vishniac, I found a quote that captured the beauty and purity of feeling I wanted to get across. I cut it out and placed it under the Margaret Bourke-White photograph.

> Outwardly they may have looked plagued by the misery and humiliation in which they lived, but inwardly they bore the rich sorrow of the world and the noble vision of redemption for all men and all beings. For man is not alone in the world. "Despair does not exist at all," said Rabbi Nahman of Bratzlav, a Hasidic leader. "Do not fear, dear child, God is with you, in you, around you. Even in the Nethermost Pit one can try to come closer to God." The word "bad" never came to their lips. Disasters did not frighten them. "You can take everything from me—the pillow from under my head, my house— but you cannot take God from my heart."

I painted a fiery red drape, slipped the pocket watch into one of the folds, and set the time at a few minutes before twelve, a few short minutes before the final hour . . . the witching hour, Walpurgisnacht. The prisoners were painted in black and white to recede in space. They signified time having passed . . . despair . . . memory. The rest of the painting is in brilliant Kodachrome colors signifying the present. The surrounding border is a sequence of prismatic colors juxtaposing a harmonic prism with the Holocaust.

I had to have a blue-and-white butterfly and found one in a botanical boutique. The wings had to be softened in order to bend them without

breaking. I perched it on top of the demitasse cup, wings open, about to fly. Only later did I find out that the butterfly symbolizes the liberation of the soul, like the Holy Ghost or the dove of Christ.

The setup was ready to shoot. My Hasselblad was loaded and positioned on its tripod. Jeanne Hamilton, my assistant photographer, switched on the lights, and I lit the red candle hovering over the photograph. It was to be a memorial candle bridging the time between 1945 and the present; it was to burn always in the painting. The lights were hot, the candle melted down, the smoke went up. I looked through the lens and saw that the red wax had begun to drip all over the book . . . it looked like spreading blood. Three drops dripped onto the quote as if they were placed there intentionally. At one point the shape of the melted wax took on the form of Hebrew letters. The candle was burning down rapidly . . . so I shot at breakneck speed. I don't know why I put the cello music in the painting. I thought of cello music as music of the spheres, but found out that the Nazis forced imprisoned musicians to play cello music while Jewish inmates were being marched to their death.

The painting was beginning to consume me. Faces of men I saw in the subway began to resemble the survivors in my painting. I stared at them, and it was only when they glared back angrily that I snapped out of it. I was totally immersed.

Three-quarters of the way through painting the canvas, I invited a former student to the studio. Stuart was now a successful private art dealer, an intellectual who was familiar with the art world.

I remember his initial reaction when he saw the Star of David. His eyebrows lifted and jaw closed shut. He remained silent.

"Well, what do you think? Say something."

"Are you really going to leave *that* in there?"

In retrospect I see that he was the only person honest enough to mention the offending object. I had the same reservations when I first placed the round charm in the still life setup. I felt uneasy, as if I was doing something wrong. I never mentioned it to anyone until Stuart brought it up.

The history of Western art is basically Christian. That is what I knew and grew up with. The Metropolitan Museum of Art is filled with paintings of the Crucifixion. Crosses jump off the walls of museums all over the world. Had I ever seen a Star of David in a museum? No, not even one! The only painting with Jewish content I could think of was Marc Chagall's rabbi wearing a Jewish prayer shawl. It seems I was puncturing

a hole in the silent but powerful and exclusive tradition of Western art. I continued working on *World War II* for well over a year. The last brush-stroke was painted in May 1978. It was one of the first paintings on the subject to reach the public.

My exhibitions continued to attract crowds. *World War II* was particularly popular. But the more people responded, the more the "select few" labeled Photorealism "lesser art." When I was singled out, the reviews were deadly.

A scorching review came out in the *New York Times* on Friday, April 14, 1978:

Audrey Flack (Meisel, 141 Prince Street): Grossness is also a feature—the feature—of Audrey Flack's work, and it has earned her a lot of critical admiration. Formerly a realist painter who made use of photographs, she became a photorealist during the 60's with emphasis on media events and feminist imagery. The three major works in this show are each eight feet square and consist of photomontage compositions executed by airbrush in hideous colors. A cross between the billboard smeariness of James Rosenquist and the thrift-shop eccentricity of the Texan Donald Roller Wilson, the canvases are packed with objects—skulls, lipsticks, jewelry, watches, hourglasses and so forth—all cornily redolent of symbolic meaning. The most horrendous of them is "World War II," in which a glistening array of giant petit fours on a silver dish, pearls, a rose, a butterfly and a cup and saucer are stacked in front of a grotesquely retouched blowup of Buchenwald inmates behind barbed wire. One critic has called Audrey Flack "an ardent humanist," another has seen her work as "a nondestructive enlargement that celebrates the pleasures of survival by the integrity of objects." This reviewer can only recoil from the vulgarity of her literal mindedness.

A review like that stings. I was devastated and angry. And my response to her showed it.

My technical skills had risen to a point where the reviewer thought my painting was a "photomontage," a "grotesquely retouched blowup"—in other words, a photograph. I expected more from a *New York Times* critic. Anyone visually aware could see that I painted every inch of that painting!

Audrey Flack
110 Riverside Drive
New York, NY 10024

Vivien Raynor
New York Times
229 West 43 Street
New York, NY 10019

Dear Ms. Raynor:

The psychological distortions and destructiveness of your personality are frightening. Fifteen years ago, you reviewed a show of mine at the Roko Gallery for Arts Magazine. In it, you discussed my "state of mind" saying that Audrey Flack seemed "inordinately pleased with herself." Never having met you, I wondered how you would know my state of mind. In fact, at that time, I felt quite close to death... I had a tragically sick child, a troubled marriage and a near starvation budget. Seeming pleased with myself was clearly a distortion which existed in your mind.

When my current "Vanitas" show opened at Meisel Gallery, I instructed my dealer not to send you an invitation, announcement or catalog. He honored my wishes and sent information to every other critic at the times and omitted you. But like a bad penny, you showed up again – your twisted motives driving you.

The words you used to describe my work, "hideous color . . . grotesque blow up . . . horrendous," are clearly again distortions of yours, which can see a beautiful rose as something hideous, tragic expressions on the faces of Buchenwald prisoners as horrendous. These words and feelings come from your mind and not my paintings. I would like to refer you to Lawrence Alloway's catalog essay for the show, John Perrault's review in Art News and Gregory Battcock's analysis in the current New York Journal of the Arts. Perhaps these writings will help you get a better grasp of reality.

Further, it is the duty of an art critic to know about art. My painting *World War II (Vanitas)* was not a blown-up retouched photograph as you publicly indicated in your review. I am delighted at the success of my trompe l'oeil technique but you should know better . . . surely ask, before sending out mis-information.

The literal mindedness in my work that you refer to, is quite intentional, designed to reach an audience larger than the immediate art world . . . an audience that has been ignored and intimidated for many years.

I want the public to feel the affirmation and pleasure of comprehension. Written material is included in the paintings to make them even more specific. This relates to a course I took at Yale University on the iconography of the Bible given by Mary Ellen Chase. I was deeply impressed with the intent of early Christian and Renaissance artists to communicate clearly and directly with their work, using both symbols and words. The angel Gabriel is often shown with words flowing from his mouth . . . "Behold, a virgin shall conceive and bear a child", as Mary is glancing at a book in which the very same thing is written. I have attempted to use this same literal mindedness in my art, and for much the same reason.

It is for you the critic to look further and examine the depths of a complicated spatial structure, compositional rhythms, baroque multiplicity and abstract formalism. The work exists on many levels.

World War Two was intended to shock as Manet's *Luncheon on the Grass*. To upset . . . in some ways to show the banality of evil. Here again, I would expect more from the trained eye than the superficial reaction you had.

I personally recoil at the thought of your eyes looking at my works. I hereby make an effort to protect them from you. My wishes are for you to never see a work of mine again. When I have an exhibition, do not enter the gallery. When in a museum and a Flack is hanging on the wall, respect the painting by looking the other way. Another solution is to wear horse blinders . . . or perhaps a blindfold would be better.

Sincerely,
Audrey Flack
May 1978

That is the magic of trompe l'oeil painting: it fools the eye. In spite of the overwhelming public response to Photorealism and my work, the "art world" failed to grasp the concept. Twenty years later, the very same newspaper referred to the very same work as a "masterpiece."

The brutal criticism of my work, aside from its female subject matter, was my use of "kitsch" objects, bright colors, and jam-packed narrative. This challenged the elite sensibility of minimalism. When viewed behind the glass of irony, sarcasm, and cynicism, it was acceptable. When presented seriously, it was considered lower-class kitsch, something to recoil from.

I had a premonition that I would die after I completed *World War II*. And indeed, I became seriously ill later that year. No doctor ever discovered what was wrong with me. It could have been from some undetectable parasite I picked up on a recent trip to India. High sedimentation rates indicated that my body was fighting off an infection of some sort. The siege lasted for three years . . . I thought I was dying and the bad reviews didn't help. I was so weak I could barely walk. Blood tests were frequently taken, and my arm had a long string of puncture marks that looked like a railroad track.

Faced with the prospect of entering New York Hospital, I chose a homeopathic program at the Himalayan Institute in the Pocono Mountains. I lived in a cell for two weeks and was allowed to talk to no one but the doctor, and then only when I had an appointment. I became friendly with a fly that accompanied the meals that were brought to my room. It was there I learned of the connection between mind, body, and spirit. I studied pranayama, the science of breath, meditation, biofeedback, nutrition, and the *Bhagavad Gita*. In those two weeks, the course of my illness turned around; I began to heal.

But I kept thinking about the painting. I remember thinking . . . *I can't die until it is placed properly. World War II* did not sell, nor was it exhibited again for almost a decade. However, years later I received a call from the Jewish Museum, which was putting together an exhibition on the Holocaust and wondered if I still had the painting, which of course I did. *World War II* took its place in the middle of a large group exhibition and was hung prominently on the first floor of the Fifth Avenue museum.

A week after the opening, I received another call informing me that a group of women had voted to give an award for *World War II*. There was to be a banquet and ceremony, which I happily agreed to attend. I walked through the glass doors of the museum and was escorted to a private ballroom on the third floor. A couple of hundred women were milling around sipping white wine as they socialized with one another.

I was surprised to see so many people. As I was being led to my seat, I asked the museum attendant who all these women were and if they were all here to attend the award ceremony. "Yes, they are. They are a group called the Tel Hai Hadassah and they are all Holocaust survivors." Suddenly it all made sense. I looked around the table at every one of them and tried to imagine the stories hidden beneath their made-up faces and fine clothing. They had no interest in me; they were into each

other, and who could blame them? I began to worry about what I could possibly say about my painting. They had lived the war. I had just made a painting. They *knew*; I just imagined.

After a rich dessert of chocolate mousse and raspberry sorbet, the speeches started. One after another, speakers went to the podium. Several of them were from my table. After the speakers, the head of the organization, a woman named Greta, took the stage.

"We have a special guest here. Her name is Audrey Flack; she is the artist who painted *World War II*."

Applause.

She beckoned me to the stage. *This is it*, I thought, *the moment of truth.* I thanked the group for the award and for appreciating my painting. Just as I began to talk about the work, a woman in the rear raised her hand.

Greta yelled out, "Stop, there's a question."

"Why did you put those petit fours in the painting?"

It was the question I most dreaded. I had been criticized for the materiality of the work, for being insensitive and placing food next to starving people. The sting of negative reviews returned. I paused to collect my thoughts, but before I had a chance to speak, Greta once again interrupted.

"Yes, yes, I thought about that too. Why did you put pastries in the painting?"

Another woman shouted, "And why did you put the silver tray and demitasse cup in it?"

They were on a roll. Questions came pouring out. Conversations broke out between the women. The noise level rose and fell again when Greta brought the group back to attention.

"Let her speak," she said.

"I put the pastries there because—"

I was interrupted again, this time by a beautiful, ash-blonde woman in a light beige suit. She made her way to the front and softly asked, "I want to know how you knew to put them there?"

"What do you mean?" I queried.

"I mean how did you *know* to put the pastries in the painting?"

Before I could assemble an answer, she went on to tell a story that brought chills to my body and tears to my eyes.

"When I was in Auschwitz with my mother, they gave us a crumb of bread and a drop of water at night. I was starving. My body was so

weak, I stopped menstruating; I hadn't enough blood. I could barely stand. The only thing that kept me alive was to imagine that the mildewed crumb of bread was a mouth-watering pastry, rich and sweet, glazed with icing, tasty and creamy. How did you know?"

I couldn't speak; I stood there silent and amazed. Just as she finished, another woman spoke up.

"Yes, yes, how did you know? The only thing that kept me alive was to remember how I polished the silver for Shabbat dinner. I would picture the dirty crumb of bread as a freshly baked challah on the silver tray. How did you know to put the silver tray in there?"

The answer is, I didn't know. *Had I somewhere deep inside connected with the collective unconscious and gotten into the minds of the survivors without knowing it?* Artists can do that. I drank it all in, rejoicing in the sweet taste of redemption. I no longer cared about the years of art-world criticism; this is what it was all about.

Someone else shouted out, "Why is the candle red? Shabbat candles are white. Why is this one red?"

"At first I used a white candle but the color receded," I explained. "I needed a vertical object to come forward in space and that particular red was the right color."

I pointed out the subtle difference between the true red of the candle and the bluish red of the rose. I told them about the wax melting, the cello music, and the butterfly. I don't know how much they were able to absorb about the aesthetics, but this painting was clearly theirs.

I thought it was over. All was quiet. I was basking in the relief and thrill of redemption, but it didn't last long. An elegant woman in a gray Chanel suit moved toward the front and raised her hand. I nodded for her to speak.

"I have one question," she said solemnly. "Where are the women?"

There was a long, thoughtful silence.

Oh my God, I had painted all men!

All of the photographs I had seen growing up were of male soldiers, male prisoners, and male dead bodies. Only years later, and then sparingly, did photographs of women with shaved heads and shriveled breasts appear here and there in the back rooms of museums or slipped between the pages of war journals. Usually, they were starved, skeletal corpses thrown naked into mass graves. I remember looking carefully to determine the gender. The ones with a semblance of breasts were the women.

"Thank you," I said. "If I were to do the painting now, there would be women. You would be in it; you are the true heroes! Thank you for surviving and telling your stories! You have redeemed me and restored my faith!"

Greta handed me an award, a bronze plaque. I held it to my chest. These survivors had lifted *World War II* out of the art world, deposited it in the real world, and taken me along with it. I left for home thinking about these incredible women, hoping that somewhere in the universe my brother, who had died only a few years before I received the award, felt a touch of redemption also. One year later, two museums and a private collector were interested in acquiring the painting. It resided in a very fine private collection and was eventually acquired by the Pennsylvania Academy of the Fine Arts.

Angel with Heart Shield and the End of the Artist's Block

After her visit to the Hamptons in July of 1985, Melissa returned to school and I felt an unusual pang of sorrow. The August rains made way for September winds that blew multitudes of leaves on the grassy lawns, and we returned to New York City. Late September was my favorite time of the year, a time of death, gestation, and rebirth. Intermittently and sporadically, I renewed my efforts to paint, but almost all of my time was spent on the Broadway Mall. I was on the bench when, suddenly, I felt an urge to return to the studio. There was no directive, no desire to paint, not even a concrete idea; it just *was*. Without thinking I walked past the homeless shelter, past the farmer's market, turned right onto West End Avenue, and felt the gentle Riverside Drive breeze usher me home. The studio doors were open and I saw the sun illuminating my blank canvas.

How pristine, I thought. *A clear surface, a blank slate.*

I went to my supply closet and was rummaging through a box of old paint tubes when my eye caught sight of a gray-green lump of clay oozing with streaks of black oil. It must have been lying around for years. Bemused, I stared at it for quite a while, picked it up, and was surprised to find that despite its putrid color and repellent, greasy texture, it felt good in my hands. It felt solid, real, and grounding.

It weighed about five or six pounds, about as much as a small baby. I lifted it up and down as I would a dumbbell weight. It was so rock-hard from lack of use that I had to pound it with a wooden mallet to bring it

back to life. It was a sensation that painters are not familiar with. You don't "hit" paint.

After a while, the block of clay softened enough for me to break off a piece. I began to knead it as if it were pie dough, pressing, pushing, pulling, all the while enjoying the undulating sensations of my thumbs and fingers. I became so immersed that I forgot about the paint I had been searching for, and for the first time in two years, I felt an infusion of quiet energy. A sense of calm came over me.

All during my time on the bench, my brain had been processing and recoding pain. I was filled with fear, sorrow, and heart-wrenching agony. Everywhere in life, there are those among us who have shared similar feelings; they have been hurt, abandoned, abused, neglected, misunderstood. Somehow, most of us find ways to get through. Others walk head-on into the ocean and let themselves be carried away.

I stepped out of life for two years, and from my bench of reflective solitude, I had been putting myself back together, taking the time to process feelings I couldn't afford to while I was in the boiling cauldron. You can't go through psychotherapy when you're struggling to survive. I had to be there for my children. I couldn't afford the luxury of despair or death, although there was one time when I was at the end of my rope. I locked myself in the bathroom, curled up in a fetal position, and screamed so loudly that the world would have trembled. But no sound came out of my mouth. After a few minutes, the reality of leaving my two children alone startled me back. I ran to the kitchen and was relieved to find Melissa watching the dryer spin and Hannah banging on a frying pan.

Even though I could siphon some of those feelings into my paintings, they were still inside my body, my mind, never allowing me a good night's sleep. Painting had been my only method of survival for so long that I had forgotten what I was living for. And here I was, standing in a small closet, holding a lump of grimy clay, feeling alive again. The tension broke; the painting block snapped and lost its hold. I felt a sense of peace and solitude.

Walking back in the studio, I glanced at the canvas on the easel. It was the same one that Chuck Close and I had talked about endlessly, sharing ideas about how to prime the surface. We painstakingly applied several coats of gesso, sanding each one with wet-dry sandpaper. After the creamy surface dried, we repeated the process until we got the perfectly glass-smooth surface we wanted. As we stepped back and looked

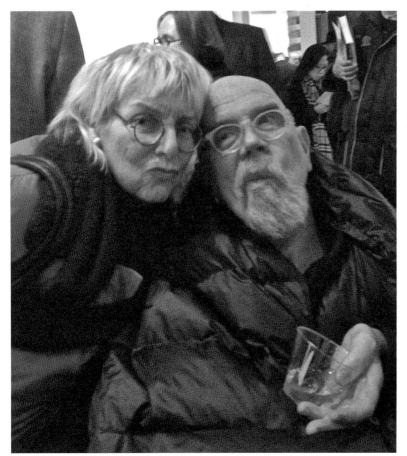

Fig. 54 Audrey Flack and Chuck Close. Photo courtesy of Audrey Flack.

at our incredible brilliant white canvases, Chuck joked, "They look like finished Robert Ryman paintings, don't they?"

It was the same canvas I had been staring at for the past two years, hoping for a miracle. I lifted it off the easel and stacked it against the back wall, where it remained unpainted for the next thirty-two years. Little did I know that at that moment, I had given up painting.

The chunk of clay I held is called Plasteline. It is ordinary clay imbued with various oils to keep it from drying. Oil paint was created in a similar manner when Jan van Eyck added linseed oil to powdered pigment. Before that, artists had to crack open an egg, remove the yolk, and mix the egg white with dry pigment and water. The medium was called egg tempera, and it dried within minutes. By adding oil, drying time was extended, and artists could approach their works with a less pressured sensibility.

Van Eyck's discovery revolutionized painting, and a similar thing happened when oil was added to clay. It became Plasteline: it never dried, cracked, or died. It got old and hard but could always be revived.

The Plasteline felt warm and sensual as I squeezed my fingers into it and started to model forms. As soon as one emerged, I smashed it and made another. Plasteline is a resilient, pliable medium that forgives mistakes and encourages free expression. The forms were coming fast; they felt alive, and so did I. Captivated, I stayed in the closet for well over an hour before I became aware that time had passed. The inner power that demands creative expression had yanked me back to life and was compelling me to sculpt.

Plato and Plotinus would say that the *daimon*, or "guiding force," was directing me—that the creative spirit had reentered me. When the *daimon* takes over, it has a will of its own. From that time on, I held a piece of clay in my hands all day long; I carried it to the kitchen, the bedroom, the bathroom, everywhere. In restaurants, when I had no clay I rolled slices of bread into lumps of dough and kneaded them into shapes. The process had begun, and I couldn't stop it. I had no idea what it would lead to and I didn't care. In an instant I had transformed from painter to sculptor.

As I worked the clay, a torso began to emerge. Over the next few days, I shaped arms, legs, feet, hands, nose, mouth, cheeks, and eyes. I spent a long time on the face. The expression had to be just right: innocent, youthful, yet knowing. I decided it needed eyelashes.

How do you make eyelashes in clay?

The Greeks thought about that too and solved the problem by inserting fringed metal strips into the eyelids.

And wings: this figure had to have wings. It felt as if this small being had been lying dormant inside of me, in a place the Hindus called the *hara*.

I carried the clay in my hands but soon realized it needed to be set down to be worked on seriously. I bought a sculpture stand and continued to model and carve. I stepped back to get a better look at my creation and was surprised to find . . .

It was an angel!

It wasn't the usual putto, cherub, or seraph; it looked like an eight-year-old child with wings.

Was it male or female?

I couldn't tell. In either case it was independent and had made its way into the world on its own. A whole story was coming to me. This angel had learned to fly early in life, exploring the world in short bursts of flight. Long-distance journeys were yet to come. It had just slid to a

Fig. 55 Angel with Heart Shield, 1981. Bronze, 9 in. Photo courtesy of Audrey Flack.

halt. Its wings had not yet fluttered closed; its legs were dangling over a ledge. The angel was holding something to protect itself.

Was it some sort of shield, a heart shield?

Like Eros, this angel also carried arrows it used to infuse people with love.

Was the statue me? Did I want to shoot people with arrows so they would love me?

I had always wanted to fly. I still have the urge to jump off terraces and have to resist leaping over the edge of the Guggenheim's rotunda— not to kill myself, mind you, just to swoop around the atrium. As a child I spent hours with flocks of pigeons in the park. I sat on the pavement with them, wanted to be one with them. I loved them. When a group took off I ran with them, flapping my arms up and down. And when they took flight, I jumped high in the air, hoping to become airborne even

for a moment, but I inevitably fell to the gravelly pavement. I wanted to catch one, kiss it, understand its anatomy and how it flew, but the pigeons were much faster than I was.

"Sprinkle salt on its tail," my father suggested, and I tiptoed after the pigeons with a chamois bag of kosher salt, sprinkling throughout the park. After innumerable failures and scraped knees, I gave up. I would have to find another way to fly.

So I decided to jump off the fire escape. I took two pieces of cardboard that stiffened my father's laundered shirts and cut out monarch butterfly wings. I colored them with ornate baroque designs, certain that the beauty of the artwork would carry me into the sky.

I stitched rainbow-colored wool through the wings and tied them to my back by wrapping the wool over my shoulders and around my waist several times, ending with a firm knot above my belly. I was ready. No one was home. I stepped out onto the fire escape. It was so rickety that it shook like my mother's bowl of Jell-O. Years of brittle paint chipped off and splintered to the sidewalk.

I looked up at the beautiful blue sky and climbed over the rusty railing, leaning forward like the figurehead on the prow of a sailing ship with my hands gripping the rail behind me. I was Icarus, ready to fly to the sun. I took a deep breath, let go with one hand, and was about to release the other hand when a voice from the more rational side of my brain told me that my cardboard wings were not wired to flap.

Oh my God, I'm in big trouble, I could fall to the sidewalk and die.

On a deeper, more analytical level, it was then that I made the decision to not commit suicide. I steadied my grip and crawled back through the window, feeling defeated but alive.

Performance artists have been known to harm themselves to an extreme. Vito Acconci rubbed cockroaches on his belly while caressing himself. Chris Burden was crucified onto a Volkswagen. Charlotte Moorman strapped plugged-in TV picture tubes to her naked torso and played the cello. Marina Abramović carved a star on her stomach.

Were these artists acting out early childhood deprivation, despair, and trauma? Were they asking for love and attention? Was the angel actually me, perched on my old fire escape?

Artists find their truth in their work. Michelangelo believed that figures lived within the marble and all he had to do was release them. What he was really releasing was his inner self.

Was something in me being released in the form of an angel?

My family, friends, and especially Lou Meisel insisted I get back to painting. They said I was being neurotic and self-destructive, sabotaging everything I had accomplished. Meisel became impatient and angry. I explained that something had come over me: I would get back to painting as soon as I finished the angel. But that never happened. Once the process had begun, there was no way to stop it.

I brought the clay angel to the Tallix foundry in Beacon, New York. Art foundries are special places. Tallix can handle something as small as my ten-inch angel or as large as the commission I was to get years later, a figure second in size to the Statue of Liberty. The foundry made a mold, and with the lost wax method (*cire perdue*), the angel was cast into bronze.

I wanted it to look ancient and crackled, as if it had been buried for centuries. I gilded the wings with flecks of fourteen-carat gold to add vibrancy and fluttery movement. It was done and it was heavy—so heavy I needed both hands to lift it. I loved its solidity and weight. I had never thought of paintings in terms of weight, and when I sold one it was gone forever. But with sculpture, I could make an edition and cast one for myself—the angel could be mine!

A major step toward self-possession?

While I was holding the bronze angel, I had a vision of it growing larger and larger, expanding in all directions until it became at least fifty feet high. It flew to the top of a Manhattan skyscraper and perched on the edge of the roof; its thighs straddled the corner and its legs dangled over the ledge, high above the city. Its cherubic face cast a gentle, protective presence on the people below.

I started to read about angels and to collect images of them—marble angels, bronze angels, angels woven into tapestries, angels inlaid in mosaic tile, angels painted on canvases, Greek and Roman angels, Byzantine angels, Renaissance angels, and Baroque angels.

In the course of my research, I found that in ancient Jewish lore, angels don't speak; they are mute, their messages delivered silently. Melissa doesn't speak . . .

Was the angel Melissa? Was it both of us? Was I giving Melissa wings to help her unsteady gait and a heart shield to protect her from harm?

It has been over thirty-five years since I created that angel. During that time, I have heard one parent after another refer to their autistic child as an angel—difficult, impossible, at times unbearable, even life-threatening, yet angelic, otherworldly, spiritual, possessing an uncanny purity.

Who are these children? What lessons do they have for us? Why are they here in this world, and why are they coming in droves right now?

Clearly they had entered my art. If anyone had told me I would one day give up painting to become a sculptor, I would have laughed. Yet here I was, obsessed with the new medium and curious to see what would be revealed.

Sculpture

I needed new equipment, sculpture stands, armature wire, hammers, saws, wrenches, and bins of clay, and I needed to learn from the great masters. I amassed a library of sculpture books on ancient Greek and Roman statuary, Renaissance bronzes, and Spanish Baroque wood carvings. I discovered figurative sculptors I had never heard of, like Alfred Gilbert, a British nineteenth-century artist, as well as Alexander Stirling Calder, father of the mobile artist Alexander Calder. And best of all, I uncovered women like Camille Claudel, Marcello (Adèle d'Affry), Malvina Hoffman, Gertrude Vanderbilt Whitney, and Anna Hyatt Huntington. For the next ten years, I closed the studio doors, worked alone, and stopped exhibiting.

I hired models and began to sculpt figures, all women. Each one became a new friend, a new protector. In an uncanny way, art was providing exactly what I needed.

The East Hampton studio was transformed to suit the needs of a sculptor. Walls to hang paintings were no longer necessary. I added mirrors to reflect all sides of my work. The studio turned into a cube of light, a white cathedral, a temple of sacred space, a sanctified ground in which to challenge the gods, a purified container to create the goddess.

I had no desire to show my work. Meisel became more impatient than ever, but all I wanted to do was mold the clay, hack it, smooth it, and stroke it. I refined and redefined body parts as I moved the warm earth around in my hands.

Sometimes, toward the end of the day as I worked in the quiet of the dwindling light, I felt I was re-creating myself. When I was deep into the work, past memories would float across my mind, but this time, they disappeared into the clay. It was like peeling layers of mirrored mica; memories showed up as glassy reflections, but there was always another layer waiting beneath the surface. The feeling was trancelike. I was beginning to hold my head up. My sense of self had taken such a

terrible beating during those refrigerator mother years that I was rendered powerless, immobilized, frozen. I also lost two years of my life on the Broadway bench, unable to move, love, laugh, or create. And now, with each sculpture, I was coming alive, becoming stronger and more confident.

I was connecting with women of the past, both real and mythological. Medusa, Daphne, and Medea became my sisters and guides; they whispered their stories in my ear and I listened. It was through them that I was able to uncover my past and build my future.

In researching their stories, I found there were hundreds of versions of each myth. In all cases the original story was distorted by patriarchal interpretations. Women were made out to be evil troublemakers, seductresses who brought men to their knees.

I came across ancient texts revealing that God was originally a woman. The Pelasgian creation myth, for example, says that Eurynome was The Goddess of All Things. She rose naked from Chaos, laid The Universal Egg, and created the universe and all things that exist: the sun, moon, stars, planets, the earth, and all living creatures. The Olympian creation myth says that at the beginning of all things, Mother Earth emerged from Chaos. These mythological women fascinated me. Some of them had perished, others survived; none received a proper hearing, and all remained mute throughout the centuries. Using my fingers and the tools of a sculptor, I gave them new faces, new voices, imagining what they might look like if they were alive today. There is a goddess in every woman and a god in every man.

Society shapes its values through its images, and I was creating a new kind of female. My pieces didn't look at all like the thick-thighed, densely packed women of Aristide Maillol. Nor did my goddesses have pendulous breasts, tiny waists, and huge hips like those of Gaston Lachaise. His women had feet so small they looked deformed, like those of the poor Chinese girls whose feet were bound to keep them from growing. Tiny feet were a sign of beauty, but they were also a sign of male domination and restriction. These defenseless girls became cripples who could barely walk. They could not run away or protect themselves.

The women I created were strong, intelligent, lithe, muscular, and sexy, modern women who worked out. My statues stand naked before the viewer without shame, confrontation, or aggression. They exhibit a sensuality and centeredness that comes from a strong sense of self. We

Fig. 56 Gaston Lachaise,
Standing Woman, 1912–15,
cast ca. 1930.

need the feminine principle to restore the balance of the planet. I felt this could be done through public art: beautiful, powerful women have to be out there, instead of generals on horses.

During my studies I came across a story about an Indian prince who was born with a bent body and humped back. Unwilling to show himself, he stayed locked inside his palace, feeling shame and humiliation. When he was twelve years old, he ordered a statue to be made of himself with a perfect body, no deformity, no hunchback. It was installed in his private garden and placed in the center of a reflecting pool, surrounded with water lilies. Every morning and evening the prince contemplated the statue and absorbed its beauty. Five years later, the prince left his palace and stood before his astonished subjects, an erect young man with a perfect body.

Was I trying to heal Melissa with my perfect statues? Is it possible for art to mend a person?

I felt a new purpose. I was on a high, riding the crest of the wave, creating one statue after another: *Art Muse, Medicine Woman, Colossal Head of Medusa*. Some were small, almost votive objects; others were life-sized and larger.

In 1991, I opened the studio doors, re-entered the art world, and had the first exhibition of sculpture at the Louis K. Meisel Gallery in SoHo. Susan Casteras, curator at the Yale Center for British Art, responded strongly to the work and wrote the catalog essay. She called the show *A Pantheon of Female Deities*.

The exhibition led to my first public commission. New York City Technical College wanted to commission a statue for its new atrium. I was amazed when I won the competition over George Segal, whose work I loved. My submission stood five feet tall, just about the size of Melissa, and I called her *Islandia: Goddess of the Healing Waters*. Islandia is about Long Island and its surrounding bays, harbors, inlets, and ocean, which I feel are sacred. I found myself giving *Islandia* long, outstretched wings and wondered where all these winged figures were coming from. Certainly not from the contemporary art world. Were they strictly products of my subconscious, or was I giving new meanings to ancient forms?

The bronze casting looked great and was ready for patinae. I stayed up nights worrying about the color. The student body was a mix of 70 percent Black and 30 percent Hispanic, Asian, and white. I wanted Islandia to reach all of them. Diversity was rarely, if ever, represented in public art. I decided to patina her gold, not only because it reflects light but because it functions as a color without really being one. I wanted everyone to be drawn to this goddess of gold.

I plated the entire upper half of the torso with fourteen-carat gold emulsion, gilded the wings with iridescent gold leaf, and blow-torched the drapery with cupric nitrate green.

Tallix—the art foundry in the Hudson Valley—fabricated a simple pedestal fitted with lug bolts to secure the eight-hundred-pound goddess. *Islandia* was driven directly into Edward Durell Stone's five-story glass atrium and lifted onto her pedestal. At that instant, I thought I saw her smile.

My dream to create a place for women in public art was coming true, and it continued when Michael Gallis, a young architect and city planner, contacted me about a commission for the city of Rock Hill, South Carolina. Its textile mills had closed and the entire industry had moved

Fig. 57 Colossal Head of Medusa, 1991. Painted and gilded bronze, 36 in. Photo courtesy of Audrey Flack.

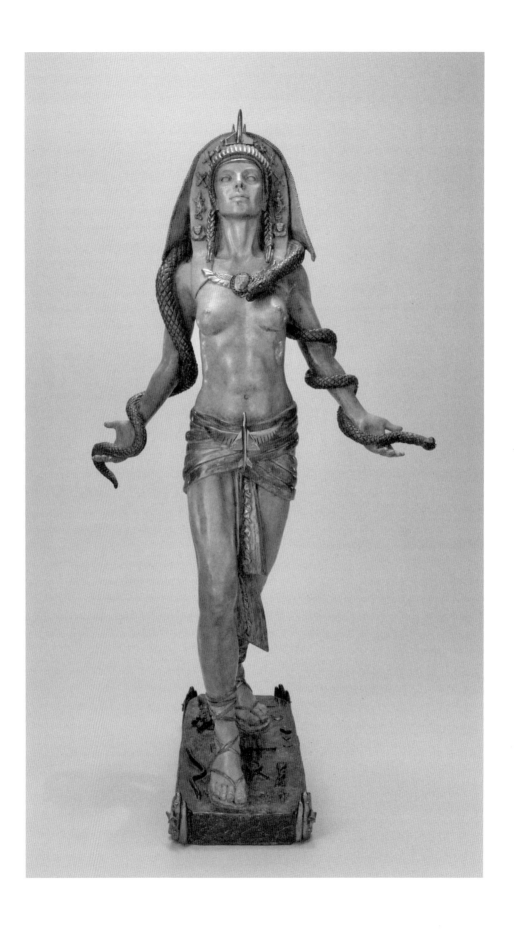

outside the United States. Stores were boarded up and nailed shut, citizens were out of work, and downtown Rock Hill looked like a ghost town. The citizens of Rock Hill had been crushed. Only twenty minutes from thriving Charlotte, North Carolina, Rock Hill had disappeared into the landscape. Gallis believed that a gateway could restore its identity and encourage business. He wanted statues that would become powerful, iconic symbols.

Gallis, the mayor, the city commissioner, and the entire city council flew to New York to visit my studio and review my work. After many meetings and votes taken, I was chosen for the project. Thinking of Greek statuary, I sculpted four giant statues, nude to the waist like the Winged Victory of Samothrace. The committee's response was overwhelmingly positive, but they knew that Rock Hill is in the heart of the Bible Belt, where even a partially naked woman was verboten. So I draped clinging fabric over their breasts, knowing that it would be a perfect symbolic element, since Rock Hill's economy had been based on the textile industry and the production of fabric. The diaphanous material looked as if it had been blown against their bodies. I extended it and turned the fabric into wings, fluttering in the breeze behind the figures.

Fig. 58 (opposite) *Egyptian Rocket Goddess*, 1990. Painted bronze, 42 in. Photo courtesy of Audrey Flack.

Fig. 59 *Islandia: Goddess of the Healing Waters*, 1987. Polychromed and gilded plaster, 5 ft. Photo courtesy of Audrey Flack.

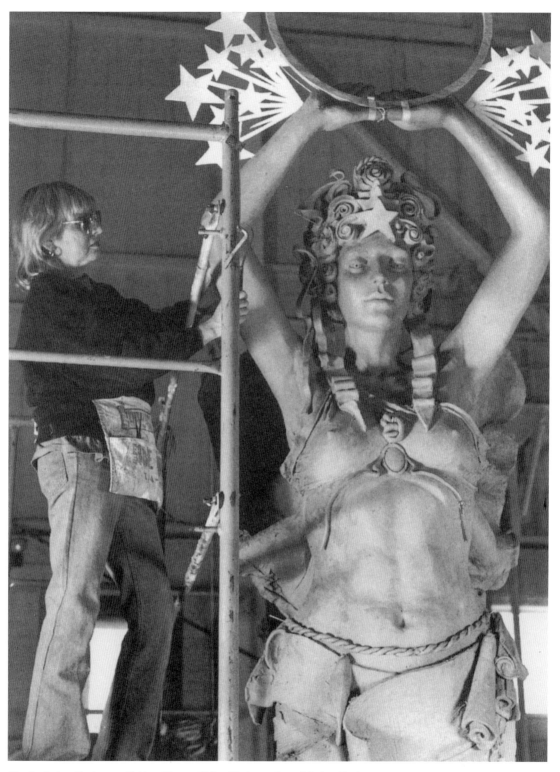

Fig. 60 Audrey Flack on scaffold working on *Civitas*. Photo courtesy of Audrey Flack.

The four colossal statues were cast in bronze, shipped to Rock Hill on flatbed trucks, and mounted in the four corners of a major highway announcing the entrance to Rock Hill. Standing twenty-five feet high on their solid granite bases, each one held a symbolic element of the city. The patina was a rich cupric green, highlighted with fourteen-carat yellow, moon, and white gold. The city named them *Civitas: Four Visions*.

The gateway restored the crushed pride of Rock Hill, reversed its economy, and turned the dying town into a thriving city. The Rock Hill Gateway won the National Transportation Award of the US government. The national news covered the installations, which led to other commissions, including one that would encompass my biggest dream and cause one of my greatest sorrows.

Portugal wanted to commission a statue and present it to the borough of Queens in the same manner that the French had given the Statue of Liberty to the United States. The site was on the Queens side of the East River, opposite the United Nations. With my heightened awareness of affirming female strength, I planned to create a monumental sculpture of a woman, every woman, and share the female principle with millions. She would be a universal woman, a healer, a survivor. This was a once-in-a-lifetime opportunity.

The statue depicted Queen Catherine of Braganza, a Portuguese princess who became queen of England when she married Charles II in 1662. The borough of Queens (Queens County) was named after her. Brooklyn (Kings County) was named after King Charles, and New York was named after Charles's brother, the duke of York.

Artists from all over the world competed. Amazingly, I got on the short list, and my maquette was one of five finalists to be presented at an event at the Waldorf Astoria. Four hundred guests attended the gala, including the president of Portugal and the borough president of Queens. After an elegant dinner with candelabras and champagne, guests were entertained with blaring trumpets and five Lipizzaner horses that pranced around the circular dance floor. The sixth and final stallion appeared with its rider mounted sidesaddle, wearing a voluminous bejeweled gown, plumed hat, and lace collar, looking exactly like Queen Catherine. It was a dazzling, unbelievable spectacle.

For the next two months I waited by the telephone and searched the mailbox. When I received word that my work had been chosen for the project, I went into orbit. The vote was unanimous.

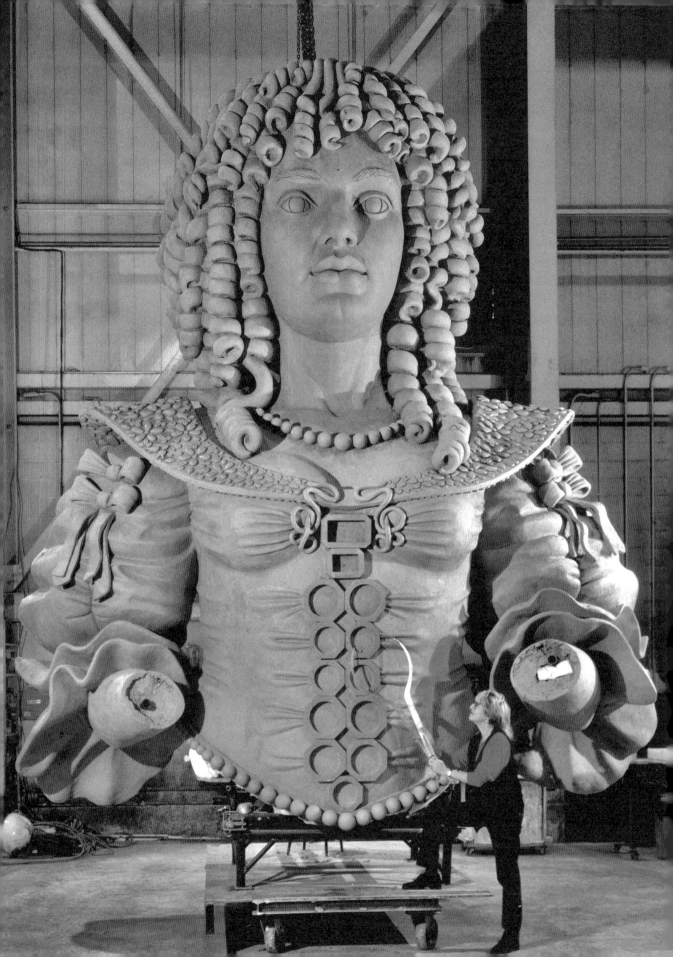

From the original small maquette, I went on to create a four-foot bronze and a ten-foot enlargement, correcting and refining each one before going on to the five-story colossus. She would set an example, be a person to emulate: strong, intelligent, beautiful, and compassionate. I wanted her to heal ruptures, bring people together. The borough of Queens, with its vast ethnic diversity, was the perfect place for her. Catherine would symbolize peace, the antithesis of a general on horseback wielding a sword. She would arrive in time for the new millennium, holding a clear crystal orb that would glisten when the western sunset hit her. This, along with the colored glass jewels embedded in her bodice, would cast a healing glow over the city, symbolizing positive energy, acceptance, tolerance, and harmony. I wanted the ideal. I was naïve.

What I failed to consider was that Portugal dealt in the slave trade in the seventeenth century, and Catherine was Portuguese. One fateful day, I picked up a copy of *Newsday*. The Reverend Al Sharpton was photographed leading a group of activists. Their placards read "SHAMEFUL QUEEN," "RACIST MONARCH." I was stunned.

The crystal ball I placed in her hand was referred to as "the bloody head of a slave." Ironically, the leading protester looked a lot like Catherine. My mother's sister, my favorite aunt, married a Black man. I have a Black family and used my beautiful cousin Karen as a model for Catherine. I had arrived at a universal face after all. Controversial articles started to appear in major newspapers both here and abroad. There was television and radio talk show coverage on almost every channel. Headlines screamed: "Slave Queen to Be Erected," "Group Protests Statue as Racist," "Colossal Statue Becomes Borough's Headache," "Flack's Statue Assailed as Racist."

Claire Shulman, the Queens borough president, called an emergency meeting to determine Catherine's fate. The Portuguese supporters sat on one side of the elongated table, the protesters on the other side, and both argued their points. In the end, Shulman decided that in order to prevent conflict (and for her to be reelected), Queen Catherine had to be shut down. From then on, I was besieged with telephone calls from newspapers, magazines, and television stations. The *New York Times*, *Newsday*, and the *New York Post* all covered the story. Artist friends said I was lucky to get all of that free publicity, but I hated it. I was shaken. With all the bad publicity, fundraising dwindled, and foundry bills were

Fig. 61 Audrey Flack working on *Queen Catherine* at the foundry. Photo courtesy of Audrey Flack.

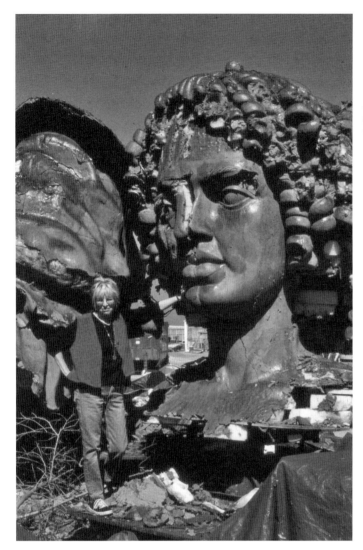

Fig. 62 Queen Catherine at the garbage dump. Photo courtesy of Audrey Flack.

not paid, including my salary. The project stalled, and the foundry threw Catherine in the dump.

I still remember climbing up the mountain of garbage and broken junk, careful not to step on any rusty nails. When I reached Catherine, I gently cupped my hand on her cheek. She had been there for several months, long enough to have been beaten by the rain, melted by the sun, and cracked by the wind. She looked petrified. Her nose was split in half, one eyebrow had fallen off, and she was leaning over a mushy piece of yellowed Styrofoam. Parts of her cheek and chin were missing. As I stood there looking up at her, a chunk of lower lip fell into my hand. That image was seared upon my brain. Something inside me had been torn apart, as if the Furies, the demons, the hostile angels, and the

princes of darkness had all conspired to destroy Catherine, to destroy me. I began to feel that I had murdered a real person, and the feeling wouldn't go away.

In 2013 Queen Catherine was melted down for scrap metal. Scrap dealers arrived at the foundry with huge trucks, weighed Catherine's body parts, and hauled her away. It was a dagger to my heart. Disillusionment set in, but after a while I was able to get back to work. Artists can create anywhere, anytime. They can visualize thoughts and emotions that are too deep to touch in any other way.

The East Hampton Party

The last days of July 1980 arrived, and it was almost time for Melissa's annual visit. Hannah, now nineteen years old, had arrived a few days earlier. I invited her to lunch at Pierre's, a French café in Bridgehampton. With garden salads and French herb omelets in front of us, Hannah had an overdue chance to talk. God knows, I have always loved Hannah, but Melissa's needs had left little time for her. I had been a wreck, always nervous, always on edge. Hannah had no childhood. After we finished our meal, we sipped tea and espresso, and I asked, "How was it for you, Hannah? It must have been so hard growing up with Melissa, and with me, too." Hannah was hesitant. I had never probed so directly. I paused. After what seemed like a long time, she finally spoke.

"Everything was chaos, Mom. I have no memory of feeling obliviously happy. I mean, just being happy and not worrying about everything around me."

"I know, things were pretty messy."

Hannah went on, "Missy's needs always came first. I never knew what she would do next. I felt like the sentinel on guard. If I didn't keep a hypervigilant watch, the world would fall apart. I felt powerless and frightened, I didn't want to make waves; things were bad enough. And I was worried about you." With everything else that was going on, she had worried about me.

"I took on the burden of alienation. But, Mom, it wasn't all bad. I am glad I have an autistic sister."

"I'm thrilled you feel that way, but why?"

"Because living with Melissa created an opening into the human condition. I see things other people don't see. She allowed a greater understanding of all kinds of things. Melissa perceives sensory data in

deviant ways, almost as if she's on hallucinogens; it made me aware of the fragility of the human body. I'm intrigued with brain chemistry, differences in perception, mental processing."

"Did you ever think of studying neurobiology?"

"Yes, but because Melissa never really got cured, I felt fatalistic. People are always looking for a cure, but sometimes you have to accept things as they are. You know, Mom, nature condemns us. It has no morals. Something less strong gets kicked out. Melissa is a flawed human being. To give her safety, love, and protection is human, but not necessarily a natural thing. People have a revulsion and fear of disability."

I felt proud of Hannah's character, her strength, perceptions, and tolerance. Proud that she could have protective feelings for those less fortunate. Proud that she could survive growing up with Melissa and love her. I told her so.

"You know, Mom, Missy is really great! I could have had a sibling that's a jerk or an awful person. We're lucky that Melissa is so charismatic and extraordinary. She has been allowed to grow into who she is. She is able to experience a lot of pleasure; she can love, touch, feel. I think we are genetically similar, Melissa and I. We have the same laugh, the same love of music, and a similar sense of humor. I feel close to her."

I worry about Hannah and carry guilt about the deprivation she had to put up with, but I know she is strong and can handle life. She has been there for Melissa and me with insights and advice that come from a profound understanding of her sister's condition. Hannah plays at least seven or eight instruments, composes soulful songs, and performs with her raucous Cajun dance band. Playing music with her brings joy to my life.

Missy arrived in East Hampton the next day aglow with excitement and laughter. She went directly to the beat-up beach piano and banged away nonstop, expressing her ecstasy at being with her family. She found Hannah's guitar case and brought it to her; she did the same with my banjo. It is her way of talking and it was perfectly clear: she wanted us to play music. We opened our cases, tuned up, and played, Hannah on guitar and fiddle, me on banjo. Melissa rocked away in heavenly bliss for the rest of the afternoon.

That weekend we were invited to an East Hampton party. Lots of beautiful people with beautiful tans showing off their Nautilus-muscled bodies and elegant summer clothing would be there. I didn't want to leave Melissa home, but taking her anywhere new was always a risk.

Fig. 63 Hannah: Who She Is, 1982. Acrylic and oil on canvas, 84 × 60 in. Photo courtesy of Audrey Flack.

I had no doubt that she would stand out. She always does. I was concerned about how people would react to her. I didn't want to ruin the party for the hostess or for myself, because if people were mean, it would break my heart. But after hearing that there would be a dance band, food, and drinks, I knew she would enjoy the evening. Bob and I conferred and decided we would introduce East Hampton to Melissa.

I dressed her in a white lace blouse, black pants, and new shoes. She looked beautiful but also different. Hannah is five feet eight inches tall. Missy is barely five feet. When Missy is relaxed, she literally glows. Her eyes sparkle, her teeth shine, she radiates love—but when she gets too stimulated, she protects herself by putting her hand in front of her face, palm outward, fingers spread, covering her eyes. She usually peers through her tensed fingers as if they were prison bars, the barrier she needs to feel safe. With her mouth pursed in a tight grimace, she presents a rather strange sight.

We parked the car and helped her walk on the uneven grass. She was wobbly but stabilized herself when we reached the wooden dance floor. She stood in the middle of the floor, made one of her grimaces,

and stared up at the colored lights strung overhead through her fingers. No one knew what to make of her. Bob and I took a protective position behind her.

"You can put your hand down, Missy, it's okay," I whispered.

She slowly lowered her hand and began to gently rock back and forth to the beat of the band.

"Let her be," Bob said, and led me off the floor.

We watched from a spot on the grass nearby. People were polite and continued dancing, making room around her. She rocked more and more, doing her dance, and then sidled up to an attractive man in a white suit.

"What's she doing, Bob?" I started toward her. Bob held me back.

"Let's see what happens," he said.

Melissa cocked her head to one side and flashed the man a radiant smile, light shining from her wide-open eyes. He took her hand.

"Bob, look, look. I can't believe it, he's taking her hand!"

The man tried to dance in a normal way, but Melissa wouldn't or couldn't, so he began to rock like she did, and they rocked together. Everyone looked on while they continued their dance. His girlfriend joined in and the three of them rocked together. Missy turned toward another man and flashed her charming smile. He reciprocated and joined the dance.

By the end of the evening, Missy had connected with everyone in the most gentle and beautiful way. It was a large party, and many people didn't know one another, but by the end of the evening they had all made contact through Melissa. Her total disregard for anything superficial—looks, wealth, position, or fame—silently affected everyone, and her sweet, gentle nature permeated the atmosphere.

Of course she had to grab a large chunk of chocolate cake, smear the icing on her new blouse, and laugh. What she really did that night was raise awareness. She was special and they knew it.

When Missy's vacation was up, we packed her clothes and drove back to school. My usual anguish over leaving her was followed by relief at having my life back. A few days later I was flipping through the *East Hampton Star* and came across "Point of View," one of my favorite columns, by Jack Graves. After the first sentence I had to set my teacup down. The story was about Melissa. I couldn't believe it.

The young woman brought by her mother to a party last Saturday was said to be autistic, unable to communicate. Yet she communicated

Color Plate 23 *Fiat Lux*, 2017. Acrylic on canvas with 22K white and yellow gold leaf, 83 × 83 in. Photo courtesy of Audrey Flack.

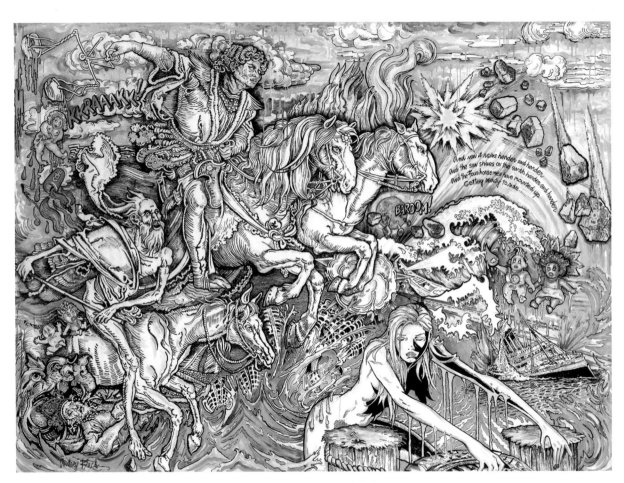

Color Plate 24 *Days of Reckoning*, 2017–20. Acrylic and glitter on canvas, 6 × 8 ft. Photo courtesy of Audrey Flack.

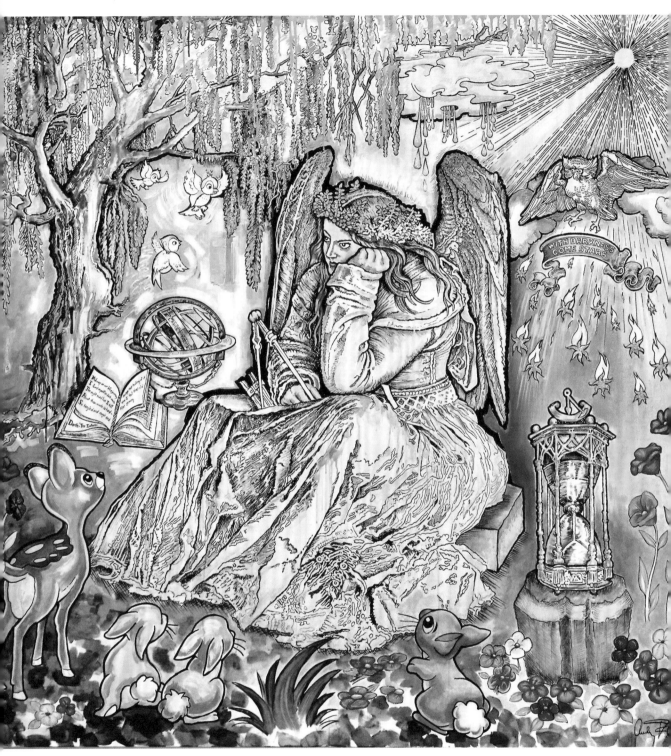

Color Plate 25 Melancholia: With Darkness Comes Stars, 2020–21. Acrylic and mixed media on canvas, 68 × 68 in. Photo courtesy of Audrey Flack.

Color Plate 26 Tidal Force, 2022. Acrylic and mixed media on canvas, 42 × 36 in. Photo courtesy of Audrey Flack.

Color Plate 27 Lux Eternal, 2022. Acrylic and mixed media on canvas, 40 × 30 in. Photo courtesy of Audrey Flack.

Color Plate 28 (opposite) Self-Portrait with Flaming Heart, 2022. Acrylic and mixed media on canvas, 40 × 30 in. Photo courtesy of Audrey Flack.

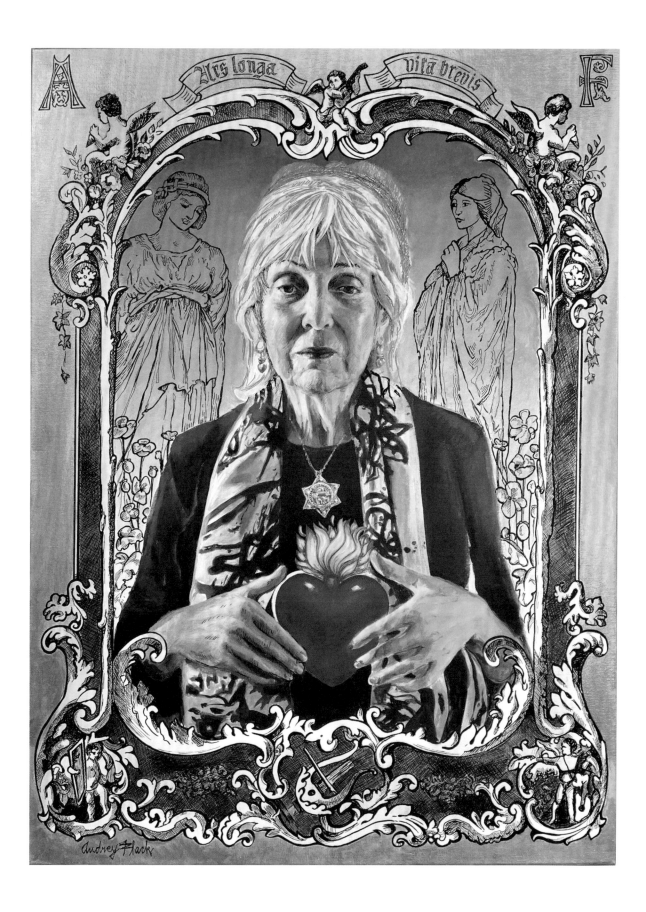

Ars longa · vita brevis

Audrey Flack

Color Plate 29 Civitas: Four Visions, 1991. Painted and gilded bronze with granite base, 22 ft. Photo courtesy of Audrey Flack.

Color Plate 30 Recording Angel, 2006. Gilded and patinaed bronze, 14 ft. with base. Photo courtesy of Audrey Flack.

Color Plate 31 (opposite) Veritas et Justitia, 2007. Bronze with gold leaf, 15 ft. with base. Photo courtesy of Audrey Flack.

Color Plate 32 *Beloved Woman of Justice*, 2000. Bronze with gold leaf and marble base, 84 in. with base. Photo courtesy of Audrey Flack.

with the rest of the partygoers very well. Perhaps far better than the rest of us, who, over the course of the evening, talked and danced with a handful of our fellows. Her name was Missy.

She on the other hand, made contact with practically everyone. Not able to speak and limited in movement, everything was expressed through her eyes.

One could not help but wonder what she was thinking. Did she in her sideways glance see through you? Yes, it seemed she did.

This was not the way it was supposed to be. She was "abnormal" and we were "normal." She was the outsider at whom I smiled nicely on being introduced, before escaping to others for pleasantries and to the music to try to lose and assert myself in dance.

Am I natural-looking? Do I look as if I am inside rather than outside, the dance? Do I look self-conscious? Confused? Preoccupied with my own little world?

All of a sudden, during a break, she is there. Quite close. She reaches out and tugs gently at my sleeve. I look toward someone with whom I've been talking, somewhat in inner confusion. She says gently, "She wants to dance."

Missy is smiling as we move. I hold her hand and look at her. We move around the dance floor together for a few moments and then she glides away, putting the back of her right hand up to her face.

She is peering back at me through her fingers, which are spread like bars over her mouth and eyes. She had, for those few fleeting minutes somehow made mine disappear.

I felt honored, blessed. It was a party I will not soon forget.

Tears came to my eyes. The handsome man in the white suit had written this. Into this "perfect" place, East Hampton, where trees are chopped down if they don't conform to a preset notion of perfection, an imperfect person called Melissa came and let her light shine.

Sometimes I think people with autism, like Melissa, are raw, unfiltered souls, tantalizing and intriguing—pure beings walking around, visible only to those able to see. They don't seem to care what they look like, no ties, jackets, makeup, or jewelry; they ask for nothing. Nothing clouds or compromises the purity of who they are. Are they without egos or are they higher beings, living, breathing works of art?

Dostoyevsky described his experience of epilepsy in this way:

For several instants I experience a happiness that is impossible in an ordinary state, and of which other people have no conception. I feel full harmony in myself and in the whole world, and the feeling is so strong and sweet that for a few seconds of such bliss one could give up ten years of life, perhaps all of life.

I felt that heaven descended to earth and swallowed me. I really attained God and was imbued with Him. All of you healthy people don't even suspect what happiness is, that happiness that we epileptics experience for a second before an attack.

Melissa doesn't have epilepsy, as far as we know, although many autistic people do. But she does have an aberration of the mind. I have witnessed her entering an ecstatic state while listening to Baroque music or following the pattern of a raindrop as it makes its way down a windowpane, shifting angles and accumulating minute amounts of water. She moves closer, mesmerized by the reflections of the sky in the raindrop before it dissolves. She watches leaves sway in the breeze and the dance patterns of flickering lights on the pavement. She runs her fingers over the topology of a piece of curled paper, studying, entranced by the shapes and delicacy of its curves and edges.

This book, besides encompassing art, is in many ways a recording of Melissa's life. She has become a source of joy, even though she remains severely autistic. The changes in Melissa came about over the years and made every one of our thousand efforts worthwhile.

The rage and frustration of years ago have all but gone. Melissa has chosen to communicate with smiles, to laugh. All those who see her are touched by her purity. From darkness and panic she has emerged, an extraordinary person, an angel, really, who has taught me the highest aspects of love.

For most of us, the need for stimulation and gratification keeps us running from one thing to another without ever being fully satisfied. But Melissa's cup runneth over. When I see through Melissa's eyes, the world becomes magical, sacred, and timeless. There are no deadlines, no manipulations, no ego, no concept of money or competition. Melissa is operating from the heart while she accesses a multidimensional universe.

I only made one painting of Melissa, when she was five years old and at the peak of her autism. But some forty years later, Melissa's beautiful face emerged as the *Recording Angel*.

Fig. 64 Audrey, Missy, Hannah, and Jeanette Flack. Photo courtesy of Audrey Flack.

Epilogue

Facing Death at Ninety-Two

If I were to die tomorrow, no one would say, "Too bad, she was so young." I have been lucky enough to make it this far and am in the process of preparing for my inevitable demise. I've lived through dozens of art movements and stylistic changes. From Ab Ex to Pop Art, from Conceptualism to Photorealism, from Minimalism to digital art and so many in between. I've seen artists reach fame and glory, only to have their careers demolished and their egos broken.

While I face the few years left for me, I look back at the broader landscape with an ego that has diminished, not only because of the wisdom that comes with age but because of real and urgent issues. Bob fell down the steps in East Hampton five years ago, cracked his head, and was subject to several brain operations that left him with lasting damage and partial dementia. I was alone looking at him lying in a pool of blood, frightened and on the verge of panic. I must mention how wonderful and kind the East Hampton police were at that moment.

One year later, I was diagnosed with ovarian cancer, something I thought would never happen to me: I was supposed have a heart attack like my father and brother. But my fate was cancer, chemotherapy, and all of the fear and pain that accompanies that dreaded disease.

Fortunately, it was caught at an early stage and I am still here, but I am left with the aftereffects. I told only close friends and family and continued drawing, painting, and teaching at the New York Academy.

I am lucky that my mind remains clear and sharp, filled with ideas for new art. The creative spirit is running strong and I continue to work. I have a passion for music and play several instruments, my favorite being the banjo, which I play in the tradition of old-time and bluegrass music. I have had two bands; the first was the Art Attacks, which included artists Connie Fox, Bill King, Donald Kennedy, and architect Bill Chaleff. We played at art openings and at local East Hampton restaurants. The second and more professional band was Audrey Flack and the History of Art Band, which included members Johnny Jackpot (on banjo), Roger Grossman (stand-up bass), Deborah Grimshaw (fiddle), Adam Grimshaw (guitar), Walter Us (guitar), and Connie Evans (spoons). I wrote songs with lyrics based on stories from art history. Most of them turned out to be about macho men and wronged women. Some were sad, others happy, but we always brought the house down.

Melissa broke her hip years ago and remains in a wheelchair, but she is handling it well. During the COVID-19 pandemic, I connected with her over video calls. As this book goes to press, I am looking forward to seeing Missy for the first time in five years.

Hannah is performing music—Irish, old-time, Cajun, and experimental. She recently started exhibiting olfactory artwork, with her first piece being shown at the Olfactory Art Keller gallery on Grand Street. She has come up to bat for all of us in her incredibly wonderful ways. Bob's children are coping well with all of the health and family difficulties that aging parents have brought. Thankfully, they've inherited Bob's steady nature.

I find myself, despite the pain and medical issues I have to deal with every day, feeling incredibly grateful and filled with love. Grateful for my sun-filled studio; grateful for the small tugboats that push huge barges up and down the Hudson River; grateful for Severin Delfs, my wonderful studio manager and friend, and for Samantha Baskind, who writes so insightfully about my art and is always there for me; grateful for Bob's sweet and kind nature; grateful for my children, family, friends. I feel love for everyone.

Bliss occurs when you let go of all attachments; so say the Buddhists. And when you are blissful, you love everyone. And perhaps it is pure love we feel when we are brought to our knees by great art. From Piero della Francesca to Jackson Pollock. From Carlo Crivelli to Mary Cassatt. These artists let go of everything and gave us the gift of pure bliss.

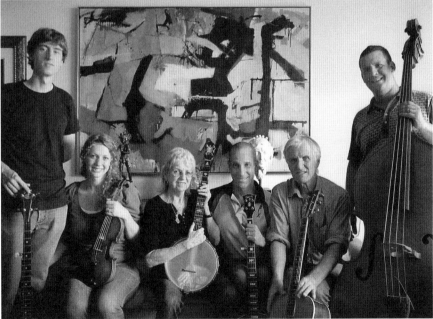

Fig. 65 The Art Attacks. Photo courtesy of Audrey Flack.

Fig. 66 Audrey Flack and The History of Art Band. Photo courtesy of Audrey Flack.

The greed, power, and money that have commodified the current art world will diminish, and the paradigm will change. So if you are feeling despondent about the art scene, give up the scene, but don't give up art. And if you have difficulties or are caring for a loved one with problems, remember to take care of yourself. And if you are different, accept it, express it, and rejoice in yourself.

Some of the most devastating conditions can be gifts. Art is a gift we are given, a gift that no one can take away. On its highest level, it bypasses the profane and deals with the sacred. Art kept me alive and still helps me cope with the most heartbreaking situations in my life. Art does that; it is the ultimate healer. In the midst of all the darkness that life can bring, art reminds us that with darkness can come stars.

Fig. 67 Audrey Flack and daughters Missy and Hannah. Photo courtesy of Audrey Flack.

INDEX